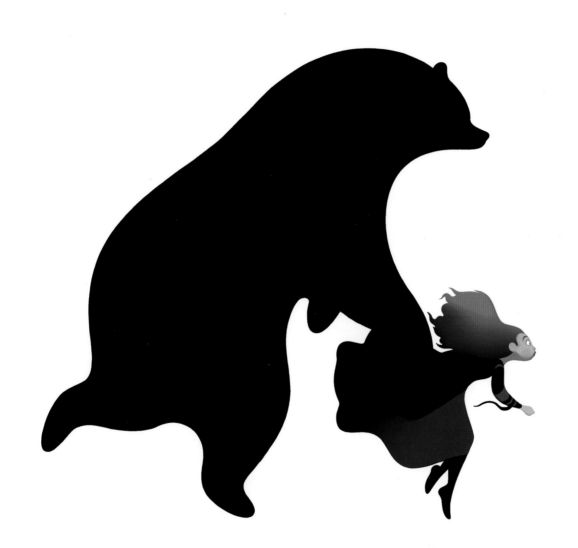

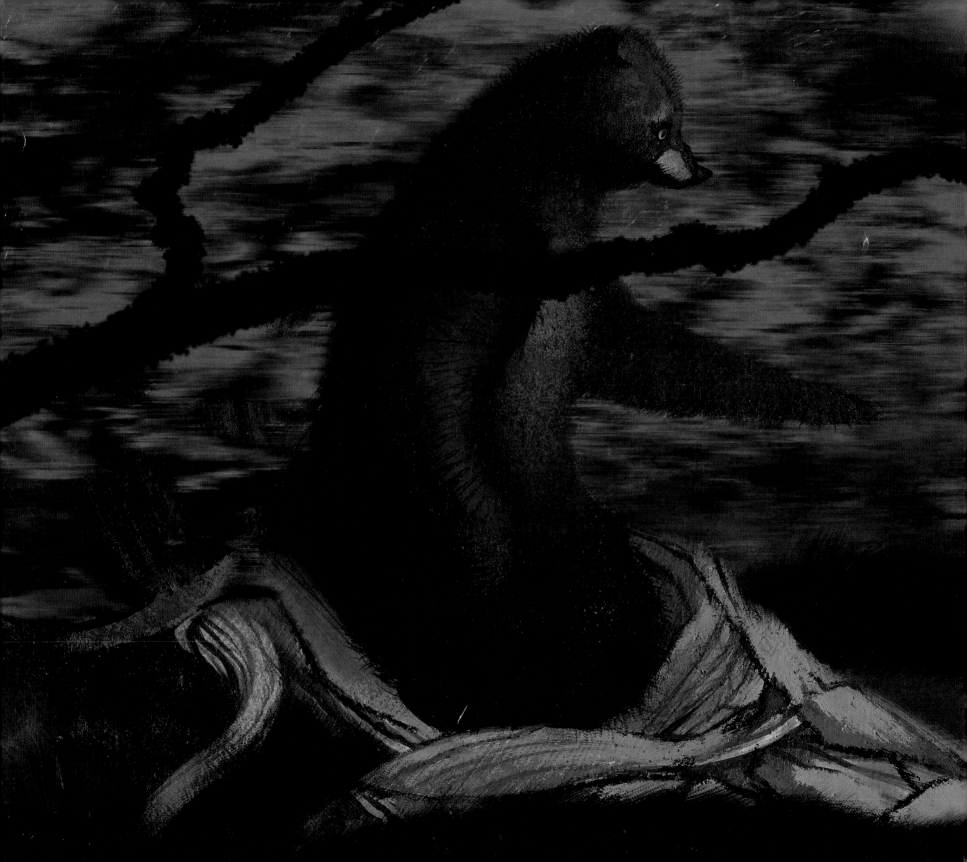

Disney · PIXAR

THE ART OF BRAVE

by Jenny Lerew
Preface by John Lasseter
Foreword by Brenda Chapman and Mark Andrews

CHRONICLE BOOKS
SAN FRANCISCO

Library of Congress Cataloging-in-Publication Data is available.

ISBN: 978-1-4521-0142-2

Manufactured in China

Designed by Glen Nakasako, Smog Design, Inc.

10 9 8 7 6 5 4 3 2 1

Chronicle Books LLC
680 Second Street
San Francisco, California 94107
www.chroniclebooks.com

Front Cover: Steve Pilcher | Acrylic, Digital | 2007
Back Cover: Steve Pilcher | Digital | 2011
Front Flap: Steve Pilcher | Digital | 2008
Back Flap: Steve Pilcher | Digital | 2008
Endpapers: Steve Pilcher | Digital | 2011
Page 1: Steve Pilcher | Digital | 2005
Pages 2–3: Steve Pilcher | Acrylic, Digital | 2011
This Page: Concept poster | Steve Pilcher | Digital | 2007
Celtic background design elements throughout book:
 Cassandra Smolcic, Huy Nguyen, Justin Cram, Steve Pilcher,
 Michael Gagné, Tia Kratter | Digital | 2007–2010

Steve Pilcher | Marker, Pencil | 2005

PREFACE

Just over twenty years ago, Pixar began work on what would be our very first feature film—and the very first feature-length computer-animated film—*Toy Story*. Part of why we'd chosen the subject matter we did was because we knew the computer could do a great job with toys, which are mostly plastic. One day, we knew, humans and animals would be easier to do, but at the time, the technology just wasn't there yet.

Brave is Pixar's first period film, our first story told in another time, and it pretty much encapsulates everything that was technologically out of reach for us when we made *Toy Story*. Medieval Scotland is as far from an environment that is natural for computer animation as you can possibly get. Forests, fields of grasses and heather, craggy rocks covered with lichens and mosses . . . even the man-made objects, hewn from rock and wood and hammered out of iron and steel, are irregular. The animals, from the king's dogs to Merida's horse, Angus, to the bears at the heart of the story, are shaggy, furry, and muscled. Humans have freckles and wrinkles and layers of clothing, all of different weights and textures. And don't forget Merida's spectacular hair.

Storytelling is at the heart of filmmaking, and what I love so much about these *Art Of* books—and all the other ways in which we look behind the scenes at the studio—is that they show how everyone at Pixar works with that in mind. How do you support the story with every detail available to you? How do you add dimension to plot and personality with a character's design, with their clothes and words and behavior, with set design and color and light and texture and composition?

Every art review on this show was a treat for me, and I am so excited to be able to share with you in this book the incredible artwork I got to see in those meetings. The level of artistry and dedication in this film's crew, in every aspect of its production, was just unbelievable. They poured their hearts into this movie, and it shows.

—John Lasseter

FOREWORD

BRAVE – |brāv| *adjective*

ready to endure or face unpleasant conditions or behavior without showing fear.

What a perfect description of a working mother and her daughter trying to cope with each other!

When I came up with the idea for *Brave*, my predominant inspiration was the bundle of passion, stubbornness, determination, and strength of character that is my daughter. Having been a shy and submissive child myself (wink), I was completely unprepared for the impact she had on my life. We locked horns, we butted heads, and we control-freaked each other to distraction. And this was when she was only five! I wondered what she was going to be like as a teenager. She'll be thirteen when the film is released—and thus I came to Merida and the story of *Brave*.

Although I am one of the great American mutts, a strong part of my ancestry is Scottish; my love of Scotland is another inspiration for this story. The people are gutsy and have a wonderful sense of humor. I have always been drawn to that beautiful and mythic country. It's a land so rugged and strong, yet it has something growing on everything—moss and all sorts of greenery—which softens it and makes it feel feminine to me. Scotland is truly like a woman: we may look soft, but we're made of much tougher stuff underneath.

Notwithstanding the fact that I love fairy tales—and that was the genre I was aiming for—I knew *Brave* had to be unique. There was no room for a prince or other love interest to come along and save the day— or even be part of the day. What I envisioned was an action-adventure, folktale, love story between a mother and her daughter. I wanted drama, darkness, and scary magic contrasted with adventure, family love, and humor. Out of that tall order came the strong, talented, and fiery Princess Merida; the dignified, hardworking, plate-spinning traditionalist Queen Elinor; and the fun-loving, wild Highland hunter-warrior King Fergus . . . as well as bears, witches, and will o' the wisps!

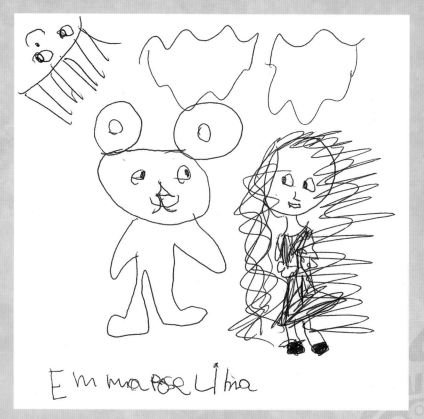

Emma Rose Lima (Brenda Chapman's daughter) | Pencil | 2006

What a challenge to offer up to my crew! I was amazed at their willingness to accept it.

Many thanks to two dear friends—co-director Steve Purcell for his support, inspiring leadership, and visual sense, and producer Katherine Sarafian for her enthusiasm and diligence in supporting the vision.

I especially have to thank another dear friend and colleague, Steve Pilcher, for accepting the role of production designer and bringing this story to life with such beautiful imagery. I had to work hard to convince Steve that I wasn't trapping him into doing a pink and purple princess movie. Luckily for *Brave*, he was convinced. *Brave* is one of the most uniquely beautiful films ever made because of his amazing talent and his incredibly gifted crew. *The Art of Brave* is filled with their work. I hope you enjoy it.

—Brenda Chapman, director

I was a fan of this project from the moment I heard about it, before I ever thought I would be working on *Brave*. Medieval Scotland, sword-fighting, archery, action—as a huge fantasy buff and Scotophile I was very excited about seeing this movie, and it was amazing to see it grow and develop in the hands of Brenda and her team.

When I came onto the project and got to see their work close-up I was even more impressed. Scotland is one of my favorite places in the world. The rich history, the weathered stones and trees, the landscapes carved by time—for me, it's a place unlike any other, one that exudes story and legend and myth and magic. I was blown away by how that spirit was captured in the character designs, in the sets, in every nuance of the art direction. Like Scotland itself, there's a story to every element in the world of *Brave*. You can feel the same richness and texture, the same sense of history in every detail.

To come into a world like that and work with such an amazing crew was just terrific. This project has a special quality to it that makes people love it and love working on it, one that comes straight from Brenda. The world and story she's created is so inspiring, it makes you want to work your tail off to make it the best it can be.

A large part of this is because the heart of the film is about something everyone can understand and relate to: the relationship between a parent and a child. As it happens, I'm both an oldest child and a parent of four myself. Merida's misconceptions about her parents—I've been there. Elinor's efforts to find the right balance between guiding her child and letting her find her own way—I can relate to that too. But everyone struggles with the tension between being shaped by your surroundings and wanting to reshape them; everyone goes through a changing under-standing of what being a parent means and what being the child of your parent means.

The depth of this feeling is what has charged the creation of every part of this world. In the hands of such talented artists it's no surprise that the results are so spectacular. It's been an honor to work with them—they'll have my sword arm anytime.
—Mark Andrews, director

Steve Pilcher | Digital | 2007

SETTING THE ARROW

Two shapes make their way across an undulating landscape of snow-buried woods. The first is the wiry figure of a girl whose mane of brilliant red hair betrays her Scots heritage. Charging ahead, she pulls behind her an enormous bear many times her size. The animal could kill the girl with a slap of its paw, but its wavering posture makes it seem unlike a wild creature. The girl looks fiercely forward as she leads them toward an unknown destination, but the bear looks back, an oddly human expression on its face....

The scene described is set in Scotland more than a thousand years ago, but it actually exists in the present. It's a concept painting, just one of hundreds that were pinned to the walls of a room at Pixar Animation Studios in Emeryville, California, during the making of its thirteenth feature film, *Brave*. The production began more than five years ago, and although this particular painting was made very early in the process, it remained where the artists could see it as they went about executing the millions of tasks that would compose the finished film.

Animated films are, true to their name, full of movement, but before they can move they have to be imagined, written, designed, and built—a process that can take many more years than the animation itself. *Brave* began as an idea and became a story, its initially small circle of artists widening in scope to become the army that constitutes a film production. Throughout the process, the directors, production designer, and crew worked together to maintain the integrity of the film's look and feel. This book is a record of the ideas and creativity (and countless hours of work) that built the foundation of the final film, of artwork that isn't intended to be seen by the audience in its original form but whose inspiration is still felt. The producer, directors, designers, animators, story artists, modelers, and sculptors all contributed, invented, and expanded on each other's efforts to achieve beauty, believability, and mood.

From its beginnings as an animation outpost along the shores of the San Francisco Bay, Pixar has been a studio that produces deeply personal stories. Whatever the setting, at the heart of each film are ideas and characters rooted in the artists' own lives, mined from their own experiences and set aloft by imagination. The studio's efforts have been so successful that the tremendous challenge of taking an unforgiving technology and bending it to produce a seemingly natural world is virtually taken for granted today. In fact, in an age when animation is appreciated and recognized as never before, the artists who produce it are still aware that many believe "it's all done by computers." It's an understandable mistake for the layperson to make and one that most of the artists who hear it are philosophical about—but it couldn't be more wrong. However sophisticated their programming, computers are simply a means to an end, another tool—along with pens, brushes, and paper—through which the filmmakers express their vision. In essence, though the tools have evolved, features at Pixar are

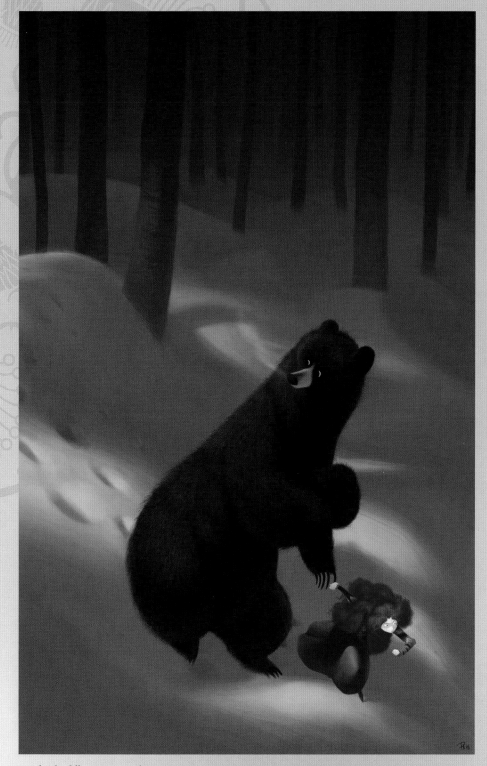

Paul Abadilla, Matt Nolte | Digital | 2008

conceived and planned exactly as animated films were eighty years ago: with observation, drawings, paintings, and all sorts of tactile exploration.

Brave presented a challenge to its artists: Create a mythic tale that transports the viewer, is enchanting in its beauty, and is relatable as a real story with real people. Present a world that's epic, yet intimate; folkloric, but set in a real place—Scotland. *Brave*'s narrative may deal in ancient magic, kings and lords, spells and witches, but in truth it's about a family's growth and transformation, about repairing the rifts among people who love but can't understand one another. It's about the burdens of responsibility—and the rewards. It's also very much about the elemental forces of nature both within and without.

It's not incidental that *Brave* is set in Scotland. Far from being simply a backdrop, Scotland itself is a major character in the film. Directly or indirectly, the mercurial moods of its weather and the wildness of its countryside inform every scene. It was a key goal of the artists to capture that spirit in *Brave*'s design. Completely committed to their task, they formed a bond as a production, based on mutual respect, curiosity, humor, and a belief in the potential of their medium to entertain and inspire.

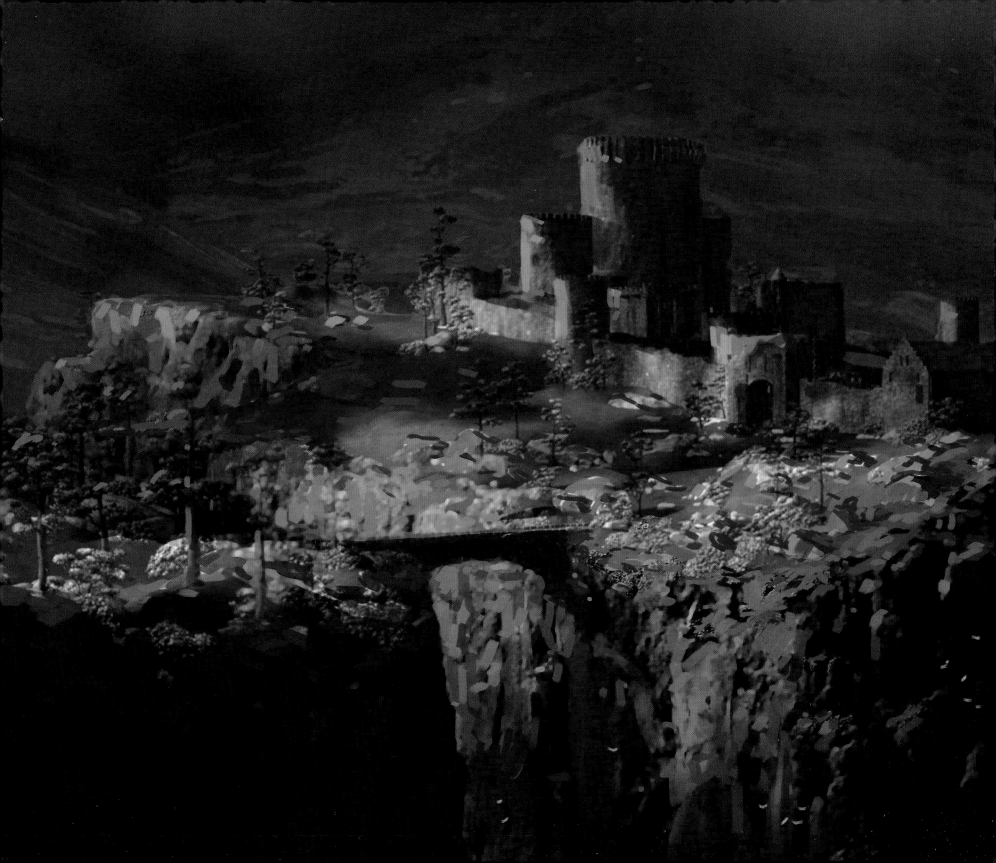

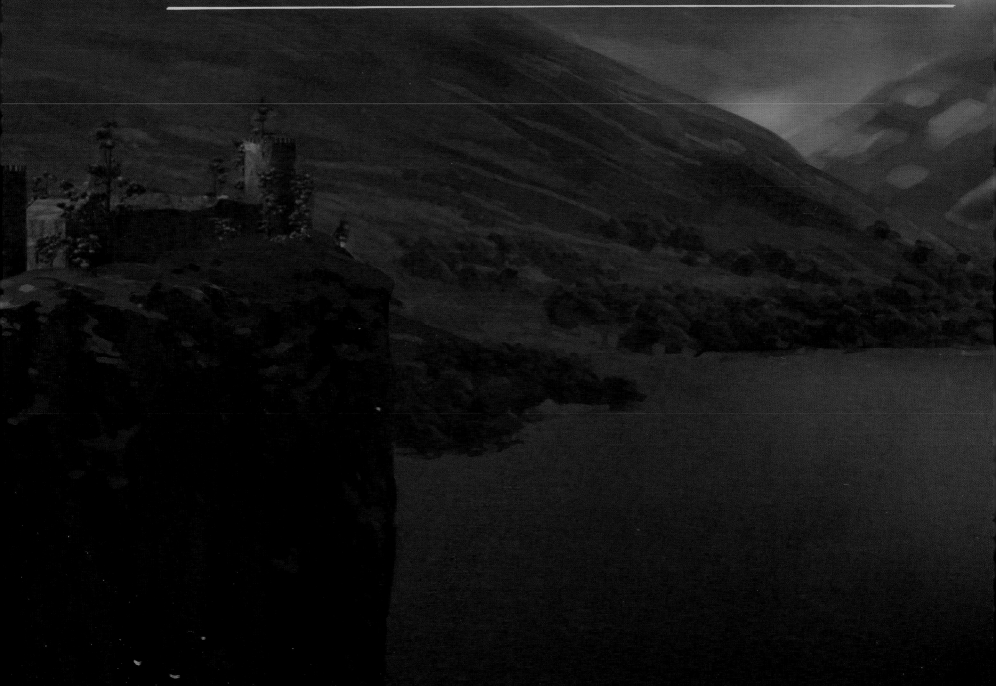

SECTION ONE
GATHERING THE CLAN

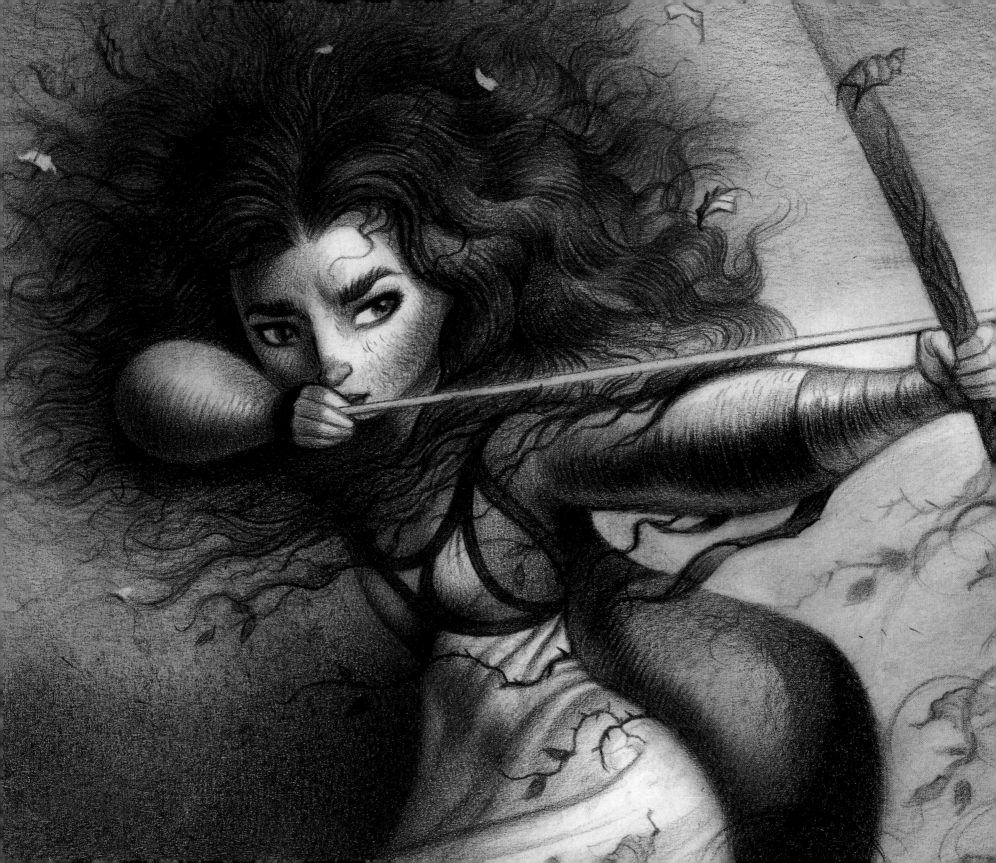

CHAPTER ONE
DRAWING THE BOW

"The main thing that inspired *Brave* was my relationship with my daughter, our love and our battle of wills," director Brenda Chapman recalls. "I wanted to create an old-world folktale—dark, but also mysterious and magical, where the magic is almost a mystery. I purposely didn't want to have a love story, I didn't want to have a prince. We've seen that, and I'd done that before. I love *Cinderella* and *Sleeping Beauty*, and I loved working on *Beauty and the Beast*, but I really wanted to do something different.

"Originally it was going to be set in some Northern European mythical place," Chapman confesses, "but I realized that I kept coming back to Scotland. I had been there once before and I'd fallen completely in love with it. I have Scottish ancestry. So it all just worked."

After a good deal of thinking about the story, Brenda Chapman pitched her initial idea to Pixar's chief creative officer, John Lasseter, who gave her the go-ahead to develop *Brave*. At the embryonic stage directors like to run a film idea by other artists. They can immediately see if the story's clicking, while at the same time putting out feelers for those who might eventually become part of the crew. "I went to lunch with some story artists I'd been working with, and over the course of the lunch they asked what I was working on as I'd finished up on *Cars*," Brenda recalls. "So I just did an impromptu pitch. It was mainly about the mother-daughter story, and how they didn't get along, and how one gets turned into a bear—the whole thing. Eventual co-director Steve Purcell was the one who kept leaning forward, listening and asking questions. The next day I found these amazing drawings he'd done of my main character that he'd slid under my door. That was really the beginning of Merida, visually."

"I liked how earthy and grounded the idea was," Steve Purcell says. "It wasn't packed full of fantastical animals. It felt like a very real, authentic folktale. I connected to it right away, so I went home and started doing some drawings."

Purcell, a man with years of experience in animation and a long-time important figure in the comics world via his creation Sam and Max, had come to Pixar at the

Steve Pilcher | Pencil | 2005
Pages 12-13: **Noah Klocek** | Digital | 2011

invitation of one of its key artists, the inimitable, much-loved story veteran Joe Ranft, to join the story crew of *Cars*. Purcell very much enjoyed working alongside Brenda Chapman on that film.

It seemed fated that the two would work together again, because Ranft pitched Purcell to Chapman as a potential head of story for *Brave*—without Purcell's knowledge. Joe Ranft wore a lot of hats in his years at Pixar—as a cross-pollinator of ideas, an enthusiastic sounding board, and always a generous facilitator of talent. In fact, it was in part through Ranft's urging that Chapman had also come to Pixar. As Brenda recalled, "Joe was the defining voice that took me to story work as opposed to becoming an animator. It was as simple as Joe saying, 'Have you ever

thought about getting into story?' after he saw my student film storyboards in my last year at CalArts. If Joe saw something in my work, I wasn't going to question it, and that was the direction I took, that created my career. I'll always be grateful." Ranft was sure Steve Purcell would be a great match to work with Chapman in developing her story further. As was usually the case with Ranft's intuitions, he was right.

Since she was relatively new to the studio at the time, Chapman's first instinct had been to choose familiar people to work with, but Purcell's reaction to her pitch made his affinity for the material clear.

Purcell's initial drawings made a tremendous impact. "Steve just kept handing me stuff that was so great," Chapman recalls, "so I just said

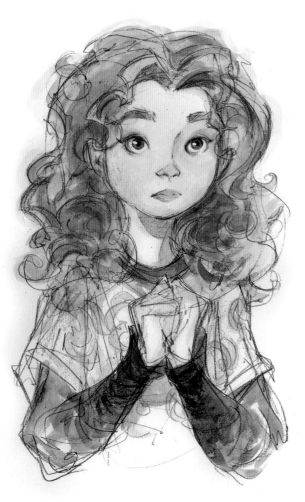

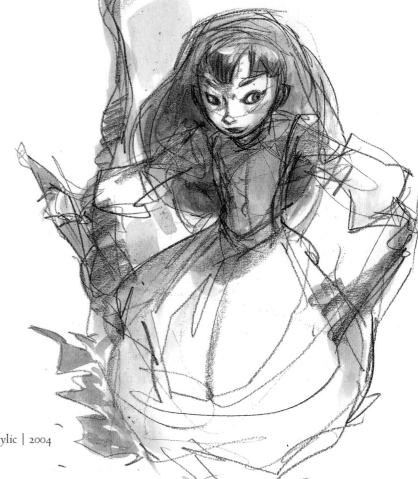

"These were the first images of Merida that I did, when she was a little younger in my mind than she ended up being."
—Steve Purcell, co-director

Steve Purcell | Acrylic | 2004

Steve Purcell | Acrylic | 2004

16

'I'd love for you to be my head of story. Joe [Ranft] believes in you, I believe in you, and I'd really like it.'" He agreed, and both began writing *Brave* together, along with Irene Mecchi (*The Lion King*).

The next key hire would be crucial: that of *Brave*'s production designer. Steve Pilcher joined the team after what became Brenda Chapman's "favorite recruiting story ever." Pilcher was an artist with years of experience at different studios on an eclectic mix of films. Some had been more interesting than others, but he'd reached a point where he was looking for something that would be truly creatively satisfying. An intense, loquacious, and sharply intelligent man, Pilcher had had enough of projects that, in his estimation, either didn't require or didn't use enough of what he could give, and he was ready for a serious challenge artistically.

Pilcher had no previous experience at Pixar when veteran Pixarian Ralph Eggleston recommended him to Chapman. As with Joe Ranft, any referral from Eggleston was a major heads-up, so in short order Chapman was reviewing Pilcher's portfolio, marveling at its breadth and beauty. With the studio interested in hiring him, she got the go-ahead to pitch him the story of *Brave*. The director and the potential production designer sat together at one of the little tables in Pixar's airy atrium. What happened next became one of Chapman's great "proof of concept" pitches, to the eventual amusement of both of them.

"I started out talking about the royal family, and a princess," she recalls, "and I could see him just sinking down in his chair." She was right: Pilcher thought he was going to hear yet another take on trampled ground, and he had his guard up.

"I have this checklist in my mind of things I've heard a million times before," Pilcher contends. "First, Brenda was talking about a mother-daughter relationship, and with that start, I thought, Hm, not sure . . . check!" He gestures ticking a box off his list. "'And there's a castle . . .', Check! 'It's in Scotland . . .' Well, okay, that's interesting. But I was still picturing, you know, your average fantasy formula—a thing that's been done over and over. I thought, There's no way I'm doing this."

Chapman adds, "I knew he was thinking pink and purple, and pointy castles. I thought to myself, Uh-oh, I've lost him already. I was aware he'd been down that road before on other projects and clearly that kind of thing didn't interest him." But firm in her convictions, she plowed ahead. "I started talking about the characters, and the type of castle I wanted, and especially about the landscape—the ruggedness and the mystery of it."

It worked. Slowly Pilcher's slumping posture began to change; he'd heard notes in the fairy tale that were different—real, but still stylized; magical, but old, older than recorded history; and gritty. A story with guts. He remembers thinking, "It's not what I thought it was going to be at all—and it's definitely something I'm interested in."

"By the end of it, he was leaning all the way forward saying 'Yeah! We could do this, and this, and . . .'" recalls Chapman. It had been her hardest sell yet, but in the end, he'd been able to see it. The world of *Brave* would "not be medieval," as Pilcher puts it, but set in the dark ages of the Scottish Isles, in the pre-written times of Pictish people—a period of Scotland's history that predates even the Roman era in that country. "I love going into unknown territory," says Pilcher. "And if it's set in our real world, then let's go into a realm where history has not been recorded, and where the magic could be real and it's mysterious. Where do the myths all come from? That's really fun for me."

The real journey was ready to begin in earnest.

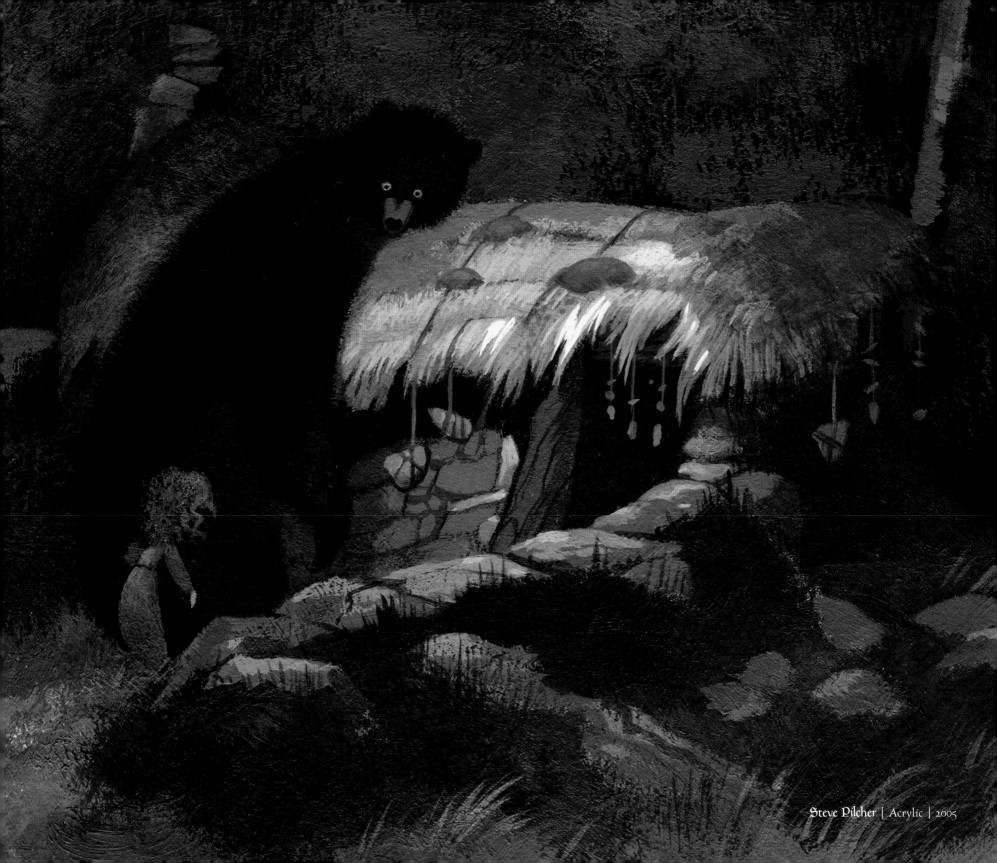

Steve Purcell | Acrylic | 2004

"In terms of the tone and scope of the movie a big impact was made early on with a particular Steve Pilcher painting, the very first painting done for the film. It shows the dramatic scale relationship between Merida and Mum-Bear. It has a real fairy-tale quality, which I like, and it's got a darkness to it, and a feeling of 'what are these two doing?' It creates a wonderful, intriguing impression that deep in the dark woods, something's going on that's really mystical and makes me want to know more."
—Katherine Sarafian, producer

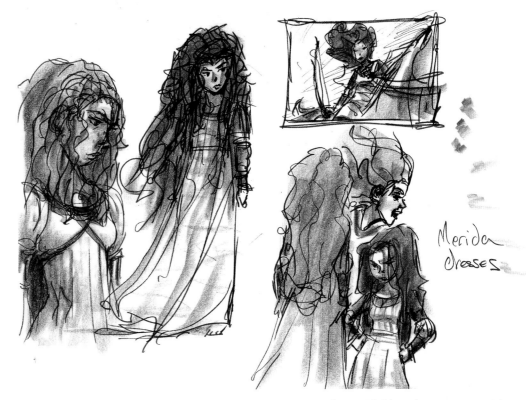

Merida dresses

Garett Sheldrew | Marker, Pencil | 2005

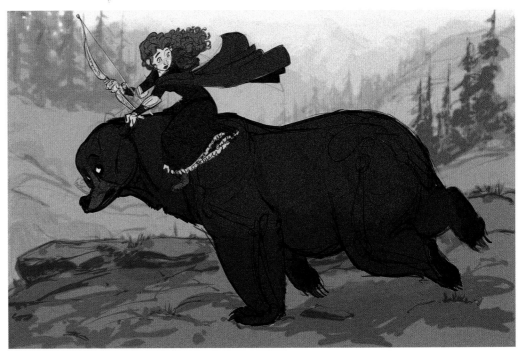

Craig Grasso | Digital | 2005

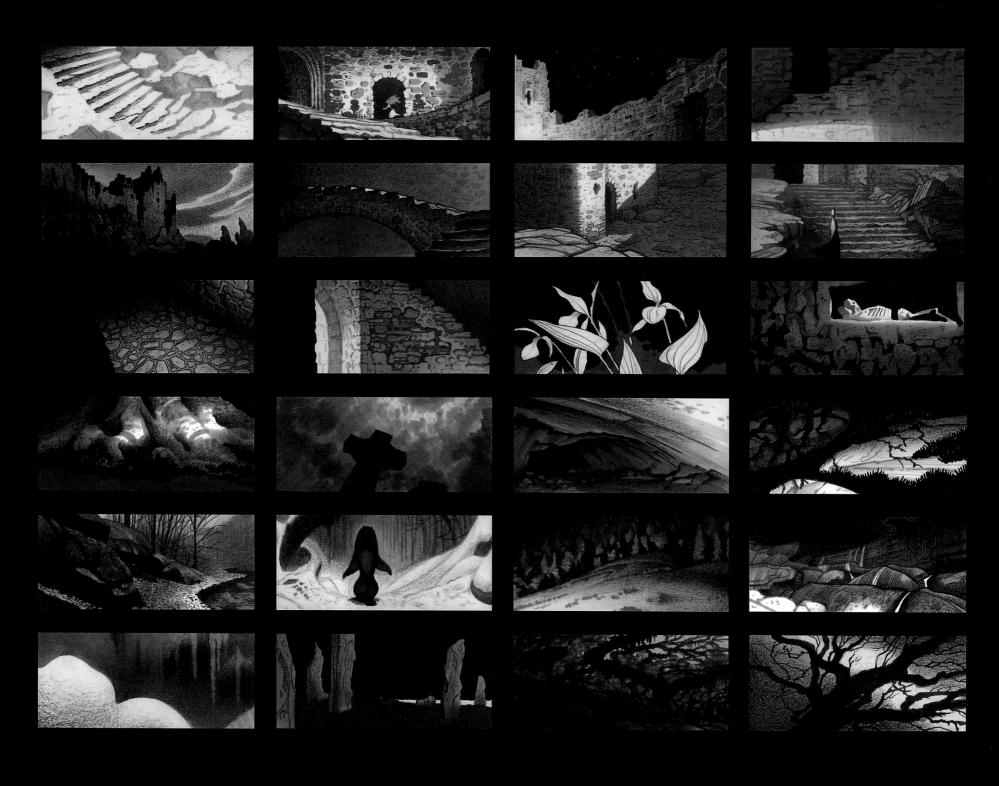

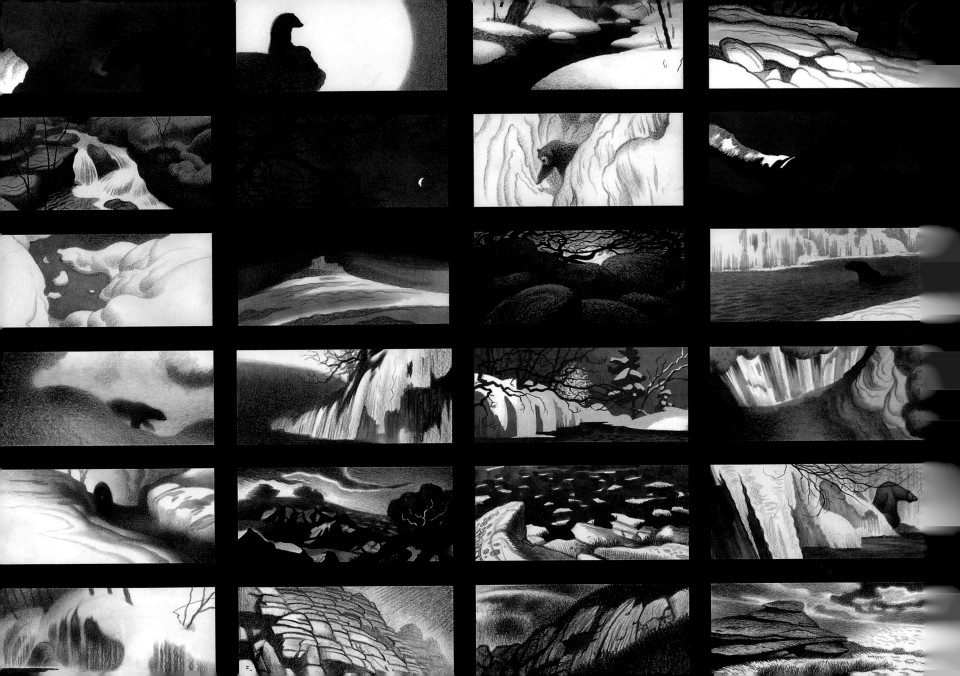

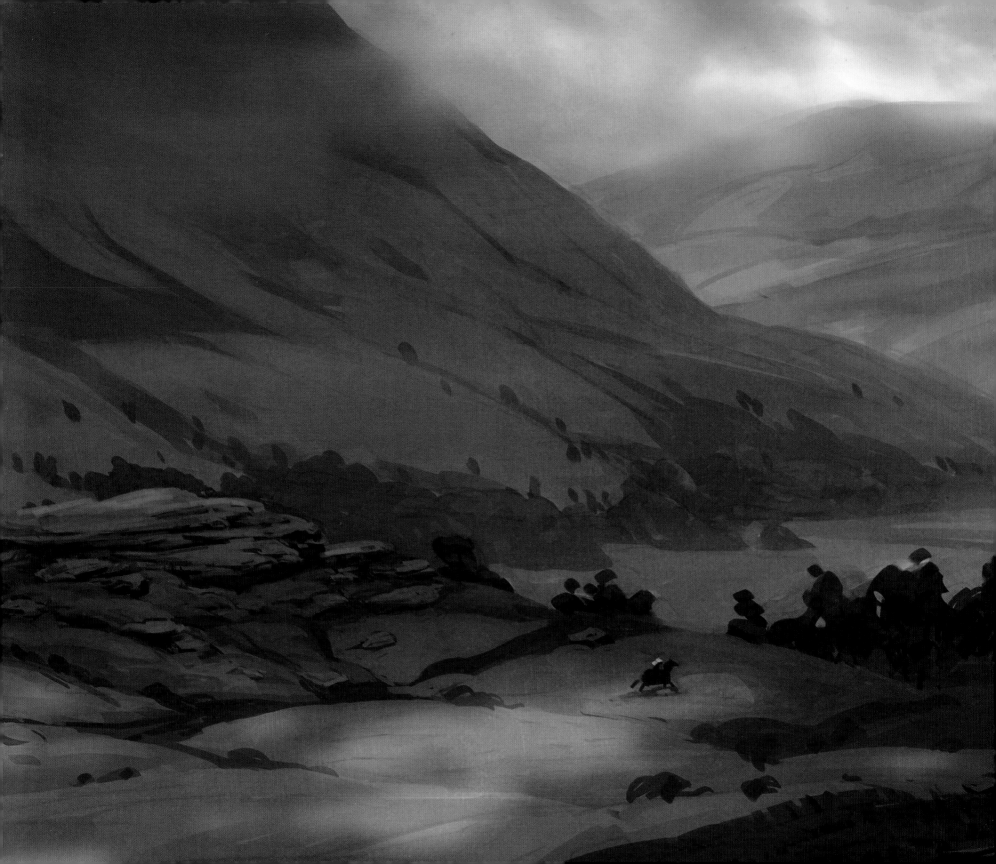

CHAPTER TWO
WIND, WEATHER, AND RUINS

O nce *Brave* was green-lit and its core creative group began to assemble, artists embarked on the first of two research trips to Scotland. Although the director and the art team felt that they knew their characters well and had a strong sense of the tone of their film, they now wanted to soak in the atmosphere of the country itself by being there, spending time drinking in the sights.

The effect upon the artists and the film was profound. The participants included Producer Katherine Sarafian, Development Producer Keven Reher, Director Brenda Chapman and then–Consultant Mark Andrews, Production Designer Steve Pilcher, then–Story Supervisor Steve Purcell, Art Director Tia Kratter, Writer Irene Mecchi, Editors Nick Smith and Torbin Bullock, Sets Artist Nelson Bohol, and story artists including Garett Sheldrew, Brian Larsen, Louis Gonzales, Craig Grasso, Barry Johnson, and Emma Coats. With a couple of guides at the front of their bus, the crew lurched deep into the highlands to see the terrain and the people firsthand, and they drew, painted, and absorbed everything they could.

Chapman and Purcell filled journals with drawings, snippets of local conversations, lyrics from traditional songs, colloquialisms—everything that made an impression upon them was soaked up like a sponge to be squeezed out once at home. Everyone's days were filled with bumpy travel over the hills in their bus on ridiculously narrow country roads, climbing crags and ruined castle stairs, resting and roistering in pubs, recording stories, hiking across the soggy peat, and always, always navigating the notoriously unpredictable weather—a feature of Scottish life that became a major character in the film.

"That's the thing about Scotland," Chapman observed. "We'd ask the guide, 'What's the weather going to be like today?' He'd answer, 'Oh, yes, you'll have some.'"

"There are a lot of pictures of Scotland, but it's not the same as being there," observes Mark Andrews. "We went to the highest part of Scotland, the lowest part of Scotland, the lochs—and everything has a story. Bob, our driver, pointed at a hill, and that had a story. And we'd drive a little farther, and he'd point at something else and say, 'Oh, yes, this has a story.' It was crazy."

Noah Klocek | Digital | 2010

In addition to the fantastic inspiration the trip bestowed on Chapman and her crew, a bond grew among them, particularly with the story group.

"The trip to Scotland really helped us discover what would be a great sequence," Andrews remembers. "We went into Eilean Donan castle, which is the most photographed castle in Scotland. It sits on a jetty right on a loch. It looks small, but inside there's lots of room. You can see the defensive qualities of it, and suddenly the story artists are thinking, Okay—we can have a scene here! We can have a scene on this castle wall and a scene outside on the battlements. Then we're in forests, and we're thinking, It would be great if Merida were out here . . . In Scotland, we really started to get a concrete sense of the stage that these characters could be on."

Story artist Barry Johnson observes, "I know the art department people were having a field day taking as many photos as possible—looking at the light at different times of the day, sketching how the stones were layered in a castle wall, recording the variety of leaf and plant shapes. It was hard getting Pilcher back in the van once he was out exploring."

As the team imagined scenes in their narrative, Pilcher and Tia Kratter did their own paintings, took pictures, and in Kratter's case, painted and collected the minute flora and fauna she used to build her ideas for textures and color, to be studied and reconstituted once she arrived back in her light-filled office in Emeryville.

"Scotland's landscape is so tactile, so lush, and so full of life that it begs to be expressed," says Pilcher. "And when I would talk to the sets team, and the shading artists for sets, I made sure that we got across these visually iconic Scottish elements: lichen and moss; mist and stones emerging from the ground; Scots pine; and lastly the power of the skies there. It was important to convey that elements of nature take over and reclaim everything. So, for example, whenever we'd design a stone wall that could've been there for centuries, we'd overtake its surface with moss and lichen. That's why neither Brenda nor I wanted the castle to be a new castle—no way! We wanted it to have been there a few hundred years before the film takes place."

Again and again, the artists came back to the effects of the weather on everything. A weather forecast that changes as quixotically as Scotland's made a perfect background for a story about humans transforming to bears and back again.

Nick Smith | Photograph | 2007

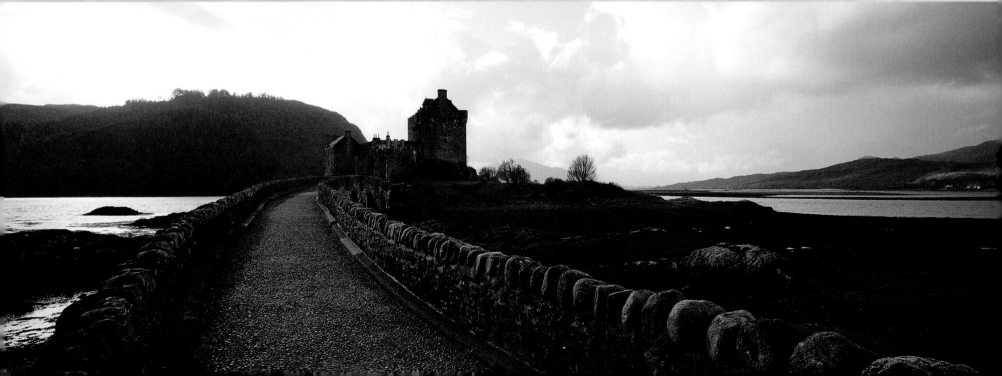

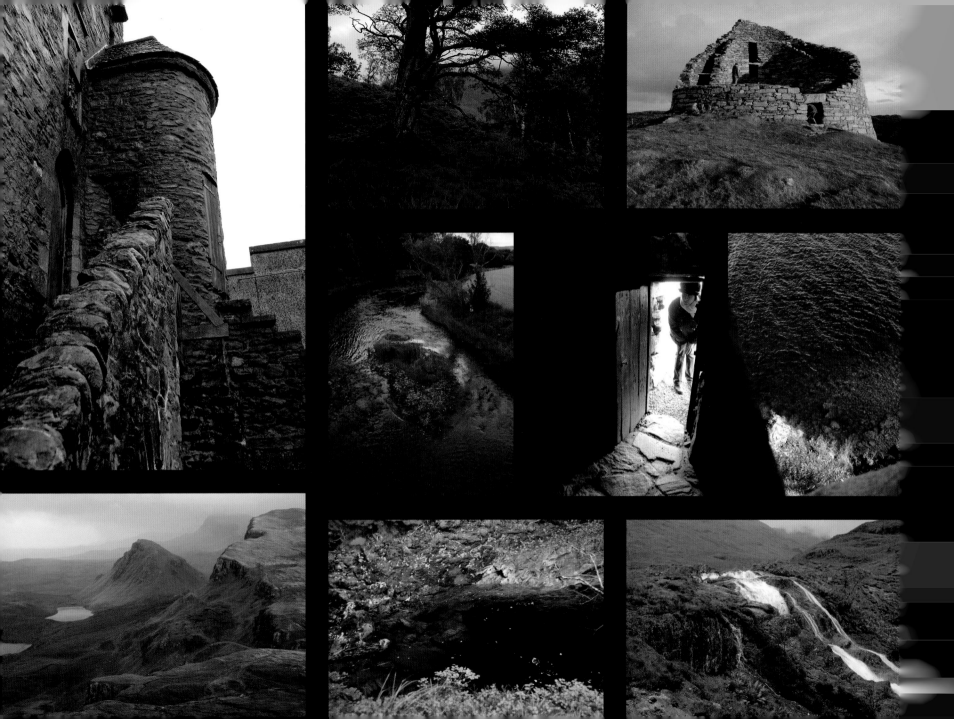

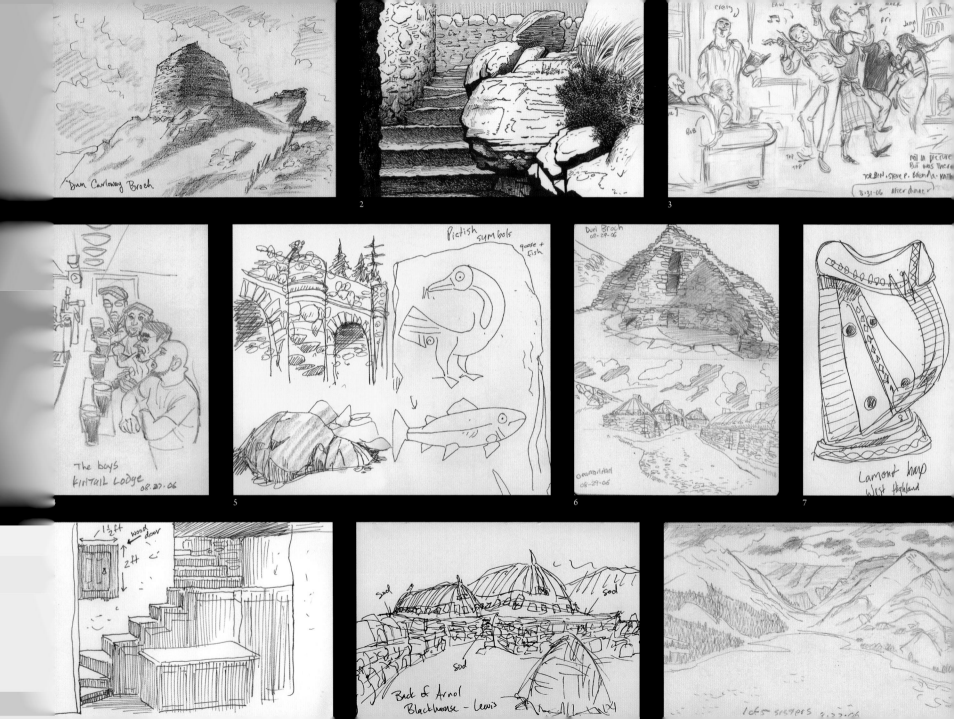

Dun Carloway Broch

2

3

not la picture
But was there
Torbin • Steve P • Brenda • Kathi
8.31.06 After dinner

The boys
KINTAIL LODGE
08.27.06

5

Pictish symbols
goose + fish

6

Durl Broch
08-29-06

Gearrarrdan
08-29-06

Lamont harp
West Highland

7

1½ft
wood door
2ft

sod
sod
sod

sod

Back of Arnol
Blackhouse - Lewis

1065 sispprs 8.23.06

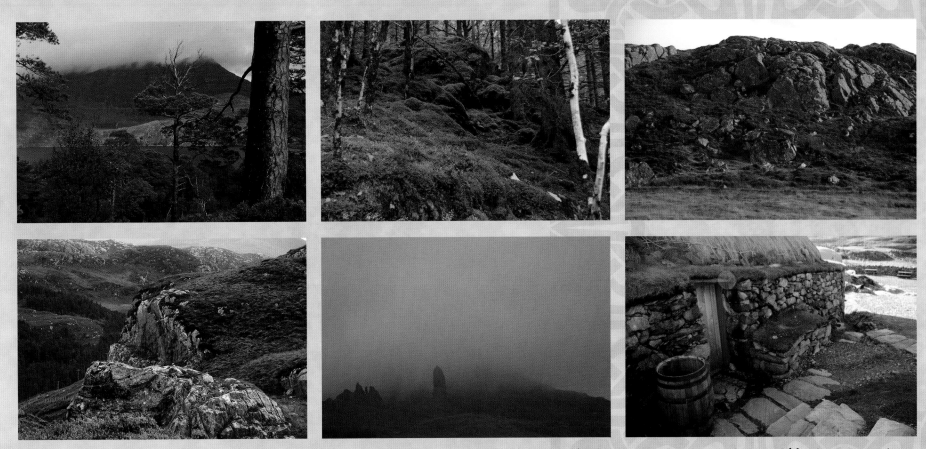

Brenda Chapman (bottom row, center), Steve Pilcher | Photographs | 2007

Andrews explains, "The gulf weather down in the Atlantic comes up into the north, off the northern tip of Scotland and Norway, and just sticks like a big wall. It circulates and eddies right over Scotland. So you have this crazy weather, always changing because of the tropics, mixed in with the cold stuff, constantly feeding each other. I took my wife there on our honeymoon, in November. It was gray. Then the next day, bright. But cold as hell. Then—snow. Then—rain. Then—sleet. Then—mist. And then light rain, but sunny. Then partially cloudy. Then windy and terrible. We drove in a hailstorm and I couldn't see thirty yards in front of me. And we loved it! It was so different. You never forget it."

The artists observed that the more ancient man-made and natural features of Scotland seemed to meld together from the effects of time and weather working on them. Once inside the castles, Barry Johnson observed, "they were darker and rougher than I'd imagined. The staircases looked like they were growing right out of the rock."

Castles like Dunnottar suggested the stronghold of King Fergus and clan DunBroch. The forests and undulating hills might provide routes for Merida's escape cross-country to undo the Witch's spell. The peat-colored rivers would serve as a setting where the girl and the bear could fish. The countless rocky crags could invoke the hidden ruins of the lair of the immortal Mor'du. And there were the Callanish Stones.

In the film, after bringing the meeting of the lords and the games to a point of utter chaos, Merida defies her family and rides Angus the horse into the woods in a blind fury. While in this completely emotional state and not knowing what to do, she's suddenly aware of the appearance of the wisps—small diaphanous creatures that glow with an eerie inner light.

"You can look at tons of photos of the countryside, and it all looks very lush and green, but then getting out there in the woods, you realize that the moss and the grass aren't solid. You can sink in up to mid-calf. You might think, Oh, they're hummocks. I can just climb all over it. But you actually sink in."
—Emma Coats, story artist

She suddenly realizes that she's arrived at a strange place, more ancient and inexplicable than anything else in her world: a ring of enormous, half-buried stones overrun with lichen and moss. These are the Standing Stones, a portal into the world of magic that exists alongside and just out of sight of everyday life.

The model for *Brave*'s stones exists in the real Scotland, on the Isle of Lewis in the Outer Hebrides: the Callanish Stones. Like England's Stonehenge, they're a ring of oblong stones erected some two thousand years ago, whose exact meaning became lost in time. Speaking of the designs carved over them, Pilcher says, "Historians can't decipher what the symbology means from Pictish times. They're informative symbols in stone. They have a rough idea of what it might have meant, but they're not really sure."

On their field trip the filmmakers wandered among them. "When I think of *Brave*, I think of the Standing Stones," says Producer Katherine Sarafian. "They have a wonderful, mossy, tactile feel. Their texture reminds you of the richness that you see all throughout Scotland. They embody strength and ruggedness, and have an organic, rooted quality; they represent the visual richness of the film. The stones also represent magic and mystery and a place for something transformative to happen. It's no coincidence that the finale of this film takes place at those stones. In every version of the movie we've ever done, that was the culminating, emotional, and narrative focal point." The stones are not just the finale, but they also mark the turning point of the film, for they and the wisps that appear near them signal the entrance of magic into *Brave*'s story. Merida finds in the stones a gateway to the strange cottage of the Witch of the wood who provides Merida with a spell to change her mother.

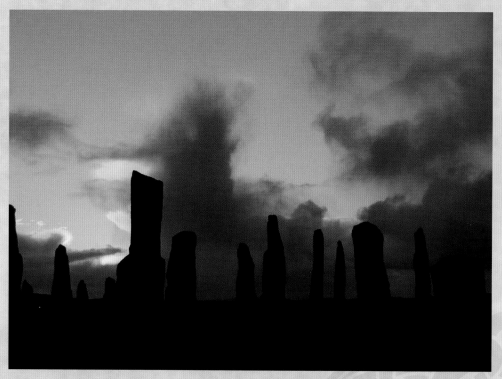

Steve Pilcher | Photograph | 2007

Production Designer Steve Pilcher's paintings were produced at a rapid rate, and the film's world took shape: the castle on the loch, with a plateau for Highland games adjacent; the forgotten ruins of another castle, broken by a long-ago enchantment; the witch's cottage; the hills blanketed with heather; the castle's battlements and inner chambers alive with torchlight. Whether outdoors or in, the overall style had to be maintained. Pilcher supervised three art directors, each of whom had his or her own responsibilities: Tia Kratter, the shading art director, Noah Klocek, the sets art director, and Matt Nolte, the character art director. Klocek and Nolte were both promoted to their positions during production on *Brave*, while Kratter had years of experience in designing the look, texture, and color of the CG objects in Pixar's films, having come there at her friend John Lasseter's invitation when it was a small and intimate place.

Pilcher also oversaw Sketch Artists Paul Abadilla, Nelson Bohol, and Huy Nguyen—tremendously talented designers who each contributed as needed depending on their unique artistic strengths. Pilcher believes in

giving his artists a shot at anything they might have an urge to try, while letting them know there's no blowback if an experiment doesn't work. That kind of room to fail, as well as succeed, is vital for a healthy art department—nothing ventured, nothing gained—and the successes of each of the artists as they stretched their skills to the limit far outstripped the occasional wobbles. This freedom was possible not only because of Pilcher's philosophy of management, but due to maintaining a small crew with a strong sense of camaraderie, which they'd need as they met the challenges that such a complex production threw at them.

Klocek summed up his philosophy of the production design crew's job, saying, "We're storytellers, not artists. When the story department hands something off to us, we have to reinforce that story visually throughout the film. It doesn't matter how good we are as draftsmen; if we don't have any ideas to support the story, it's not worth anything."

Katherine Sarafian | Photograph | 2006

Katherine Sarafian | Photograph | 2006

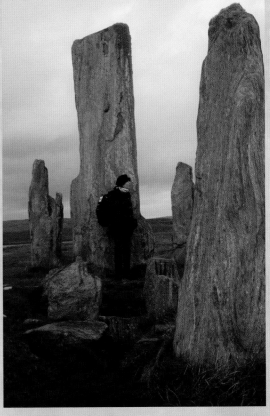

Brenda Chapman | Photograph | 2007

THE HIGHLANDS

"I want audiences to say, 'That was Scotland. That was awesome.' Mist, rock, ruggedness, skies that are changing all the time with the rain, snow, big patches of sunlight moving over large landscapes. That's what has to come across."
—Steve Pilcher, production designer

Bill Cone | Pastel | 2006

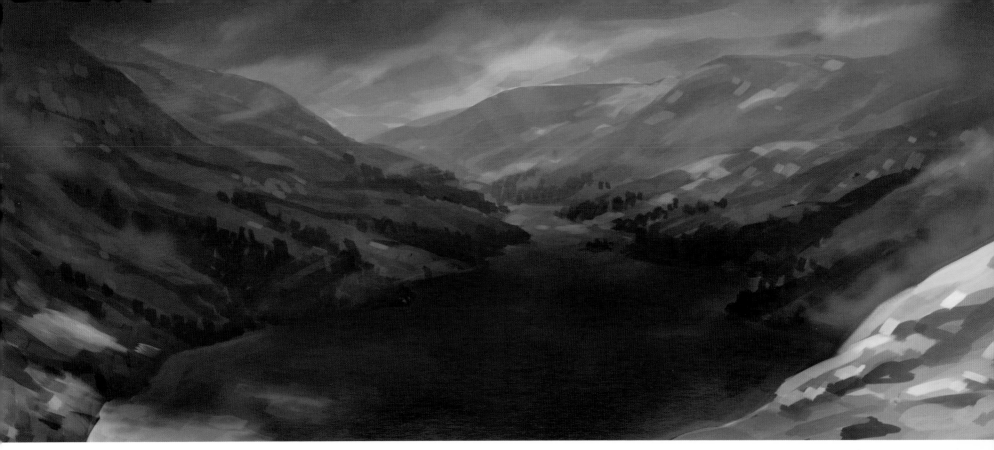

Noah Klocek | Digital | 2011

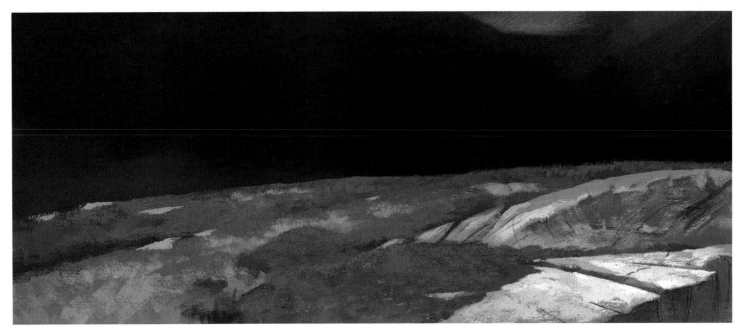

Steve Pilcher | Acrylic | 2006

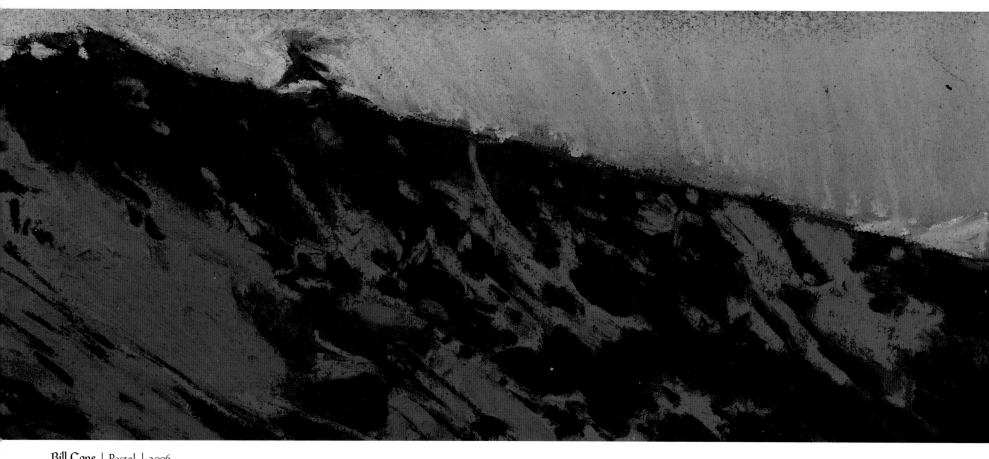

Bill Gone | Pastel | 2006

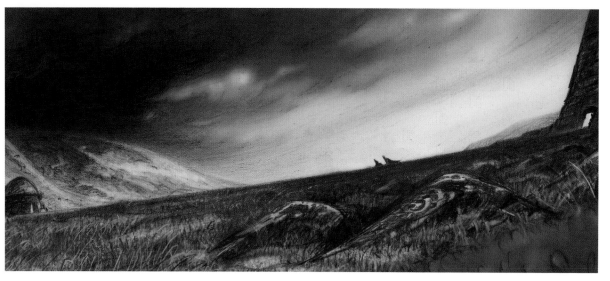

Nelson Bohol | Pencil, Digital | 2007

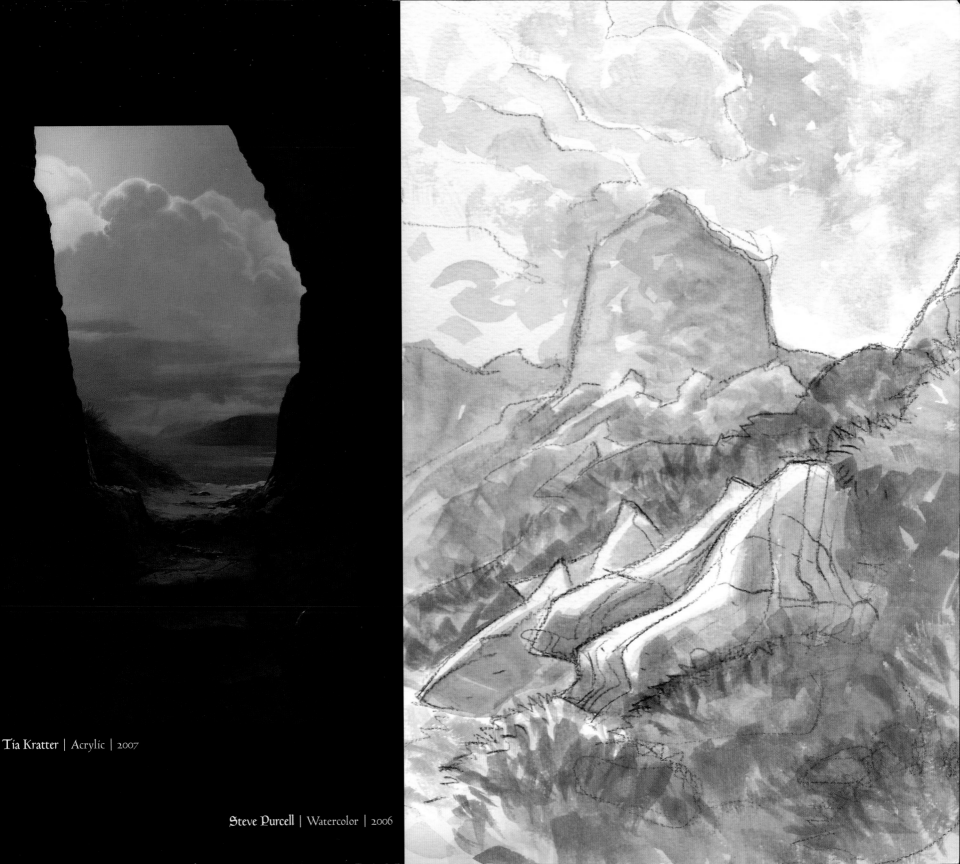

Tia Kratter | Acrylic | 2007

Steve Purcell | Watercolor | 2006

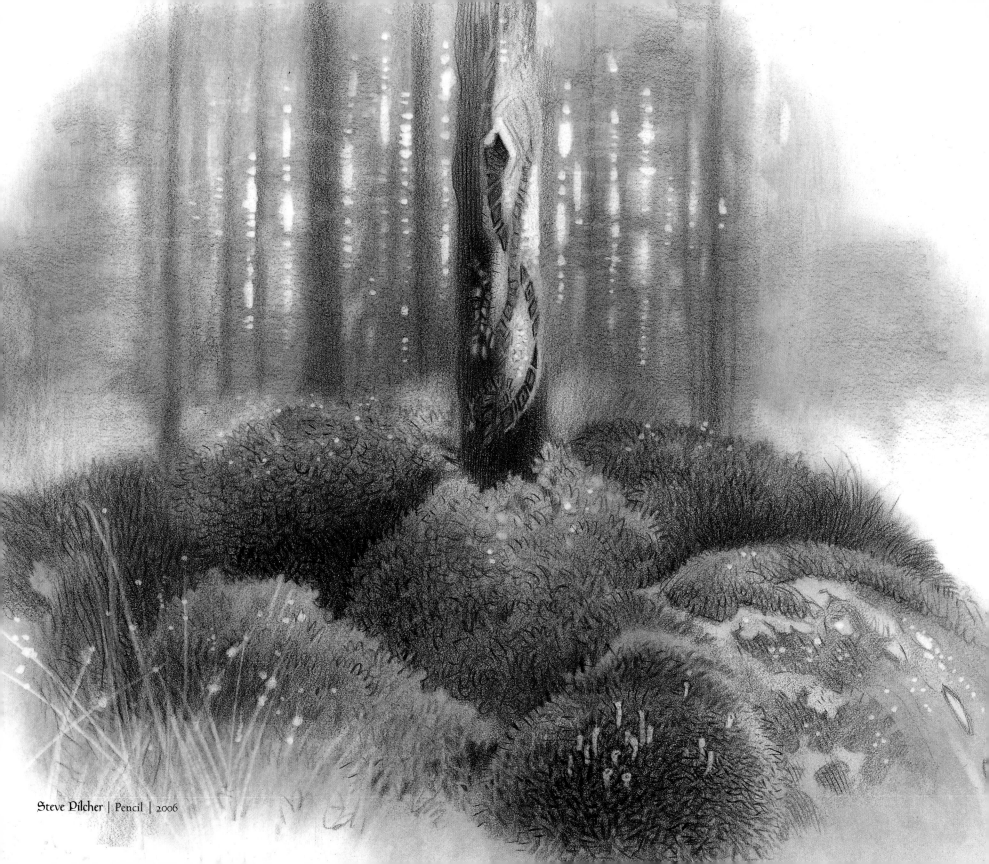

Steve Pilcher | Pencil | 2006

Steve Pilcher | Acrylic | 2006

Paul Abadilla | Pencil | 2009

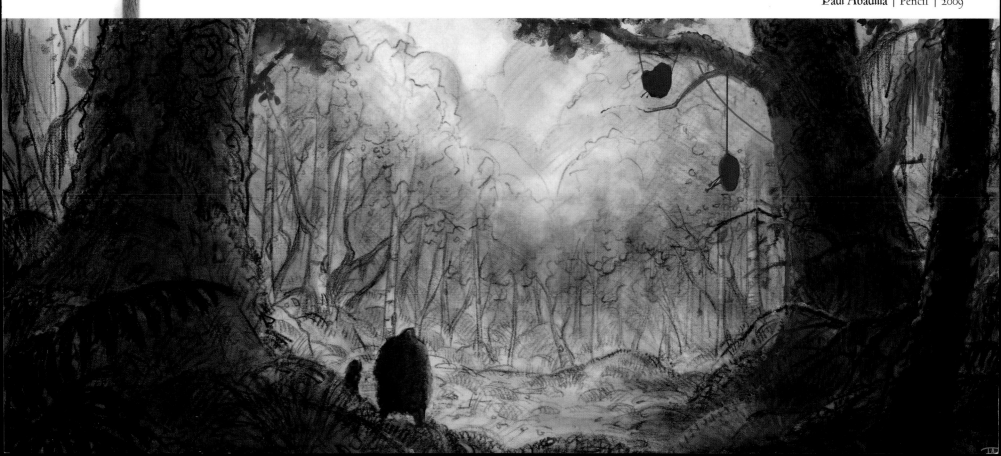

Steve Pilcher | Acrylic | 2007

Steve Pilcher | Acrylic | 2007

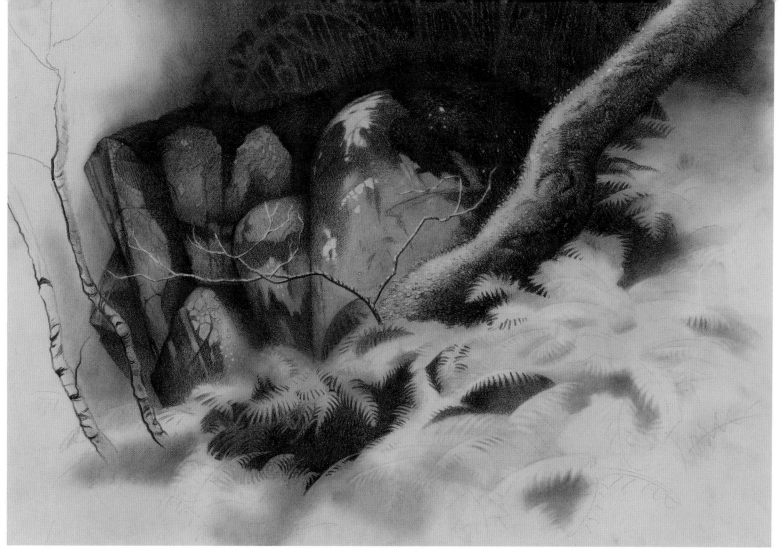

Steve Pilcher | Pencil | 2006

"The sets are characters to me. They're like the best supporting actors or actresses in the show. The sets have to have so much personality, because they enhance the actual primary characters that are acting out the story. The sets are a whole thing on their own."
—Steve Pilcher, production designer

Steve Pilcher | Digital | 2008

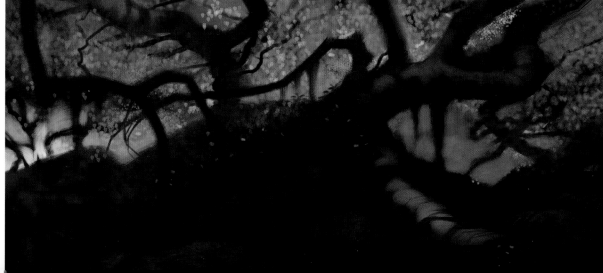

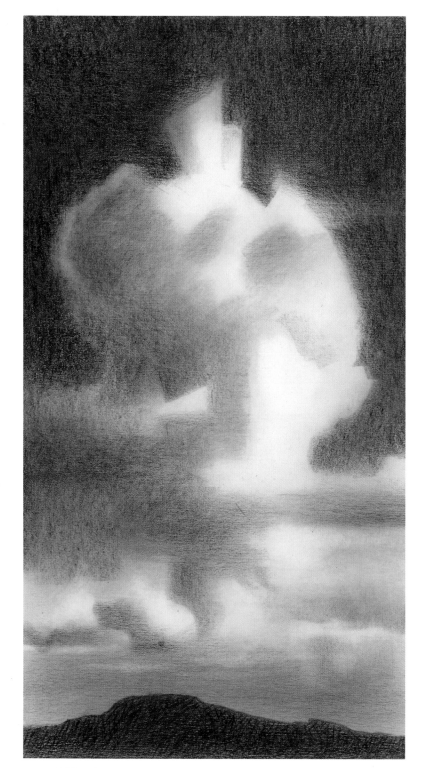

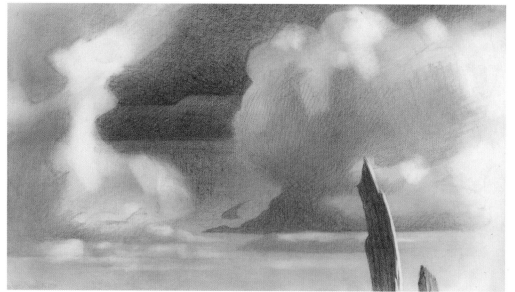

Steve Pilcher | Pencil | 2006

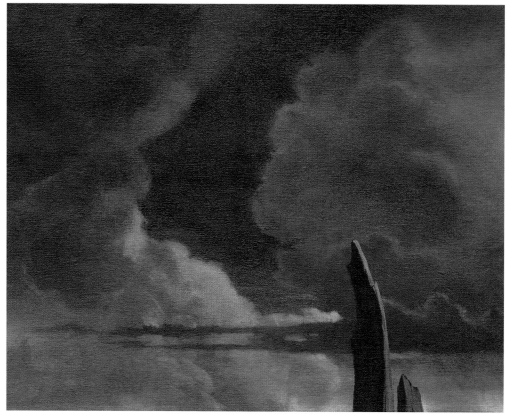

Steve Pilcher | Pencil | 2006

Tia Kratter | Oil | 2007

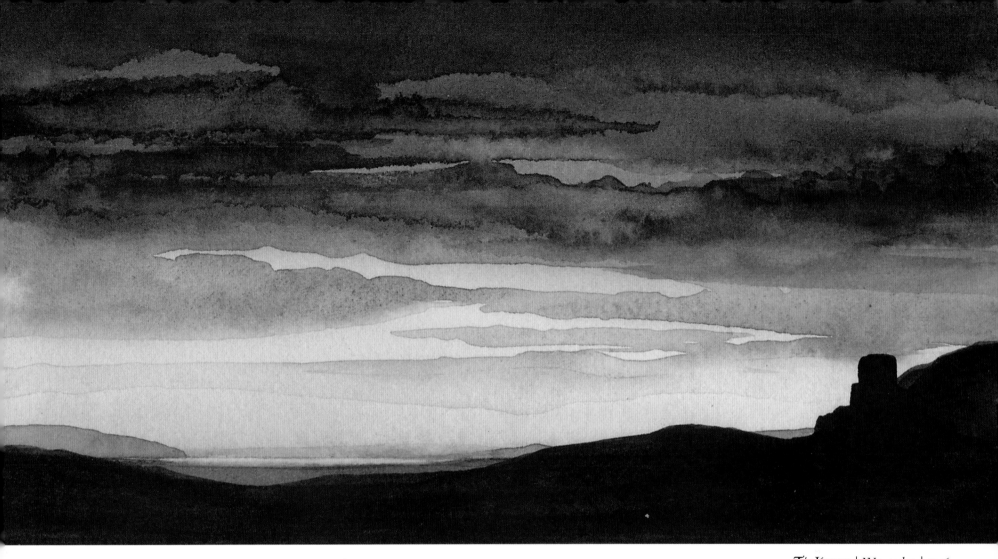

Tía Kratter | Watercolor | 2006

 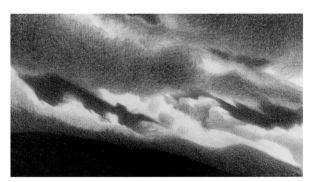

Steve Pilcher | Pencil | 2006

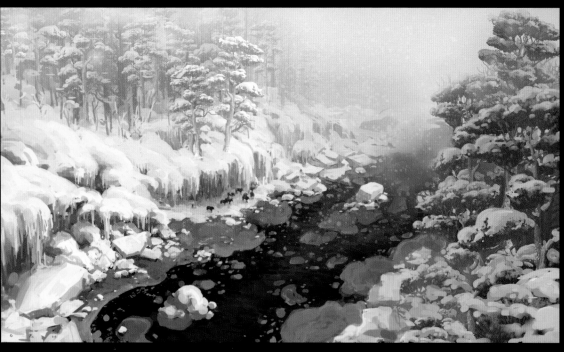

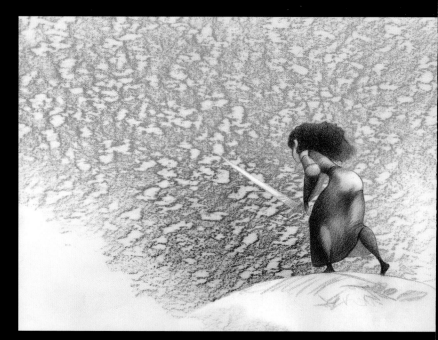

Steve Pilcher | Pencil | 2006

Snow scenes such as these were part of
the film's early development. As the story
evolved, the winter setting was lost and
is no longer used in the final film.

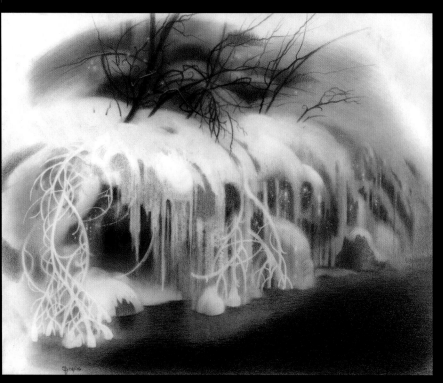

Steve Pilcher | Pencil | 2006

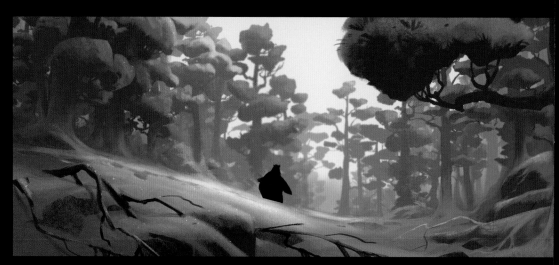

huy Nguyen | Digital | 2010

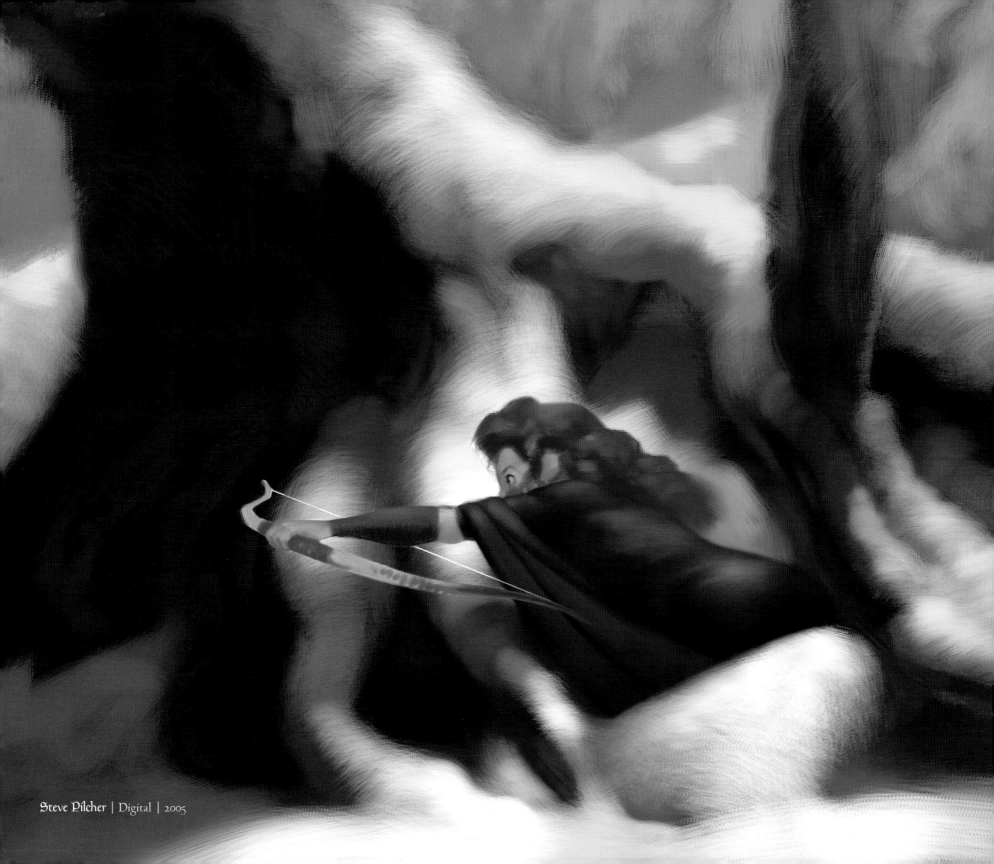

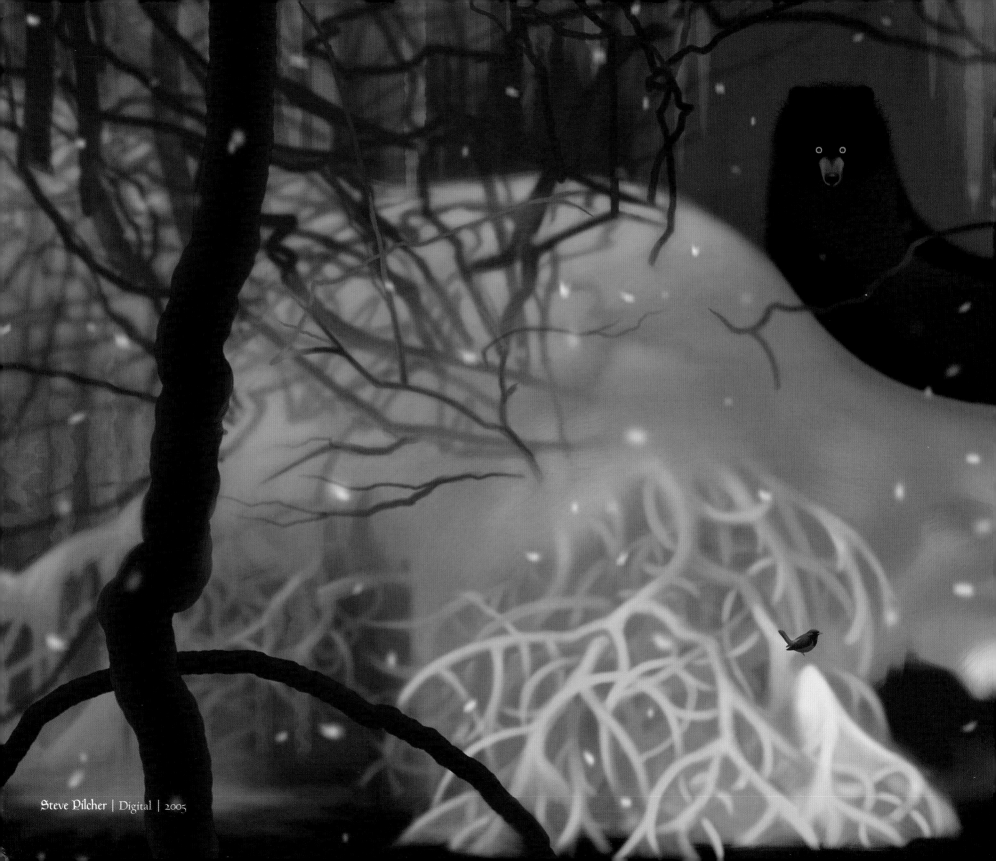

Steve Pilcher | Digital | 2005

CASTLE DUNBROCH

"The amount of dramatic scenery that changes moment to moment in Scotland is staggering. The light changes. The clouds move. It's sunny. It's raining. You're moving through this landscape, and the weather is changing in front of you. It's like a time-lapse photography experiment. So we made an attempt to use that in the storytelling, and in the art of the film, where you see a really diverse palette of weather."
—Katherine Sarafian, producer

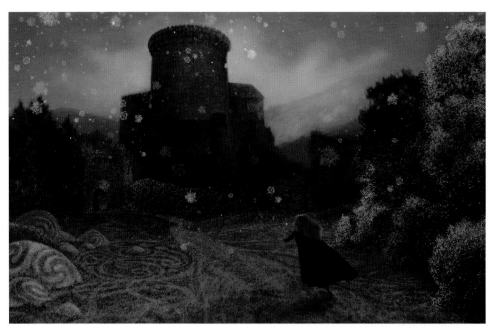

Daniel López Muñoz | Digital | 2009

Steve Pilcher | Acrylic | 2008

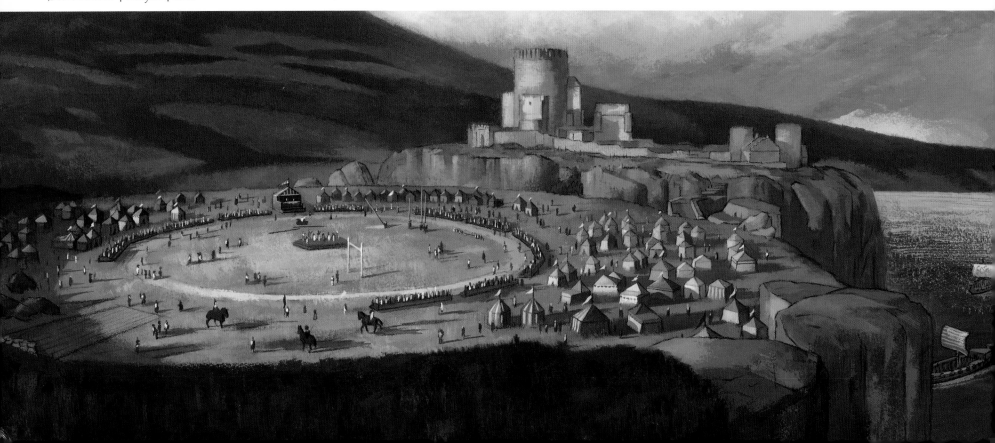

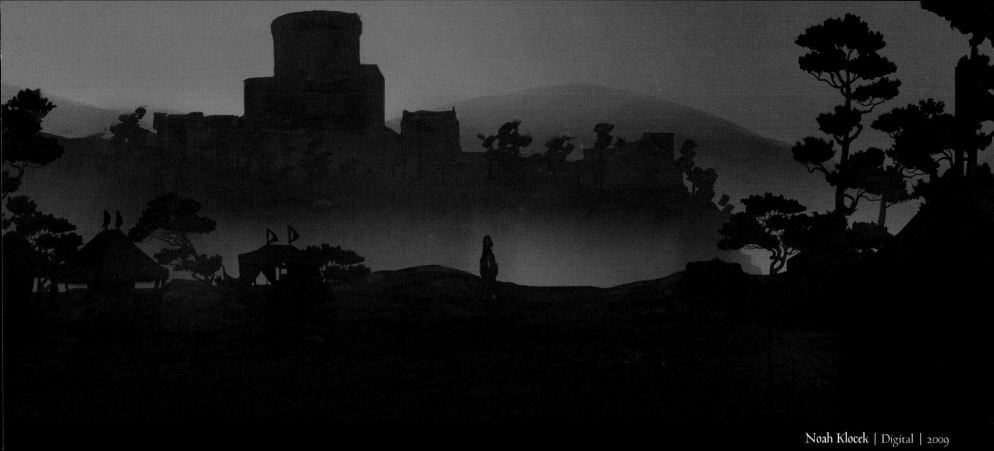

Noah Klocek | Digital | 2009

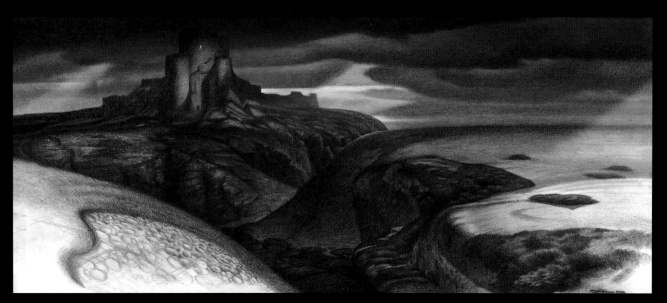

Steve Pilcher | Pencil | 2006

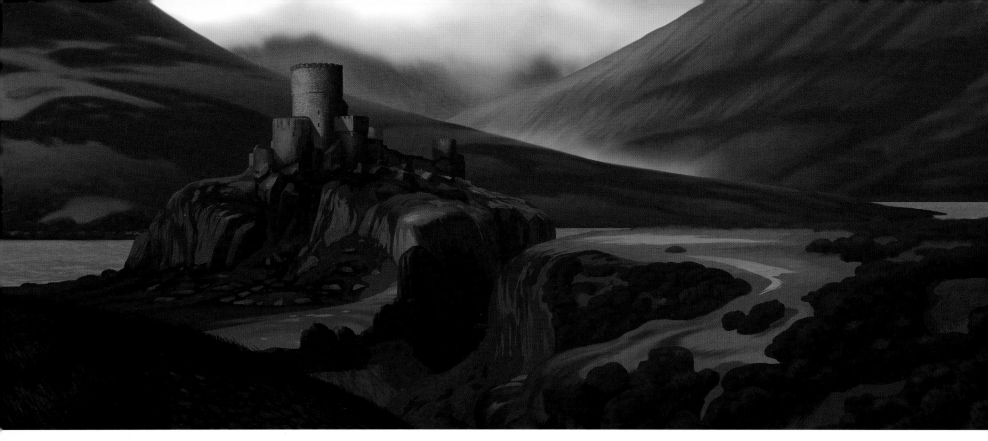

Steve Pilcher | Digital | 2007

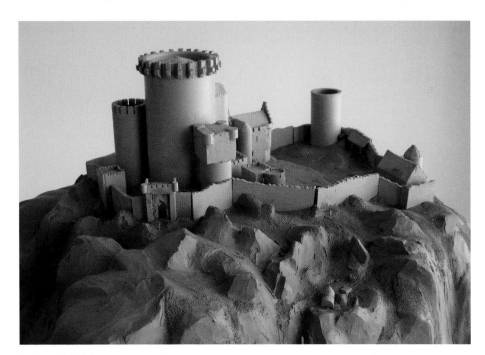

Nelson Bohol | Clay, Wood | 2008

Nelson Bohol | Pencil | 2008

48

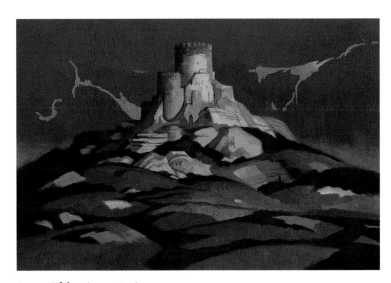

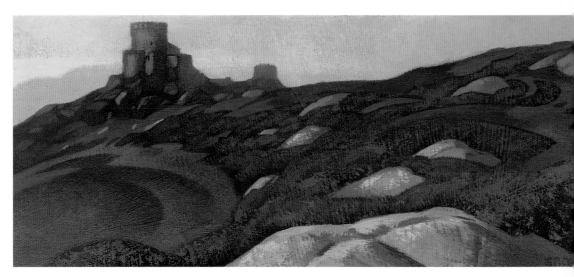

Steve Pilcher | Acrylic | 2006

Steve Pilcher | Acrylic | 2008

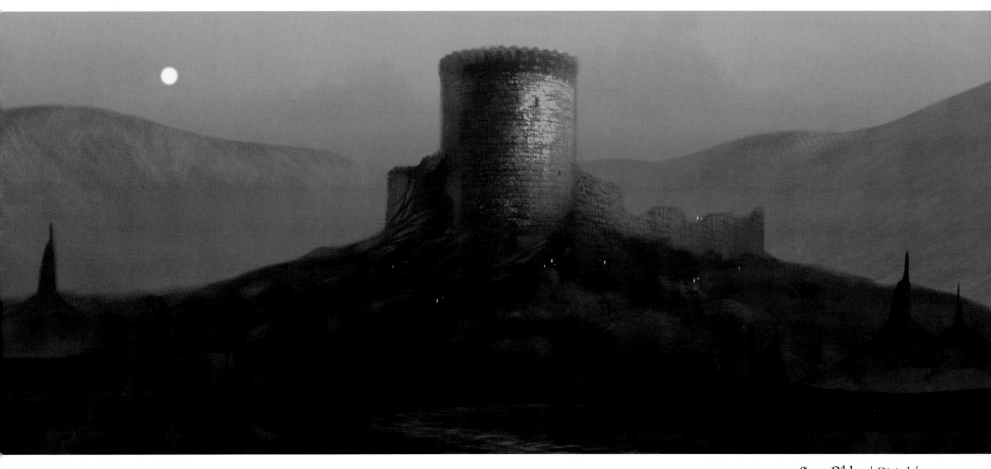

Steve Pilcher | Digital | 2007

Steve Pilcher | Ink | 2006

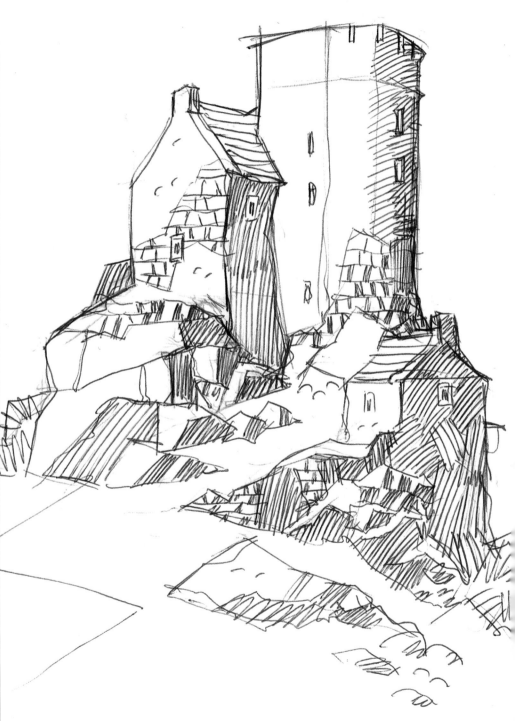

Mike Mignola | Pen | 2006

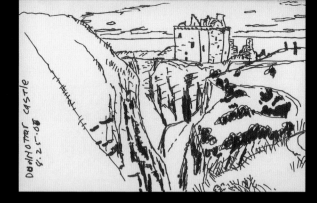

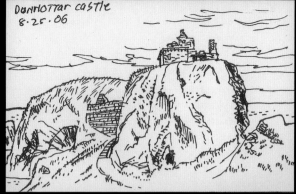

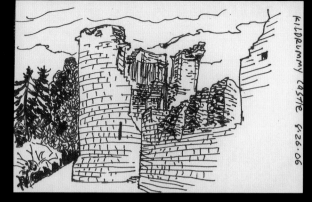

Dunnottar Castle
8.25.06

Dunnottar Castle
8.25.06

Kildrummy Castle
8.26.06

Sketchbook Drawings | **Mark Andrews** | Ink | 2006

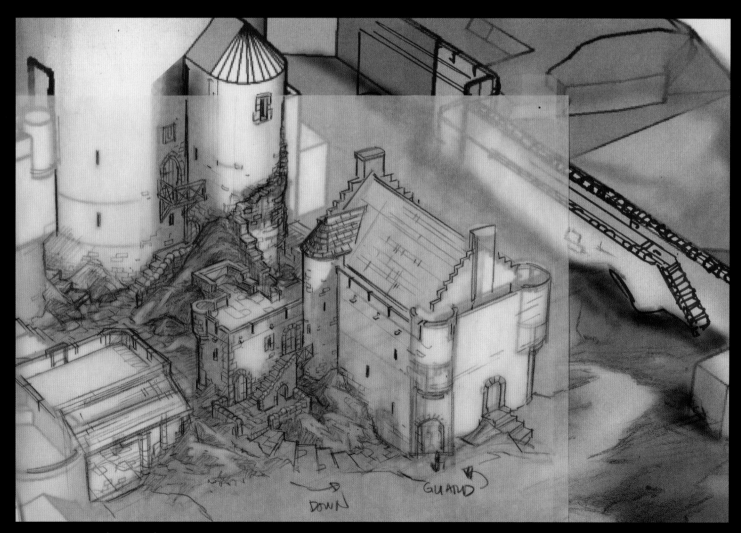

DOWN

GUARD

Castle Detail | **Nelson Bohol** | Pencil, Digital | 2008

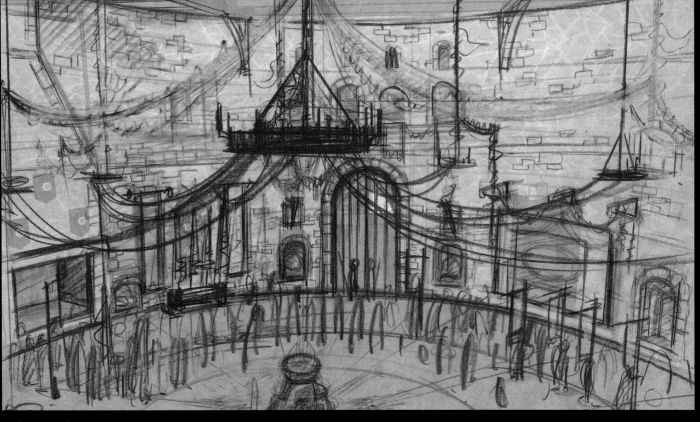

Nelson Bohol | Pencil, Digital | 2009

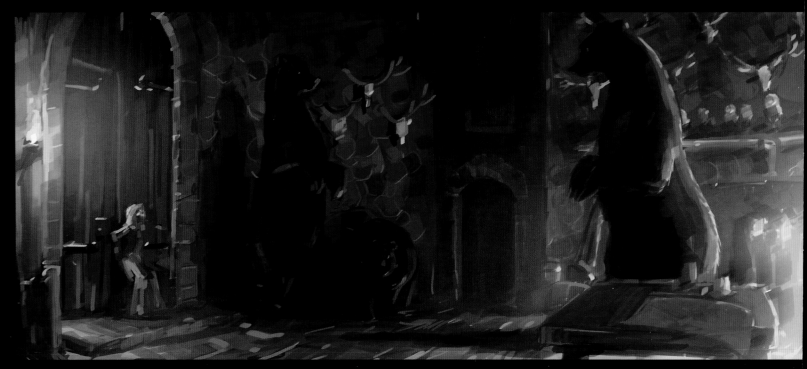

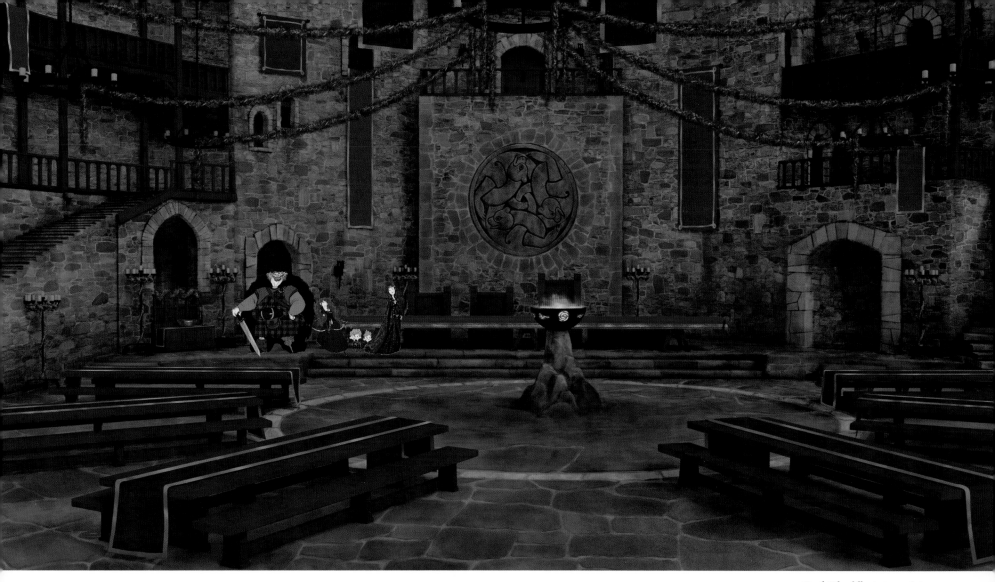

Paul Abadilla | Digital | 2010

"We took liberties with the design because it's a fantasy. There were no tartans back in the time period we're placing this, but audiences associate that with Scotland, so we added that element. We took Celtic design and mixed it with earlier Pictish design, and anything that might have been an influence in that time period, like the Vikings. You wouldn't just get pure Celtic, and you wouldn't get pure Pictish or Viking. You'd get a hybrid of these things."
—Steve Pilcher, production designer

THE STANDING STONES

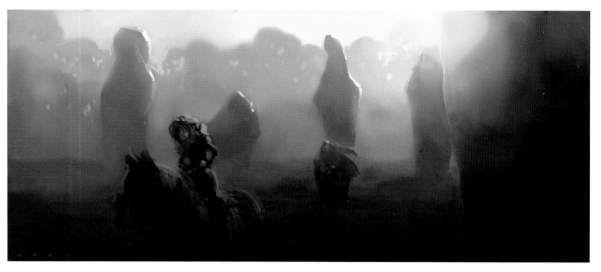

Noah Klocek | Digital | 2009

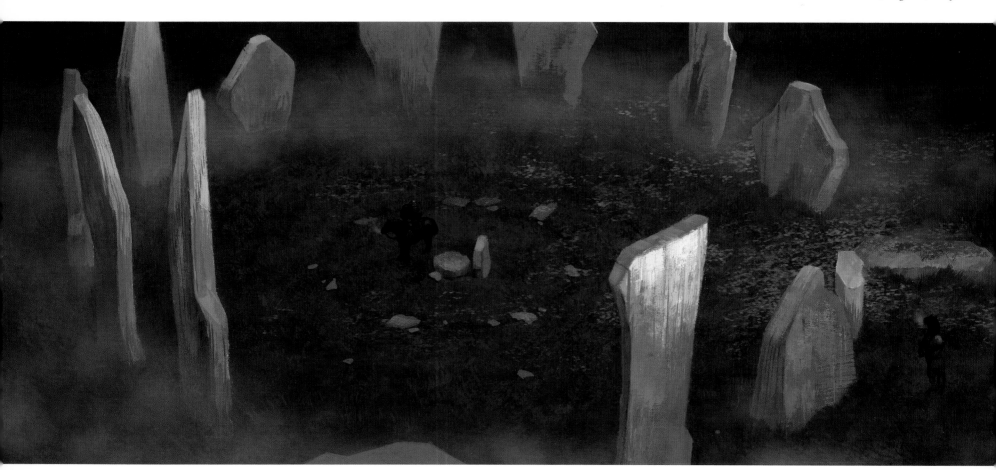

Steve Pilcher | Acrylic, Digital | 2008

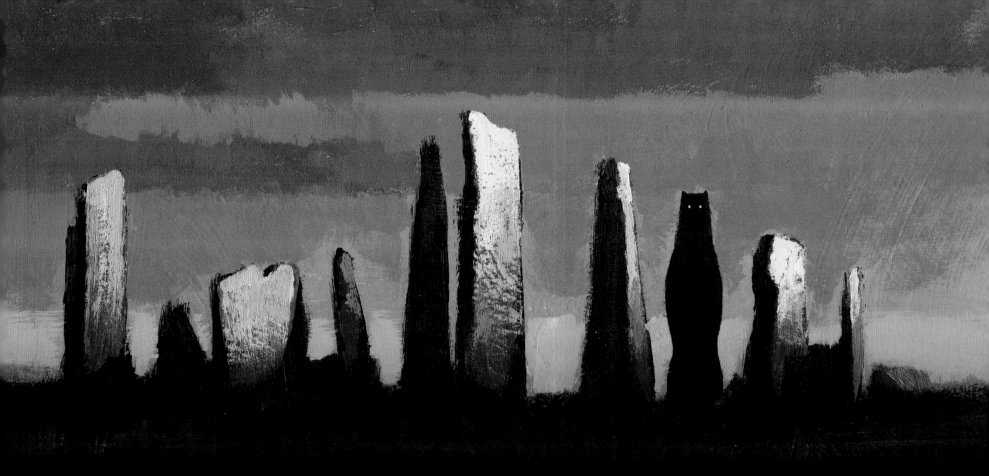

Steve Pilcher | Acrylic | 2005

"Quite a large part of the Standing Stones is not even visible. You see only the above-ground portion. They actually reach way down deep underground. So the idea that the stones are deeply rooted in the earth is something that's integral to the film. Even mystical objects are grounded in reality. And the stones are huge and imposing and strong, but they are located on this exposed hillside full of wind and sun—a place for characters to be vulnerable and, eventually, to change."
—Katherine Sarafian, producer

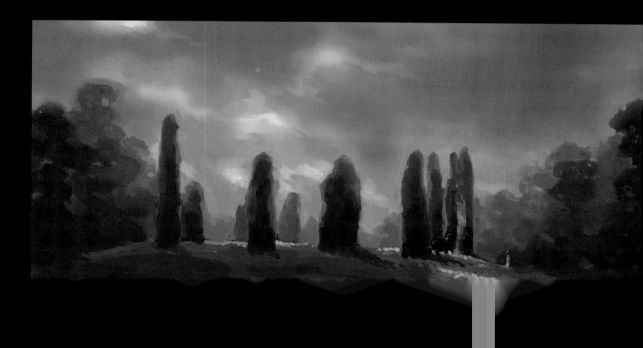

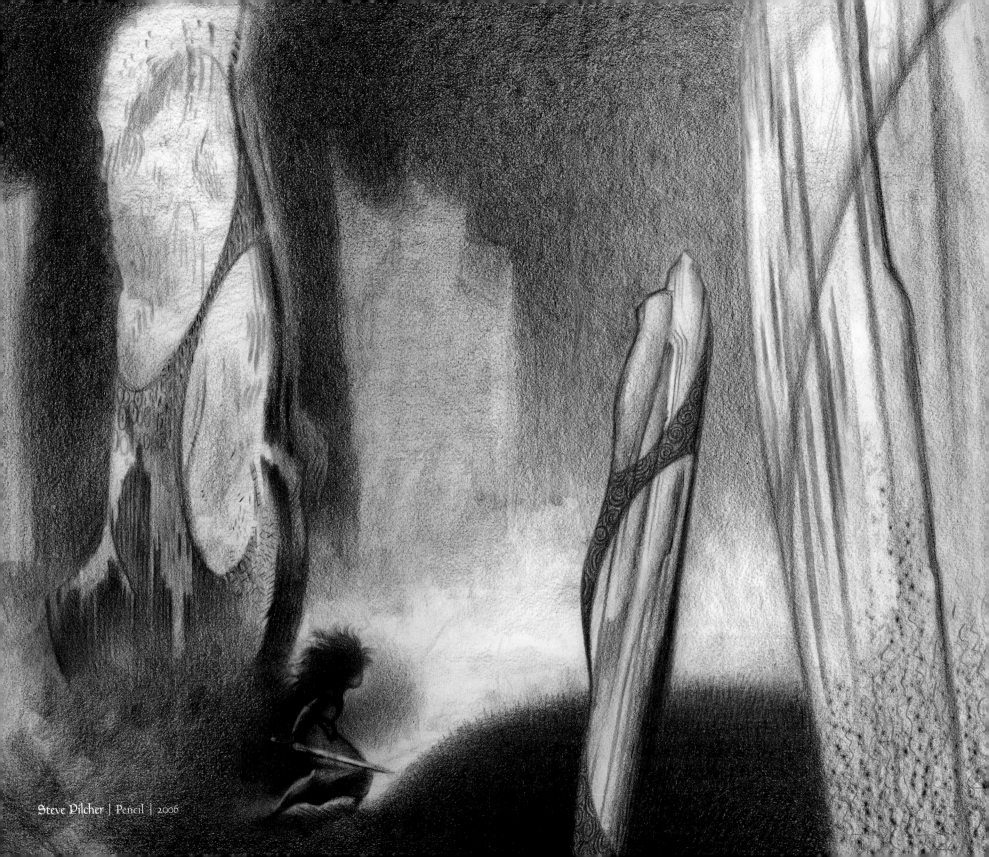

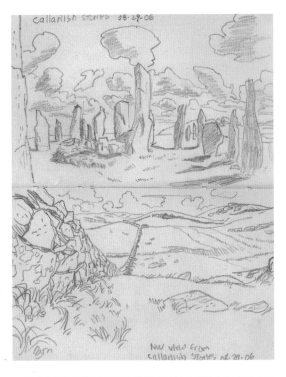

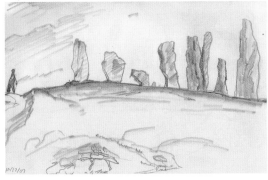

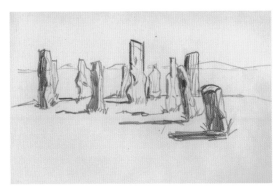

Sketchbook Drawings | Mark Andrews, Emma Coats, Brian Larsen | Pencil | 2006-2007

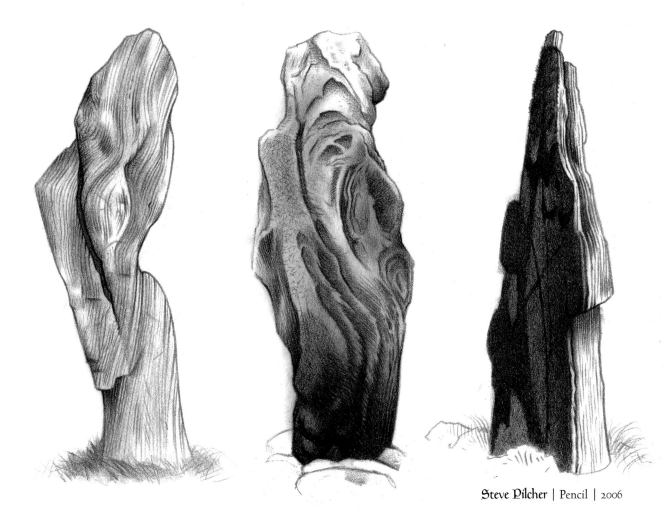

Steve Pilcher | Pencil | 2006

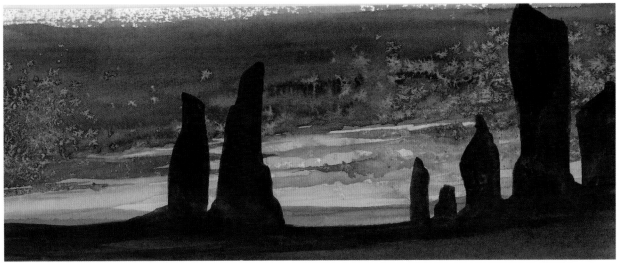

Tia Kratter | Watercolor | 2006

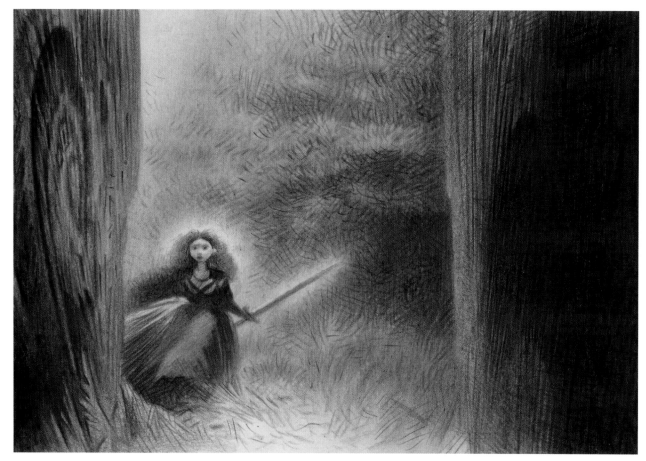

Steve Pilcher | Pencil | 2006

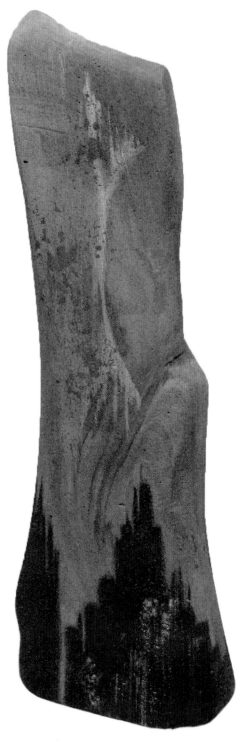

Steve Pilcher | Pencil | 2006

Tia Kratter | Acrylic on Foam | 2008

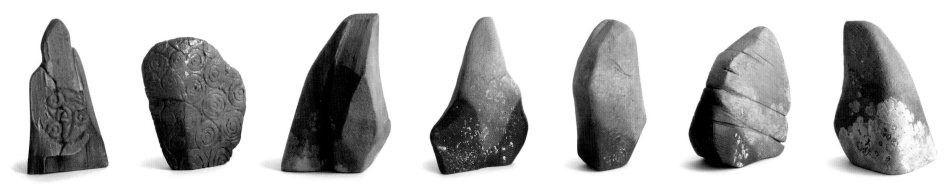

Tia Kratter | Acrylic on Foam | 2008

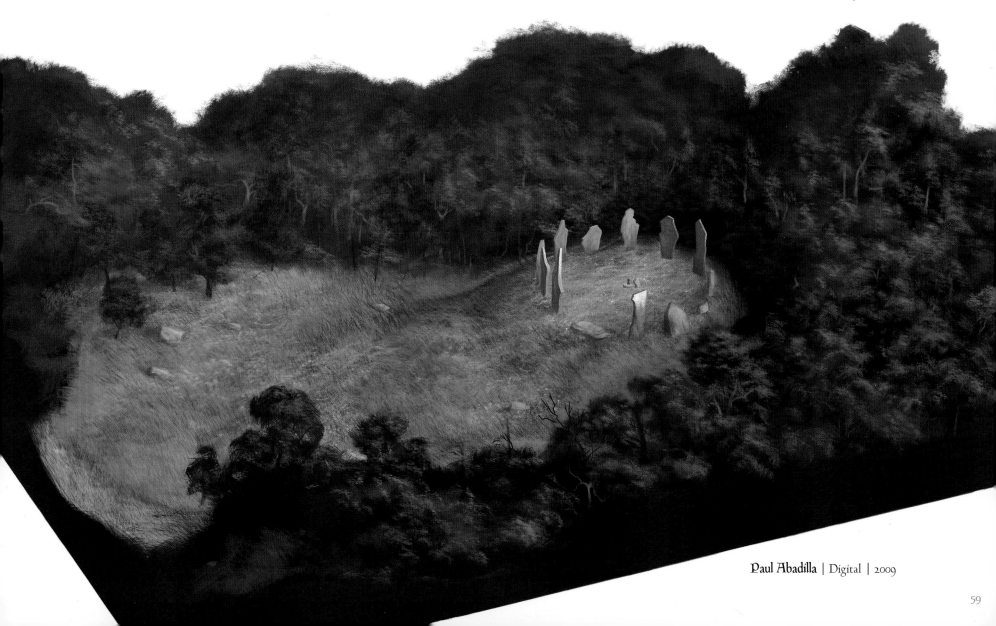

Paul Abadilla | Digital | 2009

THE WITCH'S HUT

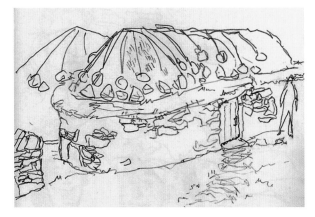

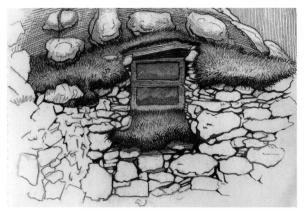

Sketchbook Drawings | Brenda Chapman, Emma Coats,
Steve Pilcher | Pencil, Pen | 2006-2007

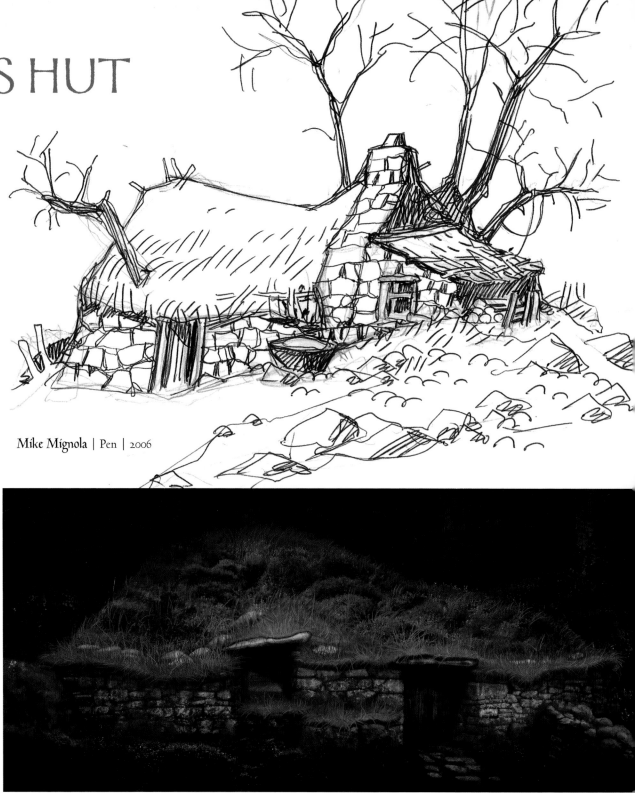

Mike Mignola | Pen | 2006

Japeth Pieper | Digital | 2009

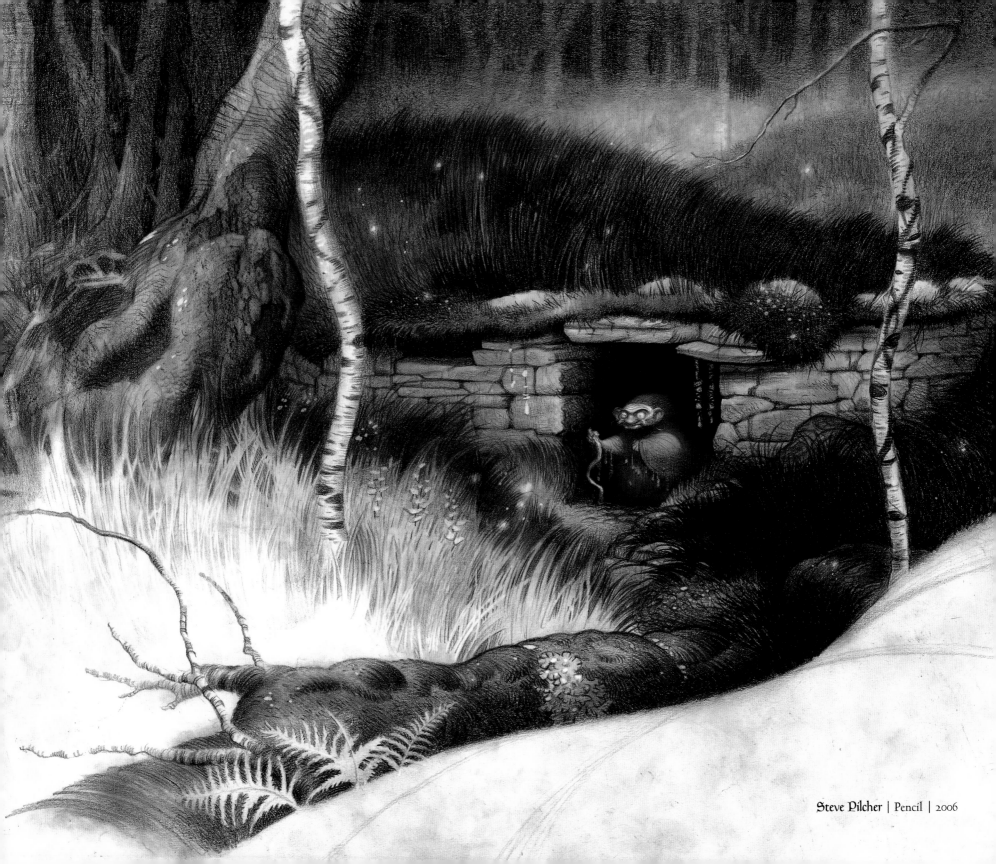

Steve Pilcher | Pencil | 2006

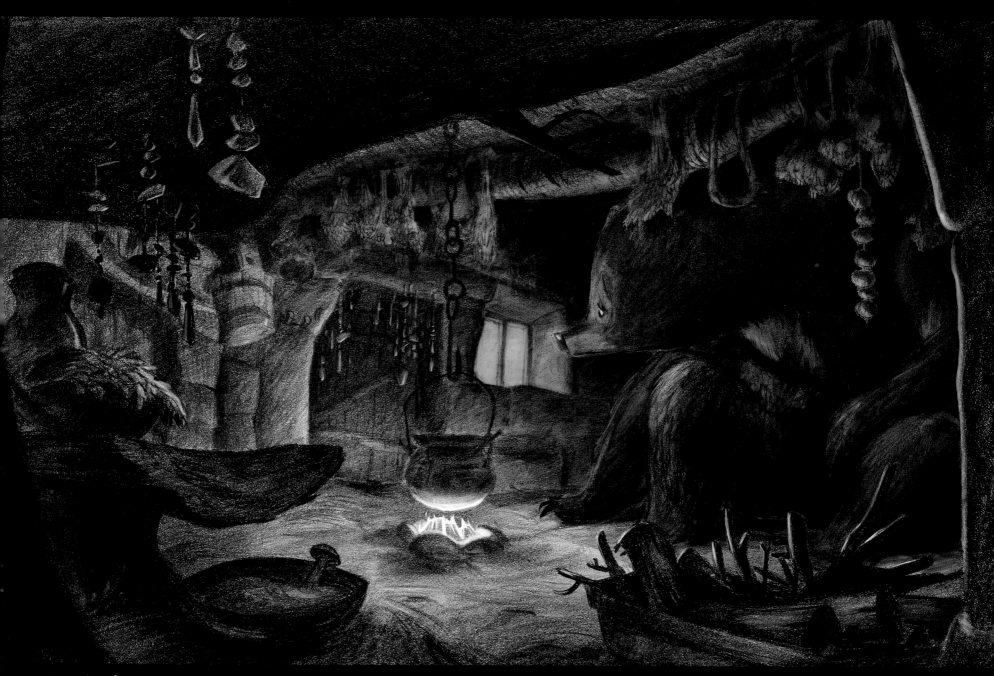

Louis Gonzales | Pencil | 2006

Steve Pilcher | Pencil | 2007

Mike Mignola | Pen | 2006

Steve Pilcher | Digital | 2008

63

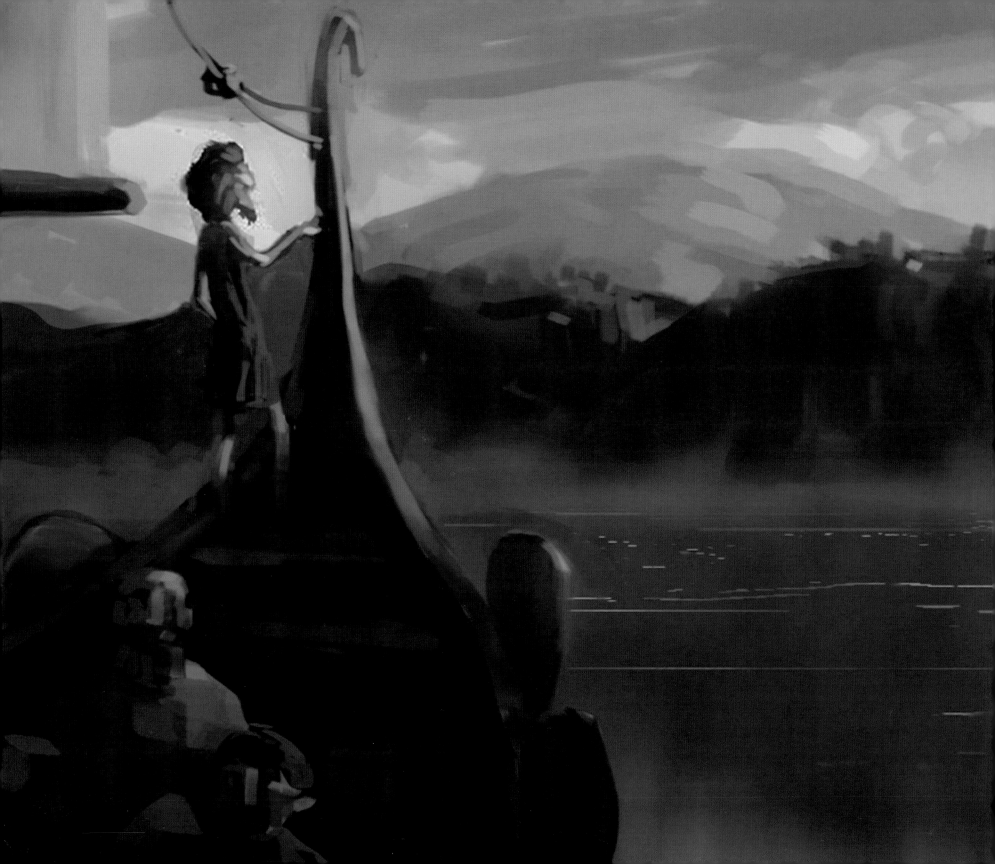

Noah Klocek | Digital | 2011

CHAPTER THREE ———

KITH, KIN, <u>AND</u> BEARS

O ne of the most stunning aspects of *Brave* is the look of its characters. The trickiest thing to achieve on a film can be a sense of appeal. It's a word that's been used since the early days of the Disney studio, when Walt searched for artists who could design characters that audiences would immediately respond to. The quest to get much more appeal from the initially stiff, sometimes generic designs of the early 1930s resulted in character design at Disney being rethought and pushed by artists including Fred Moore, Mary Blair, and Milt Kahl. Their success became part of a standard that's still influential today. Appeal can be hard to define, but one knows it when it's there. It's a visceral impression of rightness, of charm and life in a face and figure that makes the viewer want to keep looking at what that character is doing for the sheer pleasure of it. The characters of *Brave* have appeal in abundance.

Brave's key artists had a very strong sense of who the characters were from the beginning. It was evident when Steve Purcell generated his first sketches of Merida holding her bow, in Steve Pilcher's initial paintings of Merida and her mother Elinor as a bear, and in artist Daniel López Muñoz's kinetic sketches of King Fergus on the move, among many others.

Mark Andrews and Brenda Chapman describe the key characters with the same essence and spirit. Merida in particular was fully realized from the start, and that immeasurably helped the artists designing her. One of those artists was Matt Nolte, who had been hired at Pixar as an animator. He loved his job, but realized he wanted to "draw more" and had started doing character designs of *Brave*'s bears—Mum-Bear and the triplets as bear cubs. He had encouragement from one of the great modern masters of animation design, Tony Fucile, who'd done passes on *Brave*'s character lineup. Given the opportunity to step into the design department on *Brave* as part of Pilcher's crew, Nolte eventually rose to the role of character art director, overseeing the translation and consistency of the characters in the film from drawings to models and through animation. He notes, "In this film, shape is really important. The shape of the

characters, and even of the world that Steve Pilcher created, has certain lines to it and a certain flow. It's a very subtle thing, and the trick is to catch the feeling of Steve's first drawings." Pilcher believed in Nolte's ability, and as with other key members of the crew, his faith paid off in a unit that worked together beautifully to create a cohesion of design throughout the picture.

Nolte's versions of Merida advanced the look of the first drawings as well as of Pilcher's paintings, and all versions shared the girl's most arresting feature—her mass of wiry, red hair. "Merida's wild, red, curly hair is so much a part of her character—it represents who she is—this wild child," explains Chapman. "Our initial idea was that her mom was always trying to contain her daughter's hair, but Merida was always setting it free. Finally, as the story went on, she would find a way to pull it back herself so it was out of her way, but it was still her." Shading Art Director Tia Kratter agrees, and stresses the importance of getting the look of her hair just right, which meant surmounting some technical challenges: "This isn't the first film in which we've tried to do really wild hair. We thought about doing that with Boo in *Monsters, Inc.*, but ultimately came back with the pigtails because technically we just weren't there yet. For *Brave*, they made the big jump, and it so aptly fits Merida's personality.

We did a lot of research on hair and a lot of motion studies to see how those big clumps of hair would move together."

Ultimately advances were made with Pixar's animation software that made rendering the look they wanted possible, used first during the production of *Brave*. The new software allowed the artists to design their characters knowing that the tactile, earthy quality of the clothes they wore, and the fabrics and hair on their bodies, would retain the look they wanted. This was crucial, as in *Brave*'s world the surfaces had to read as organic—moss; heather; the threads of a tapestry; a horse's coarse mane; a girl's unruly hair; the beads, cords, shells, and dust that crowd an old woman's hut; and yards of kilts—all had to have exactly the right feel. This would be a place of muck and turf and thatch, designed with an artistic flair while remaining believable next to the characters.

Under the ruling clan of DunBroch are the three other clans of the kingdom: Macintosh, MacGuffin, and Dingwall. These kingdoms' lords, each with a son and heir, are summoned with their kin to gather at the castle of King Fergus, where the young heirs will compete for Merida's favor in a meet of Highland games. The designers had a terrific time delineating the clans from each other using the three very distinct lords, each with a totally unique look.

Tony Fucile, Matt Nolte, Daniel López Muñoz, Tia Kratter, Steve Pilcher | Pencil, Digital | 2008-2010

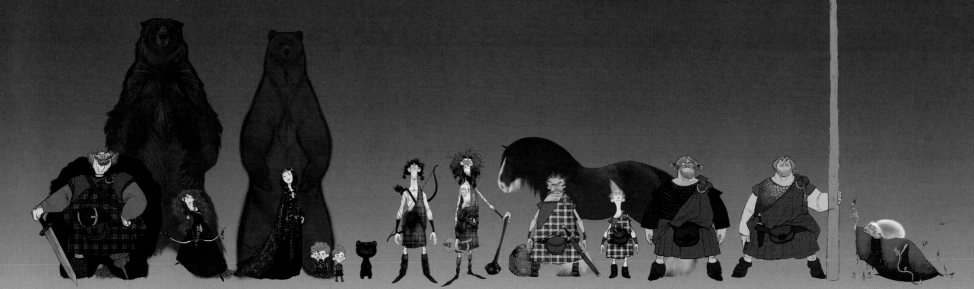

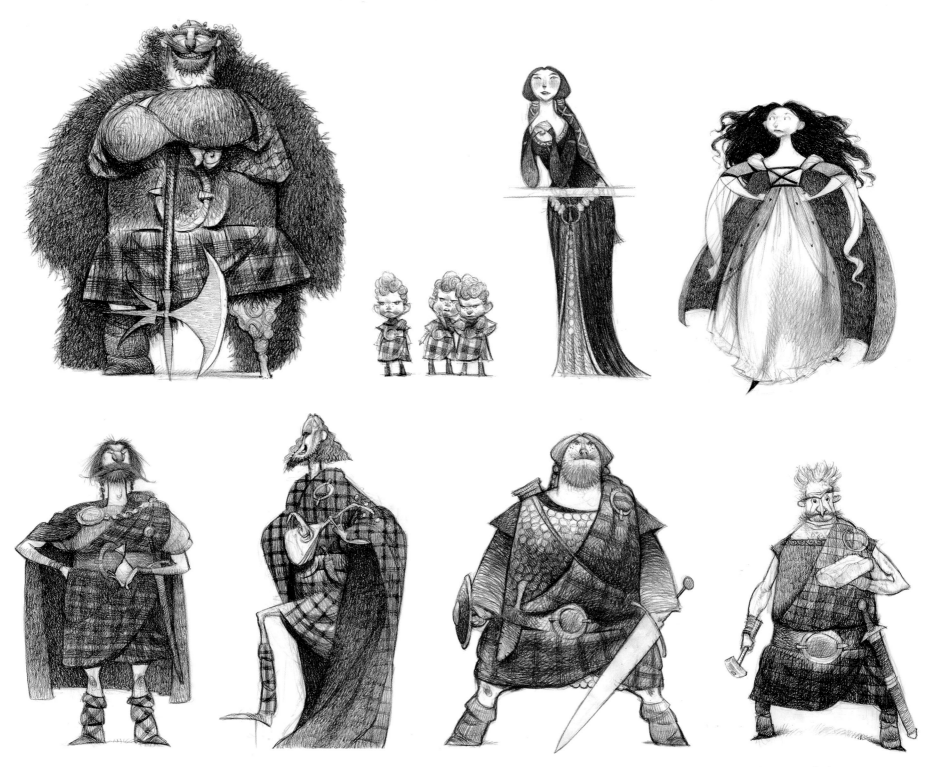

Carter Goodrich | Pencil | 2006

MERIDA

"We really thought about how Merida's red hair would be accented in different environments, working with palettes that complement and harmonize with it. You don't want to upstage it, but yet you don't want to make it garish. You're always thinking in context."
—Steve Pilcher, production designer

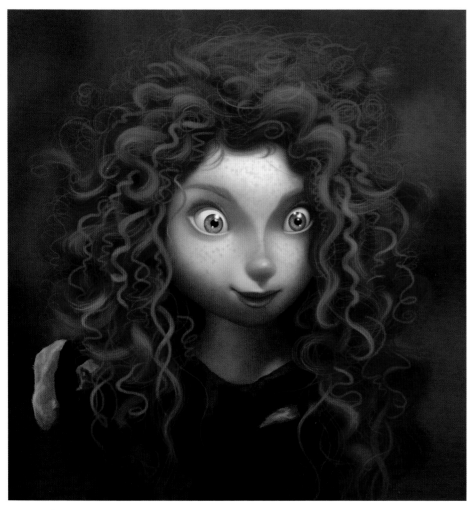

Steve Pilcher | Digital | 2008

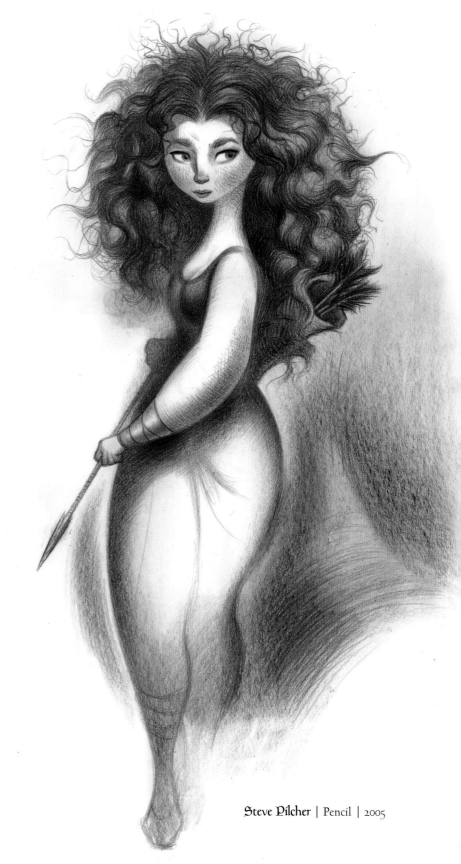

Steve Pilcher | Pencil | 2005

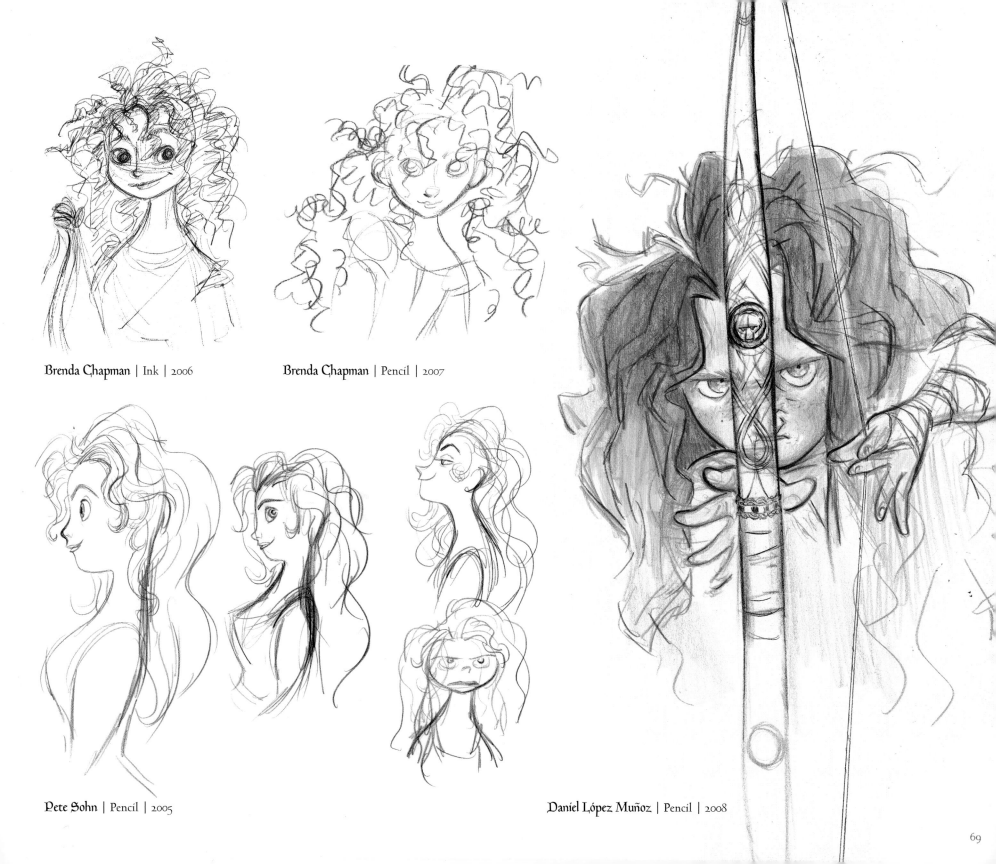

Brenda Chapman | Ink | 2006

Brenda Chapman | Pencil | 2007

Pete Sohn | Pencil | 2005

Daniel López Muñoz | Pencil | 2008

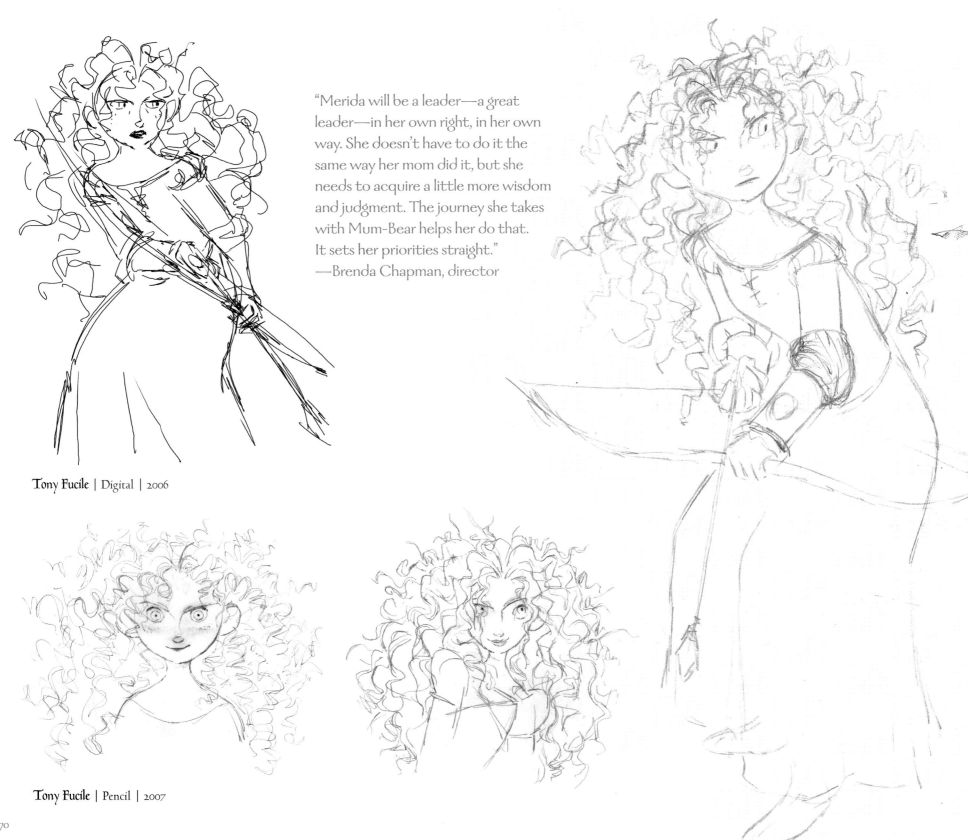

"Merida will be a leader—a great leader—in her own right, in her own way. She doesn't have to do it the same way her mom did it, but she needs to acquire a little more wisdom and judgment. The journey she takes with Mum-Bear helps her do that. It sets her priorities straight."
—Brenda Chapman, director

Tony Fucile | Digital | 2006

Tony Fucile | Pencil | 2007

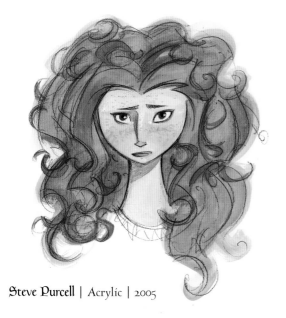

Steve Purcell | Acrylic | 2005

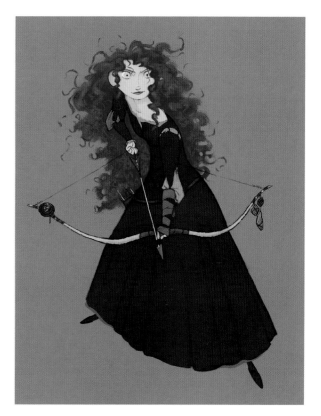

Matt Nolte, Tia Kratter | Digital | 2007

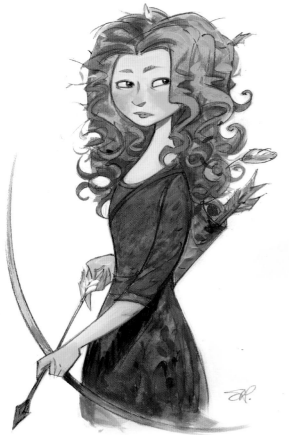

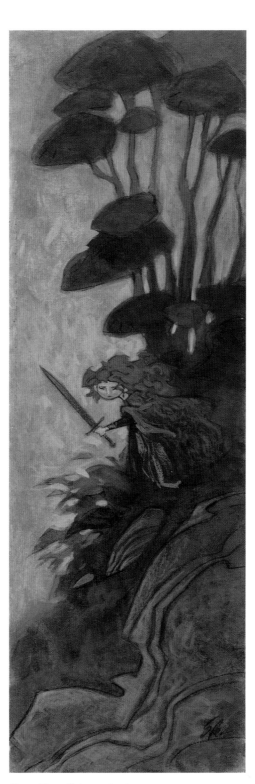

Steve Purcell | Acrylic | 2005

Steve Purcell | Acrylic | 2006

Matt Nolte | Pencil | 2009

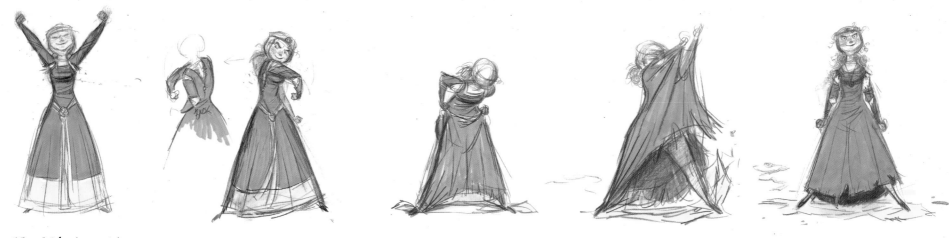

Matt Nolte | Pencil | 2009

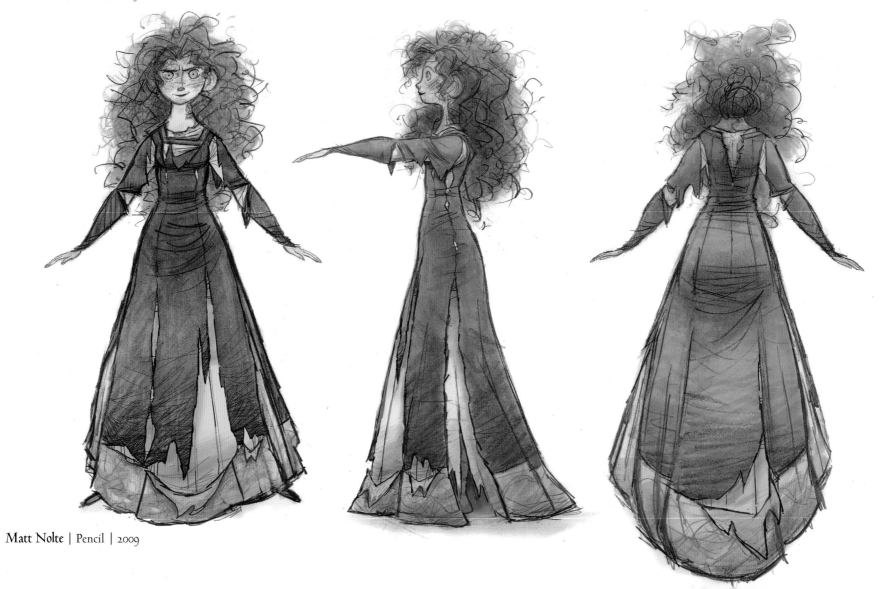

Matt Nolte | Pencil | 2009

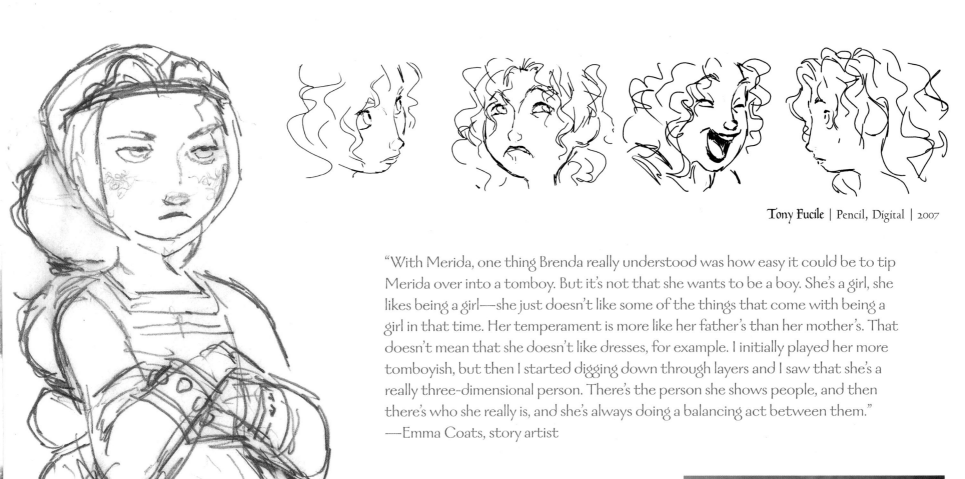

Tony Fucile | Pencil, Digital | 2007

"With Merida, one thing Brenda really understood was how easy it could be to tip Merida over into a tomboy. But it's not that she wants to be a boy. She's a girl, she likes being a girl—she just doesn't like some of the things that come with being a girl in that time. Her temperament is more like her father's than her mother's. That doesn't mean that she doesn't like dresses, for example. I initially played her more tomboyish, but then I started digging down through layers and I saw that she's a really three-dimensional person. There's the person she shows people, and then there's who she really is, and she's always doing a balancing act between them."
—Emma Coats, story artist

Tony Fucile | Pencil | 2007

Tony Fucile | Pencil | 2007

Steve Pilcher | Digital | 2008

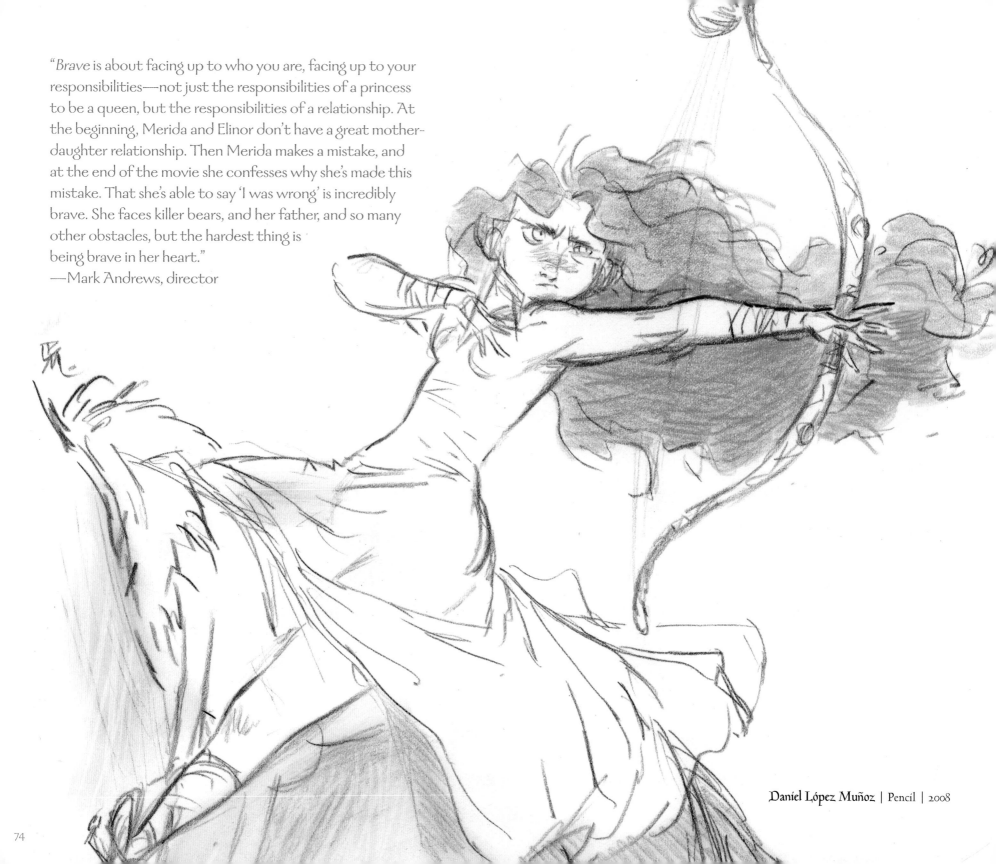

"*Brave* is about facing up to who you are, facing up to your responsibilities—not just the responsibilities of a princess to be a queen, but the responsibilities of a relationship. At the beginning, Merida and Elinor don't have a great mother-daughter relationship. Then Merida makes a mistake, and at the end of the movie she confesses why she's made this mistake. That she's able to say 'I was wrong' is incredibly brave. She faces killer bears, and her father, and so many other obstacles, but the hardest thing is being brave in her heart."
—Mark Andrews, director

Daniel López Muñoz | Pencil | 2008

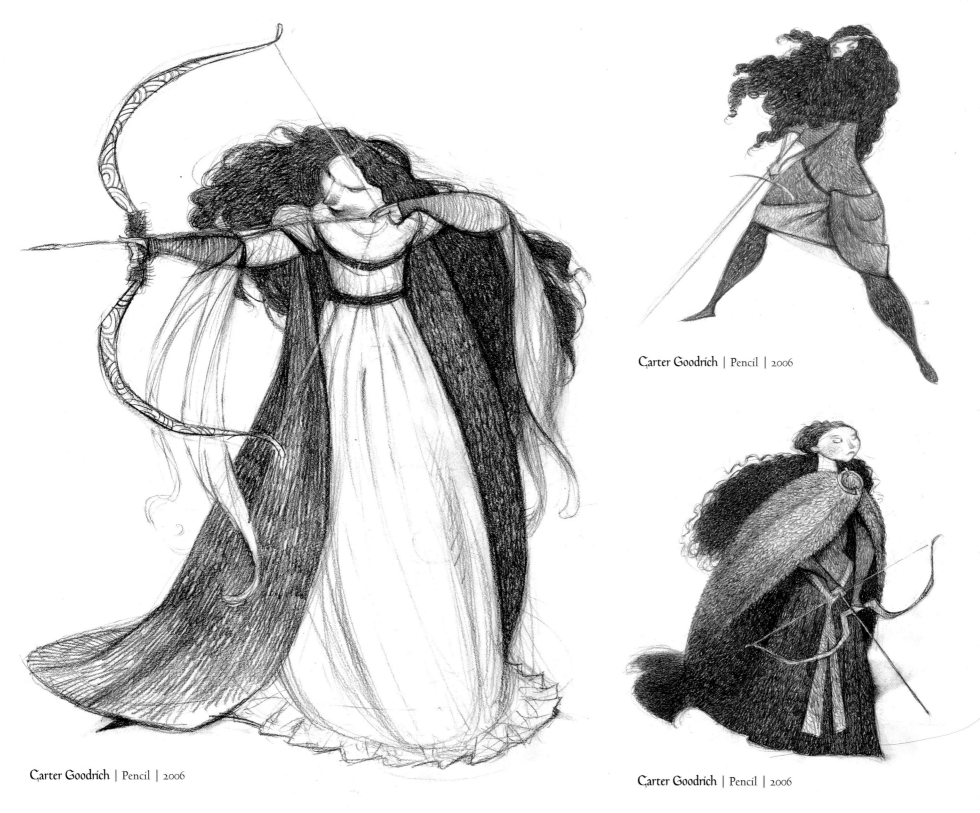

Carter Goodrich | Pencil | 2006

Carter Goodrich | Pencil | 2006

Carter Goodrich | Pencil | 2006

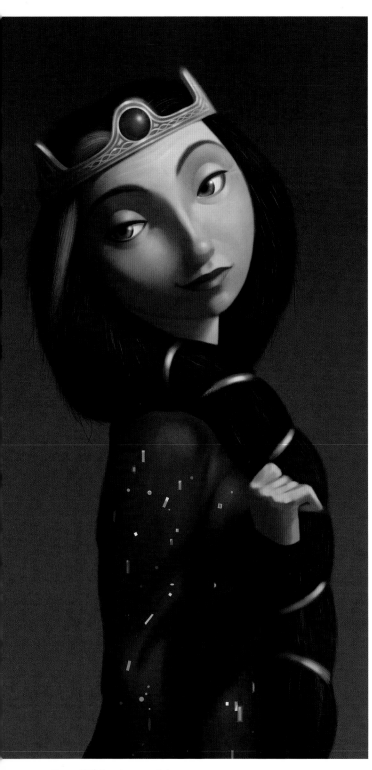

Steve Pilcher | Digital | 2009

QUEEN ELINOR

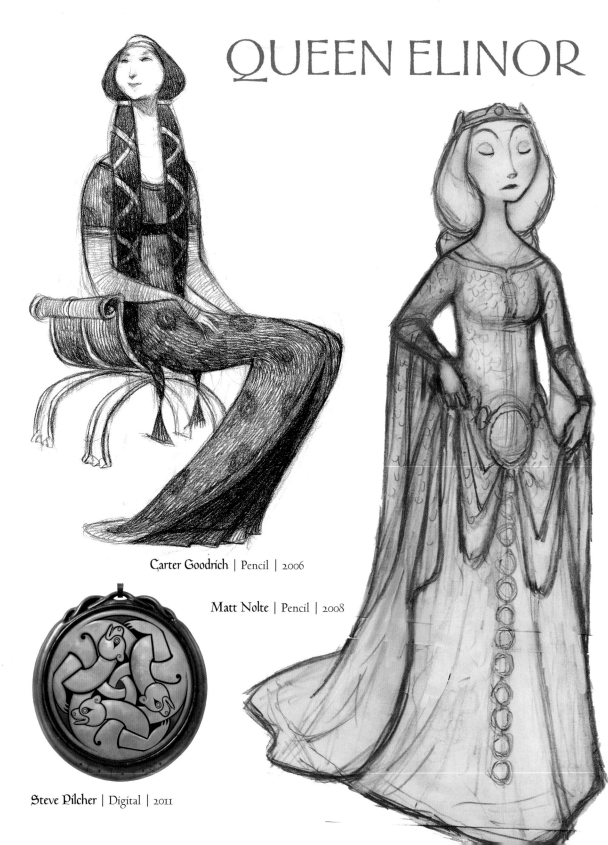

Carter Goodrich | Pencil | 2006

Matt Nolte | Pencil | 2008

Steve Pilcher | Digital | 2011

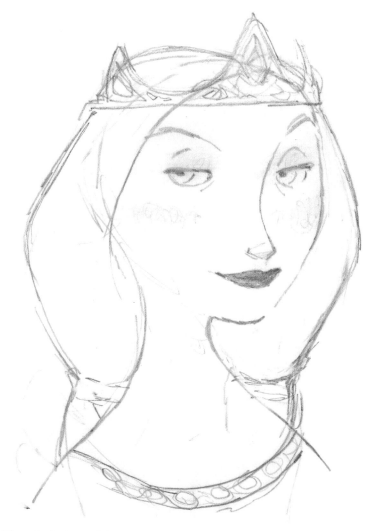

Tony Fucile | Pencil | 2007

Steve Pilcher | Digital | 2010

"Fergus lives somewhat in the past, because he's interested in the stories of exploits that happened before. Merida is a teenager and, like all kids, lives in the now. Elinor lives in the future—Merida's future and her plans for the kingdom. So you have three sides of a perfect triangle: past, present, and future. Merida is stuck right in the middle. Elinor doesn't really comprehend that. So when she's a bear, she sees her daughter for the first time outside the context of, 'What's my daughter going to be?' And she realizes, 'I'm missing my daughter's life. I'm totally missing her.'"
—Mark Andrews, director

Steve Pilcher | Digital | 2007

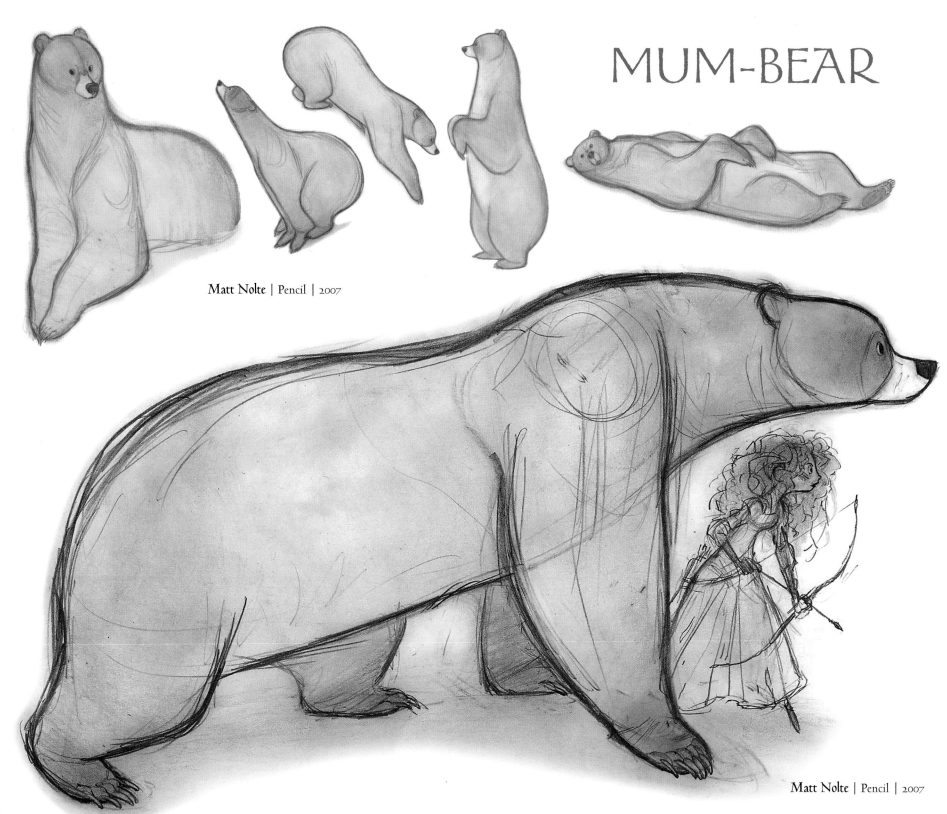

MUM-BEAR

Matt Nolte | Pencil | 2007

Matt Nolte | Pencil | 2007

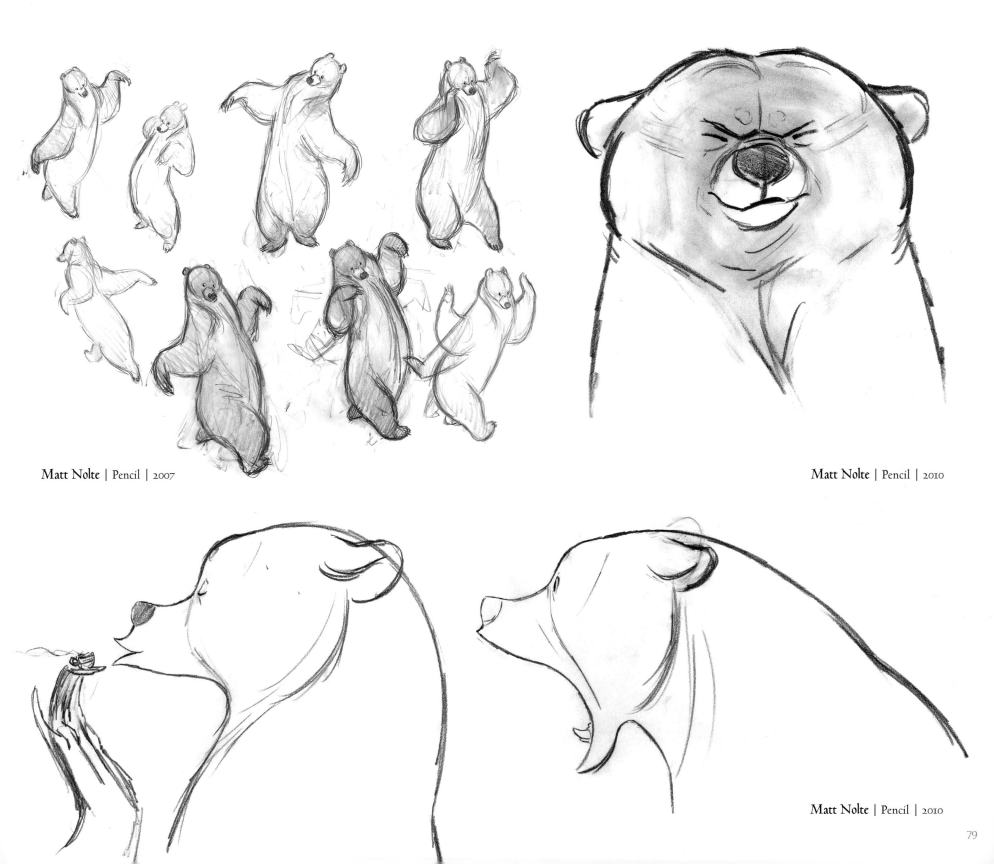

Matt Nolte | Pencil | 2007

Matt Nolte | Pencil | 2010

Matt Nolte | Pencil | 2010

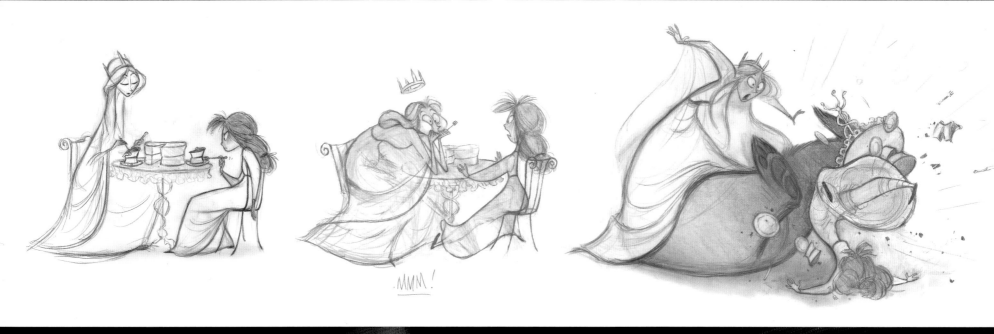

MMM!

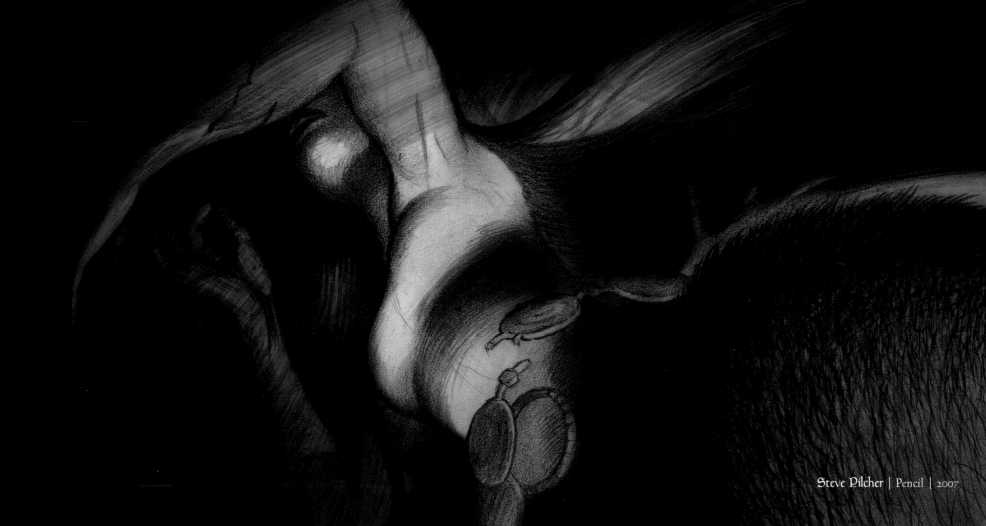

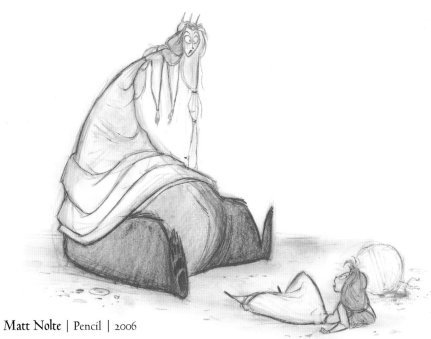

Matt Nolte | Pencil | 2006

"We always look at the original design and color to inspire what a character is going to look like in animation. Initially with Mum-Bear, we started getting more real with the details, and then we ended up having to smooth out the form. In a lot of Pilcher's paintings, the appeal is that Mum-Bear is just this dark, smooth shape in the woods, and we want to keep some of that feeling in the film."
—Steven Clay Hunter, supervising animator

Lou Hamou-Lhadj | Marker | 2009

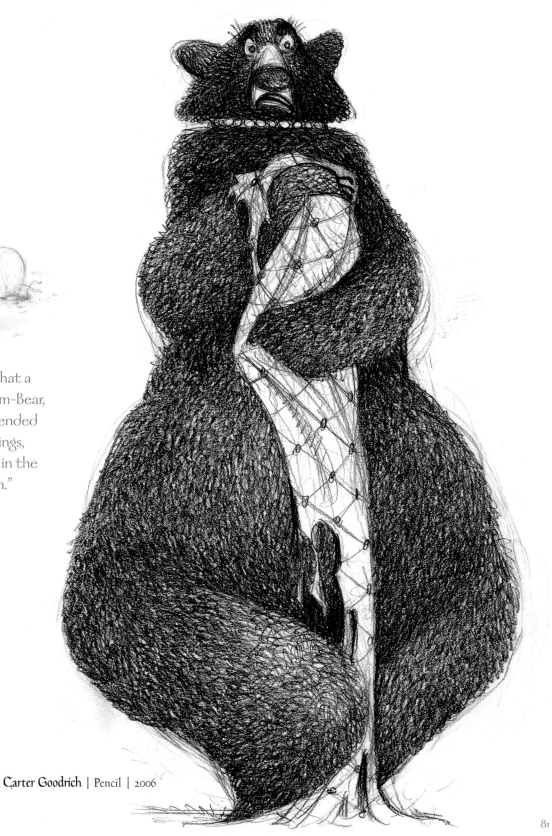

Carter Goodrich | Pencil | 2006

KING FERGUS

Matt Nolte | Pencil | 2007

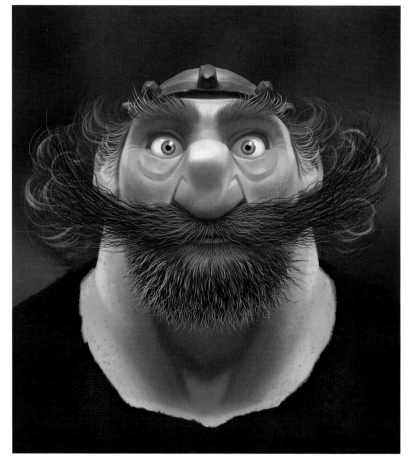

Steve Pilcher | Digital | 2009

Tony Fucile | Pencil | 2007

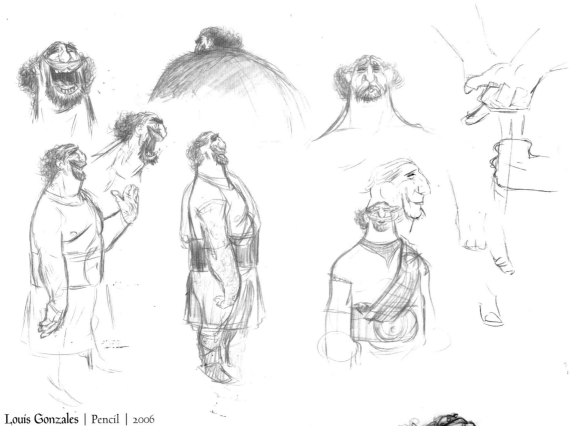

"Fergus looks like a Viking. We don't say he is, but you look at his red hair and his fair skin, and he looks like a different bloodline than Elinor. Merida's kind of a mix of the two. I love that their backstory influences their physical appearance, their hair color. We think very carefully about that."
—Steve Pilcher, production designer

Louis Gonzales | Pencil | 2006

huy Nguyen | Digital | 2009

Matt Nolte | Pencil | 2009

83

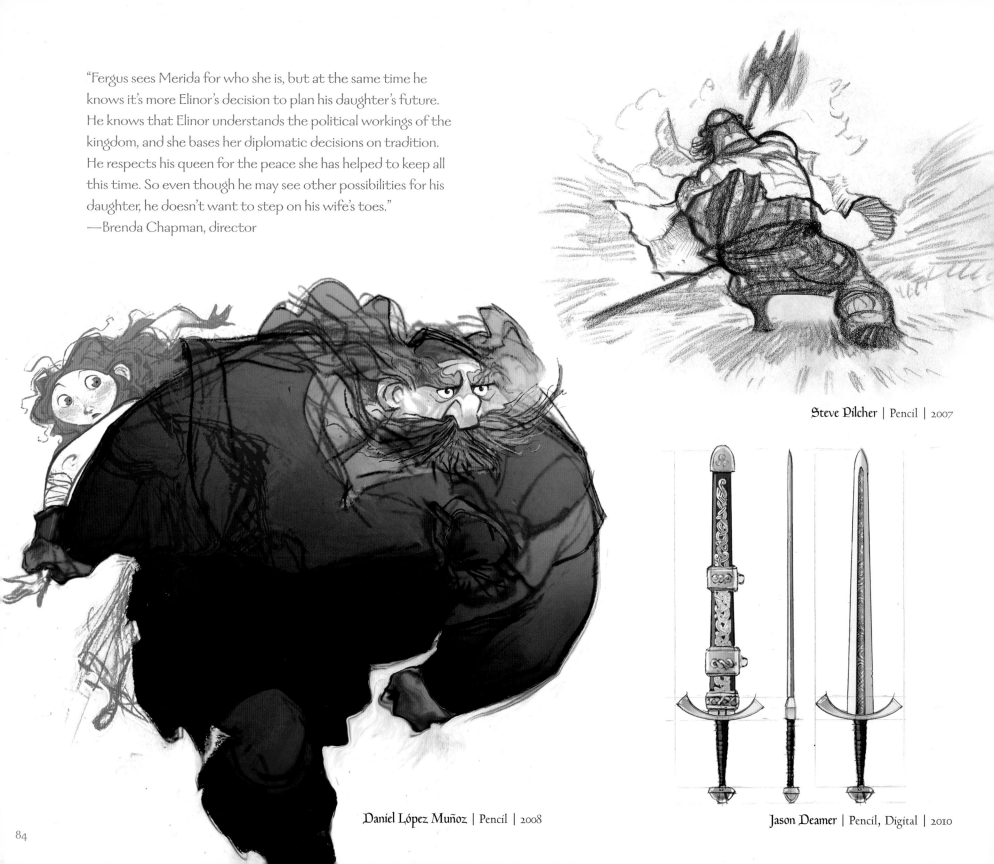

"Fergus sees Merida for who she is, but at the same time he knows it's more Elinor's decision to plan his daughter's future. He knows that Elinor understands the political workings of the kingdom, and she bases her diplomatic decisions on tradition. He respects his queen for the peace she has helped to keep all this time. So even though he may see other possibilities for his daughter, he doesn't want to step on his wife's toes."
—Brenda Chapman, director

Steve Pilcher | Pencil | 2007

Daniel López Muñoz | Pencil | 2008

Jason Deamer | Pencil, Digital | 2010

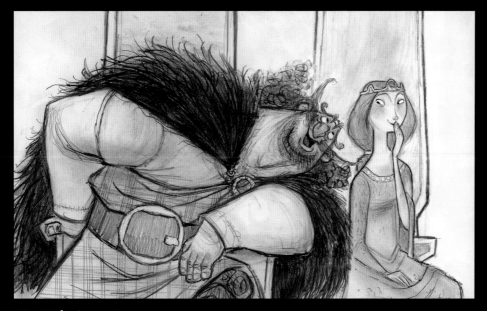

Matt Nolte | Pencil | 2007

"Fergus can be a bit of a goofball, but when it comes to protecting his kingdom and his family, he's fierce. He can also be incredibly clever and smart. I wanted to show him as this amazing über-warrior and hunter. With his ginormous energy and spirit, he's comic relief, yes, but he's strong—a force to be reckoned with."
—Brenda Chapman, director

Daniel López Muñoz | Digital | 2008

THE TRIPLETS

"Three boys? I had twins this year, two boys, and I've already seen enough of their secret ways of talking. Even as one-year-olds, they were communicating. I don't know what they're saying, but they have their own language."
—Alan Barillaro, supervising animator

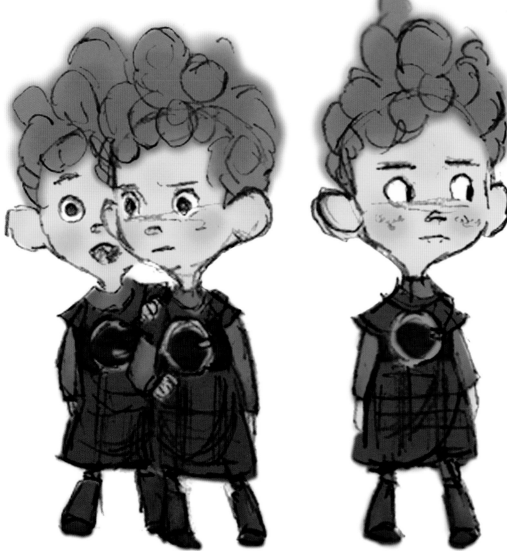

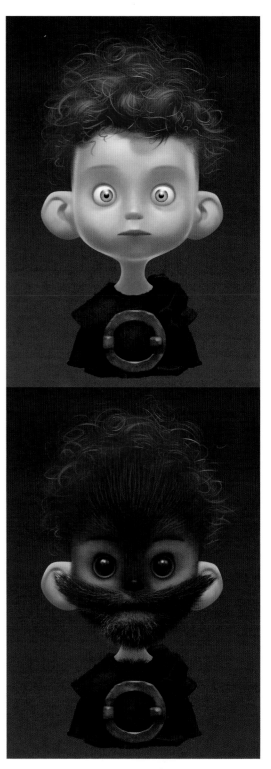

Tony Fucile | Pencil | 2007

Steve Pilcher | Digital | 2011

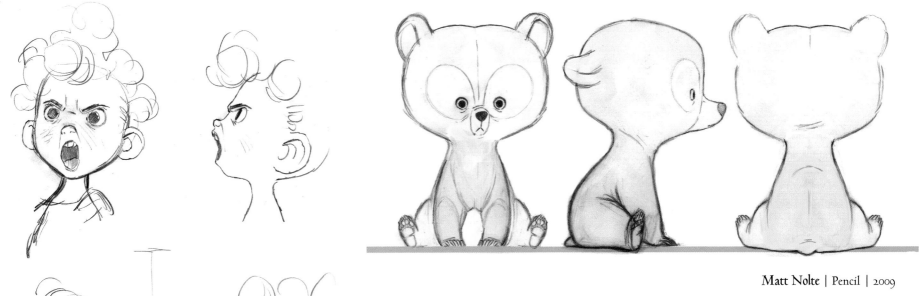

"I felt like we've seen arguing brothers and sisters before. So we thought, What if Merida and the boys are allies? What if they actually like each other? What if she bribes them with sweets, and what if they'll do anything for her? They just look up to her—they think she's so cool."
—Brenda Chapman, director

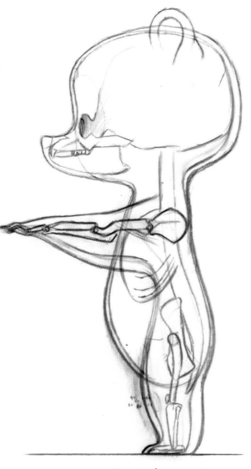

ANGUS

Angus, Merida's horse, is a massive, powerful Clydesdale, a breed well known in the Highlands. He shares with her an intuitive bond, the result of being raised together. Both enjoy the rush of cold wind in their manes, and neither likes being tied down.

Tía Kratter | Digital | 2009

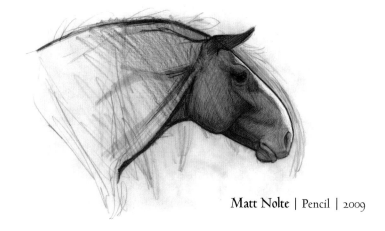

Matt Nolte | Pencil | 2009

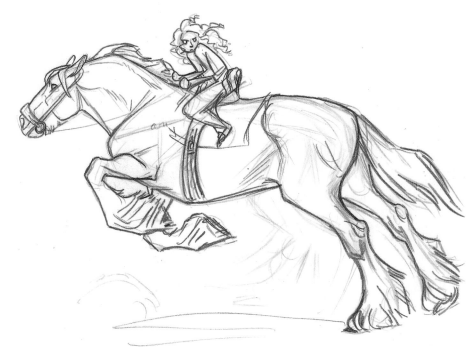

Emma Coats | Pencil | 2007

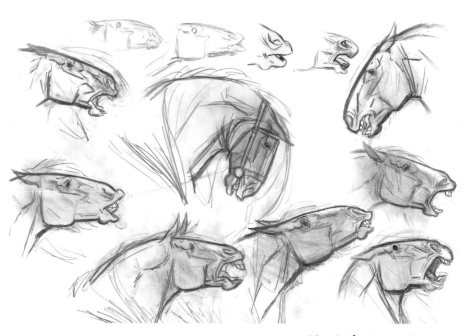

Matt Nolte | Pencil | 2005

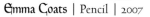

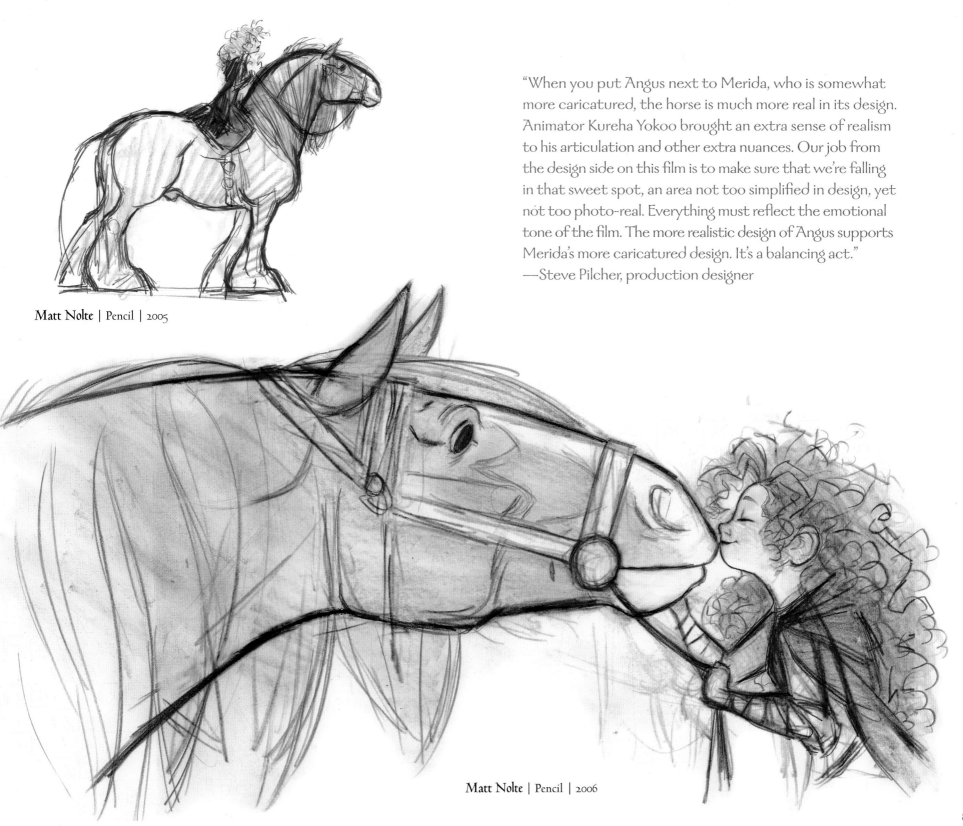

"When you put Angus next to Merida, who is somewhat more caricatured, the horse is much more real in its design. Animator Kureha Yokoo brought an extra sense of realism to his articulation and other extra nuances. Our job from the design side on this film is to make sure that we're falling in that sweet spot, an area not too simplified in design, yet not too photo-real. Everything must reflect the emotional tone of the film. The more realistic design of Angus supports Merida's more caricatured design. It's a balancing act."
—Steve Pilcher, production designer

Matt Nolte | Pencil | 2005

Matt Nolte | Pencil | 2006

THE WISPS

"In Scotland the reality behind the wisps is that they are swamp gas—methane bursts or something like that. That was the inspiration for our testing. We needed to make them look gaseous, not like a small character that has burst into blue flame. So we slowed a lot of the gravity down. We made it very languid, very soft. It's almost like an echo of itself. It has some characteristics of a flame with regards to shape, but not with regards to activity."
—David MacCarthy, effects supervisor

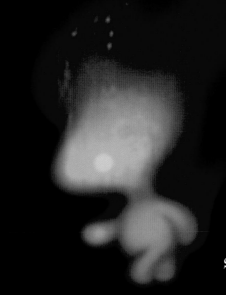

Steve Pilcher | Digital | 2008

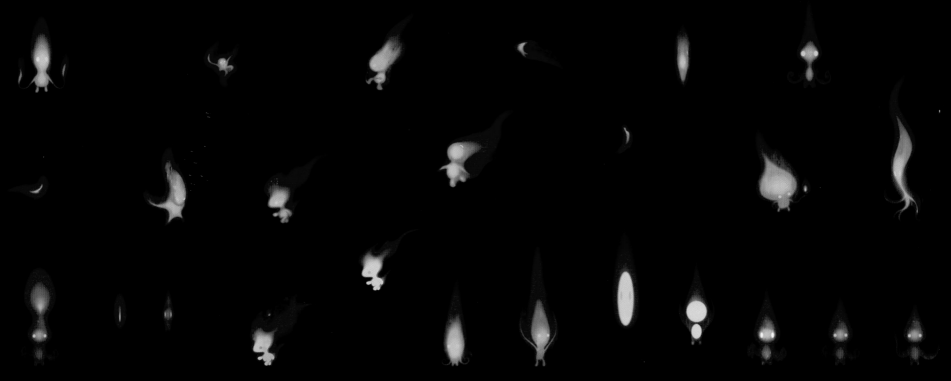

Steve Pilcher | Digital | 2008

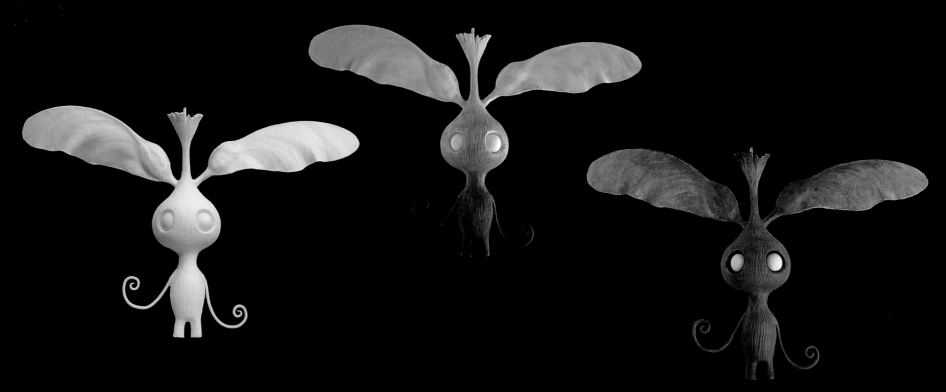

Concept Sculpture | **Jerome Ranft** | Acrylic, Cast Urethane | 2007

Concept Sculpture | **Jerome Ranft** | Acrylic, Cast Urethane, and Cotton | 2007

"The wisps behave in different ways, particularly in how they appear, how they disappear. A wisp can be quite soft, and it can be quite violent, or aggressive. With a character that has appendages, all the action is made to be readable—you don't want it to be ambiguous. But in this particular case, it's the opposite. Especially with the arms and legs, which come in and out of being; sometimes you can see them, sometimes you don't. Sometimes they create little fists, sometimes they're very amoeba-like. They're very ethereal."
—David MacCarthy, effects supervisor

THE WITCH

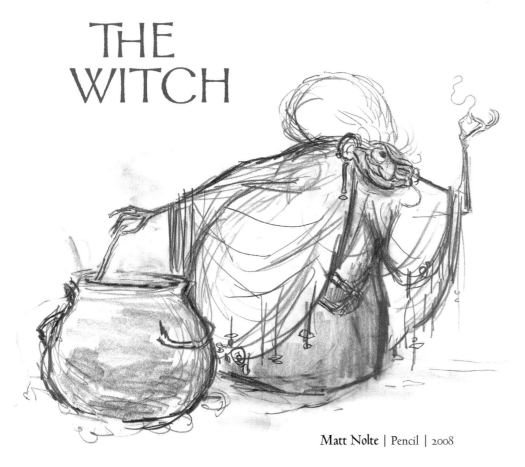

Matt Nolte | Pencil | 2008

Matt Nolte | Pencil | 2011

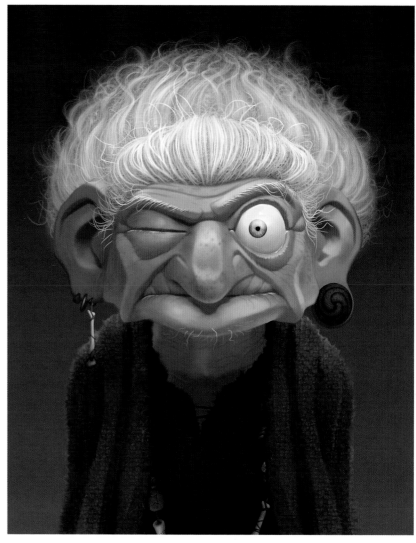

Steve Pilcher | Digital | 2009

"I found myself really invested in the Witch since I had written and boarded the first drafts of her scene, performed her temporary voice in scratch, and even modeled for the pose that was used for the sculpt. We always liked the idea of her having quick, brittle movements as she scurries around the cottage. And that big eye that could zero in on Merida and throw her off-kilter. When the Witch emerged from our characters department, she was a thing of beauty."
—Steve Purcell, co-director

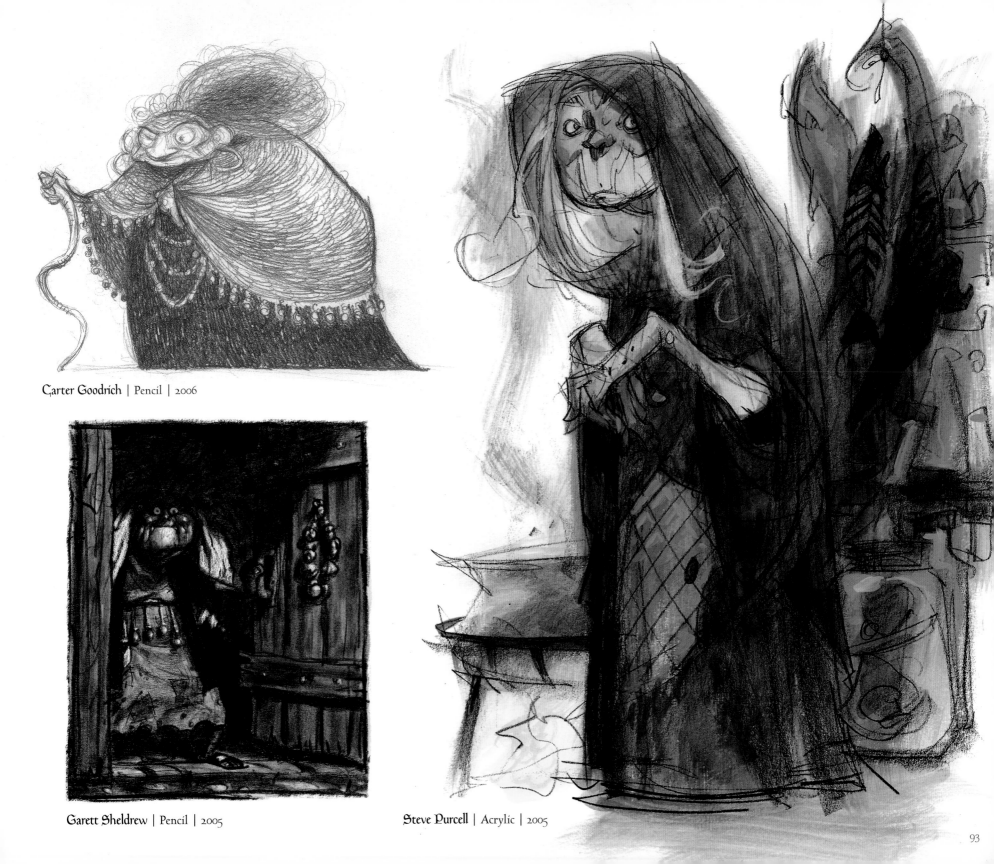

Carter Goodrich | Pencil | 2006

Garett Sheldrew | Pencil | 2005

Steve Purcell | Acrylic | 2005

MOR'DU

Steve Pilcher | Digital | 2010

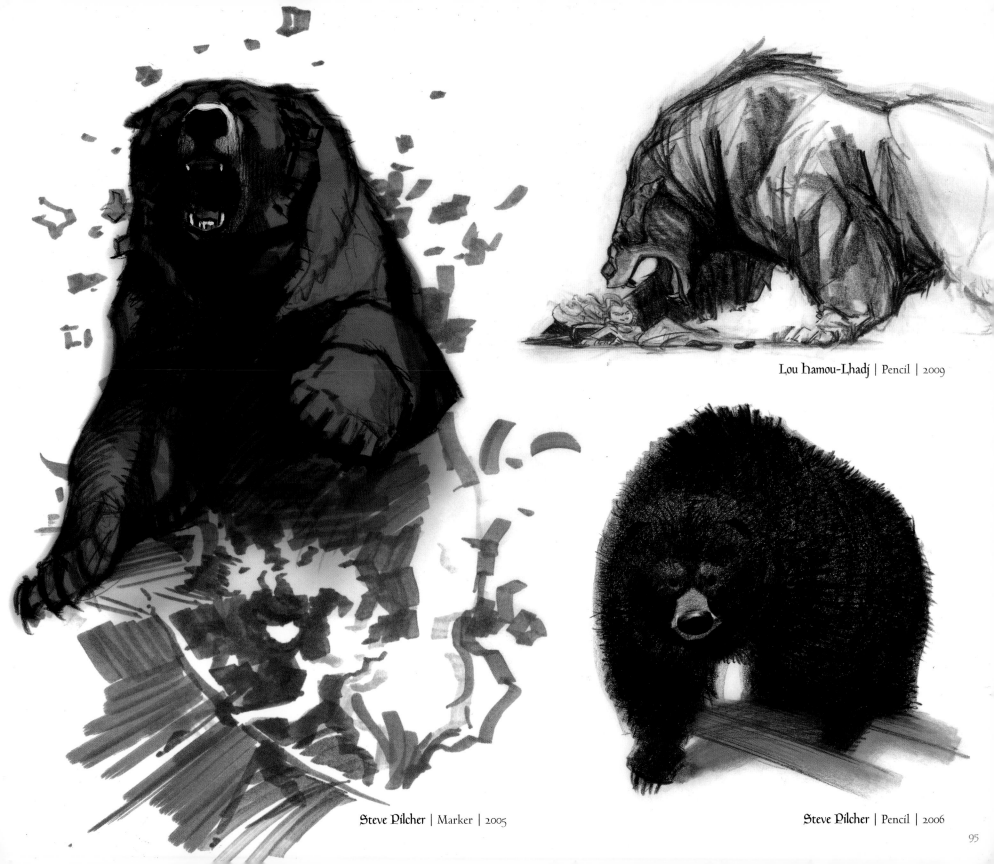

Lou Hamou-Lhadj | Pencil | 2009

Steve Pilcher | Marker | 2005

Steve Pilcher | Pencil | 2006

95

Steve Pilcher | Digital | 2011

Mor'du is not simply a bear, he is *the* bear; there has never been anything else like him in anyone's memory. His size and malevolence far surpass any other animal's, and few have escaped a meeting with him alive. One of these rare hunters, however, is Fergus, who lost his leg to the monster years ago. Mor'du's outsized presence inspires fear and hatred, but also a brimming caskful of songs and stories.

Steve Pilcher | Clay | 2011

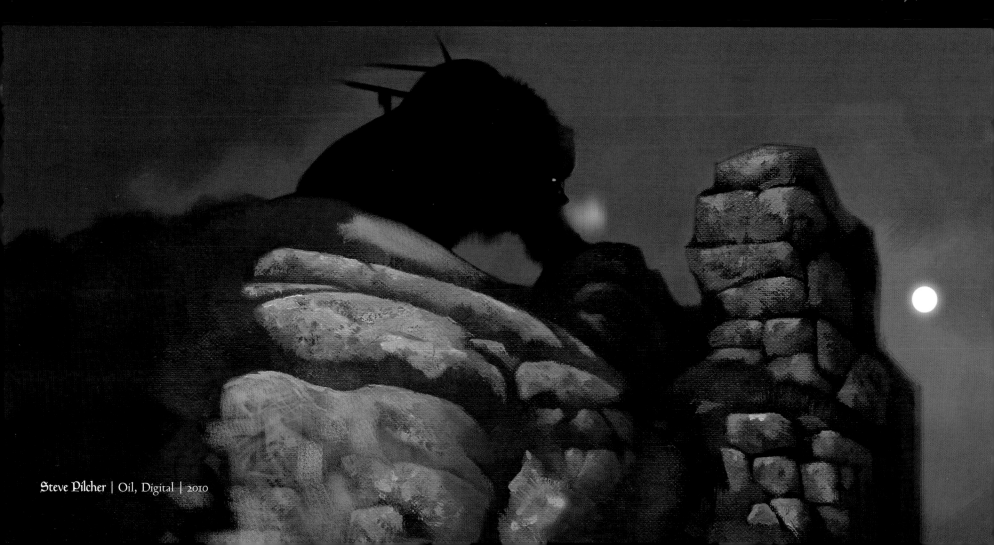

Steve Pilcher | Oil, Digital | 2010

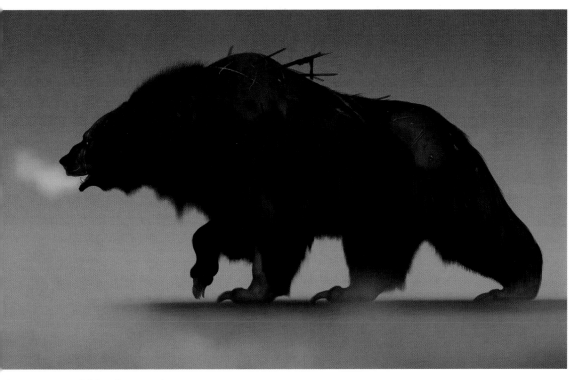

Steve Pilcher | Digital | 2010

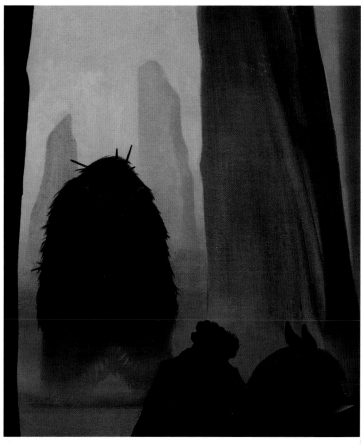

Tia Kratter | Acrylic, Digital | 2008

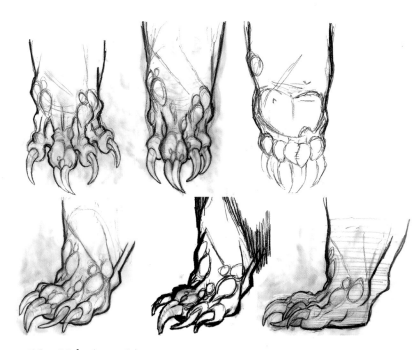

Matt Nolte | Pencil | 2011

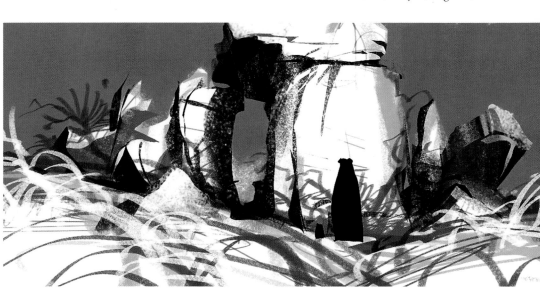

huy Nguyen | Digital | 2010

THE LORDS

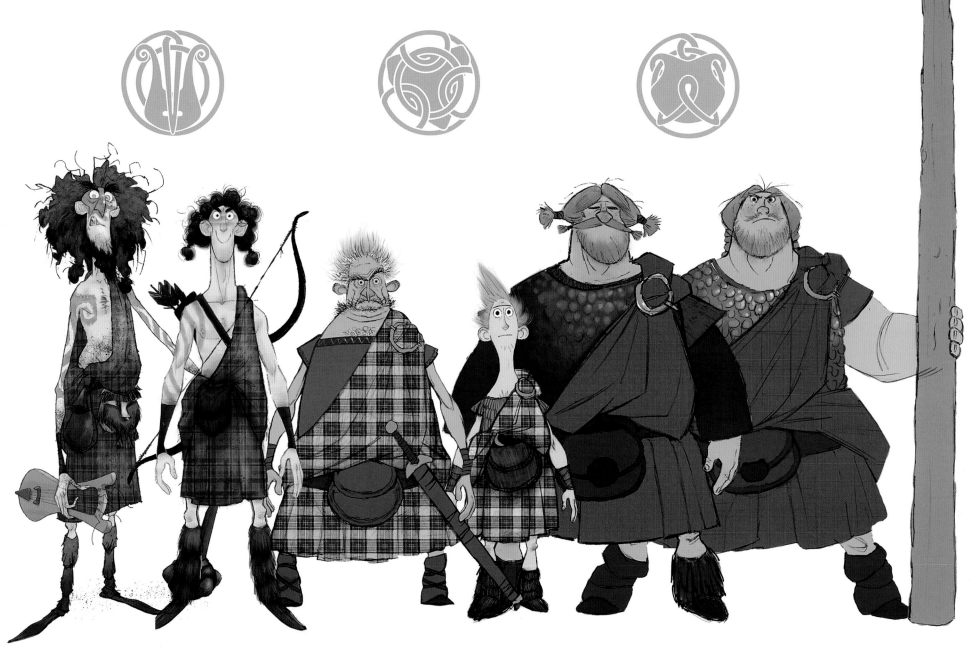

MACINTOSH DINGWALL MACGUFFIN

Matt Nolte, Daniel López Muñoz, and Tia Kratter | Pencil, Digital | 2007-2010

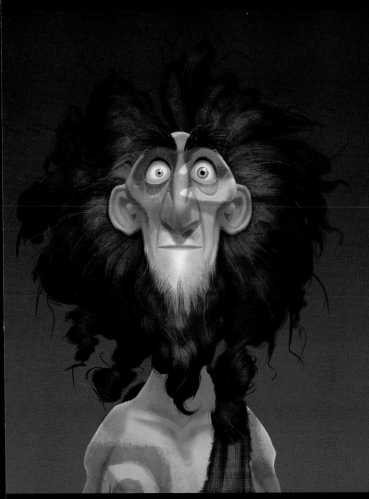

huy Nguyen | Digital | 2009

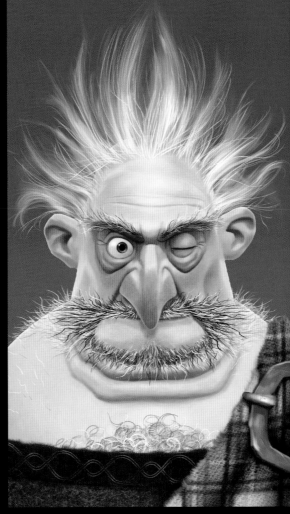

Daniel Lopez Munoz and huy Nguyen | Digital | 2009

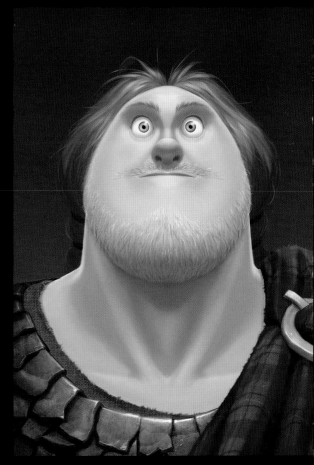

huy Nguyen | Digital | 2009

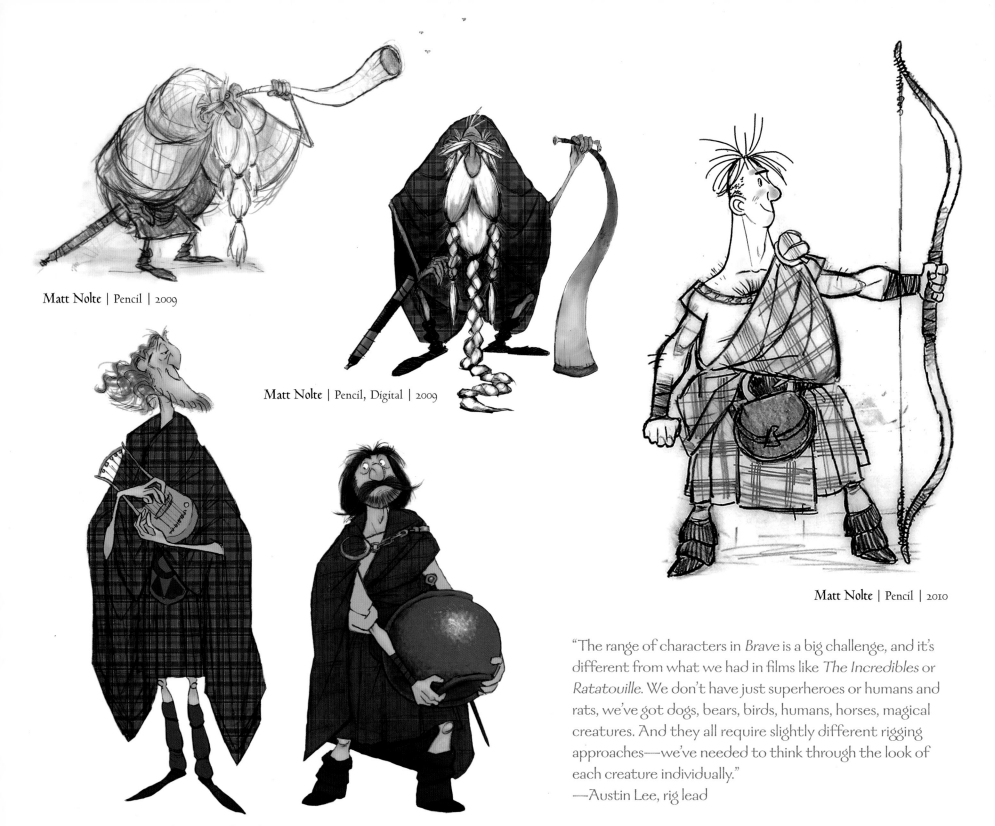

Matt Nolte | Pencil | 2009

Matt Nolte | Pencil, Digital | 2009

Matt Nolte | Pencil | 2010

Tony Fucile, Matt Nolte, Tia Kratter | Pencil, Digital | 2008

"The range of characters in *Brave* is a big challenge, and it's different from what we had in films like *The Incredibles* or *Ratatouille*. We don't have just superheroes or humans and rats, we've got dogs, bears, birds, humans, horses, magical creatures. And they all require slightly different rigging approaches—we've needed to think through the look of each creature individually."
—Austin Lee, rig lead

ANIMALS

Steve Pilcher | Pencil | 2006

Jason Deamer | Digital | 2010

Matt Nolte | Pencil | 2010

Matt Nolte | Pencil | 2006

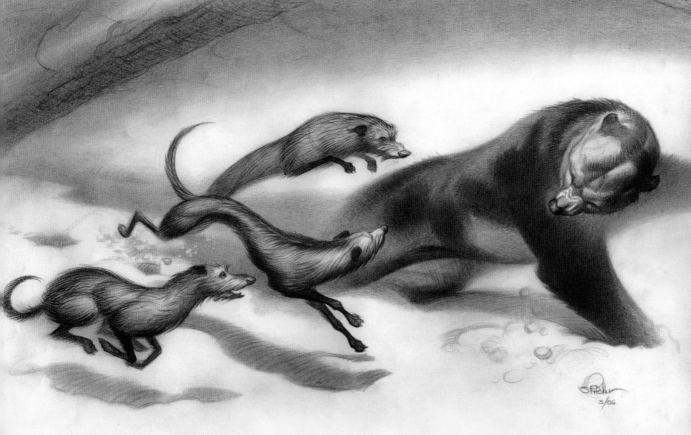

Steve Pilcher | Pencil | 2006

Daniel López Muñoz | Digital | 2009

WARRIORS & VILLAGERS

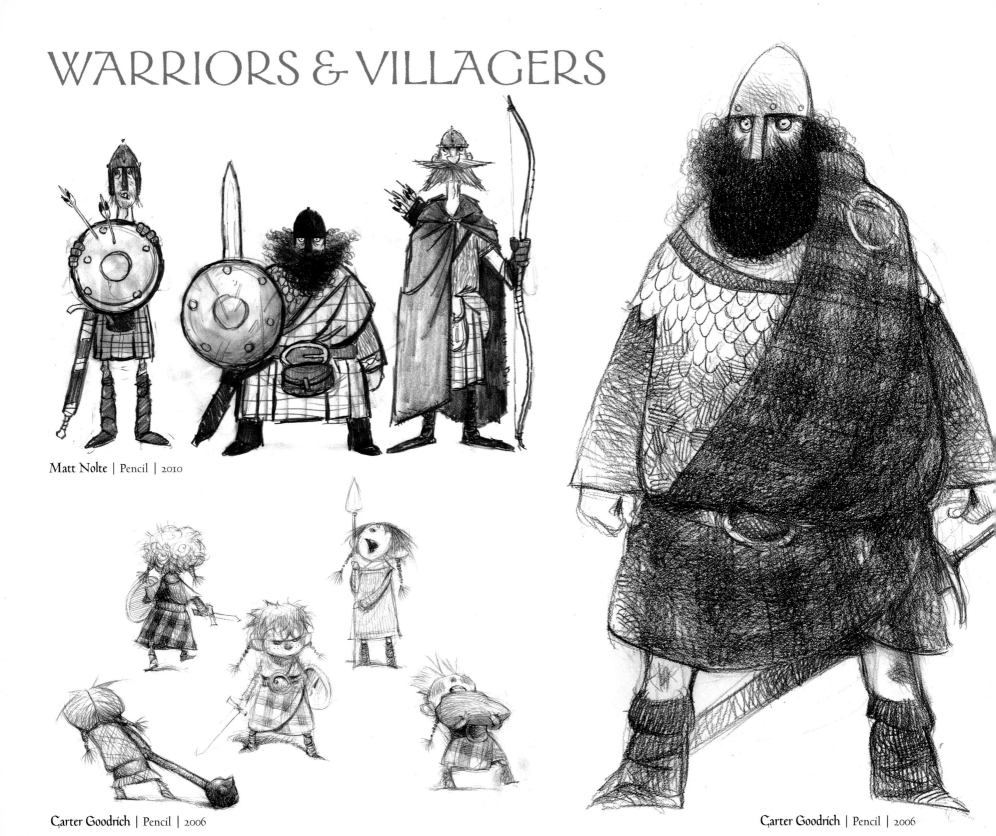

Matt Nolte | Pencil | 2010

Carter Goodrich | Pencil | 2006

Carter Goodrich | Pencil | 2006

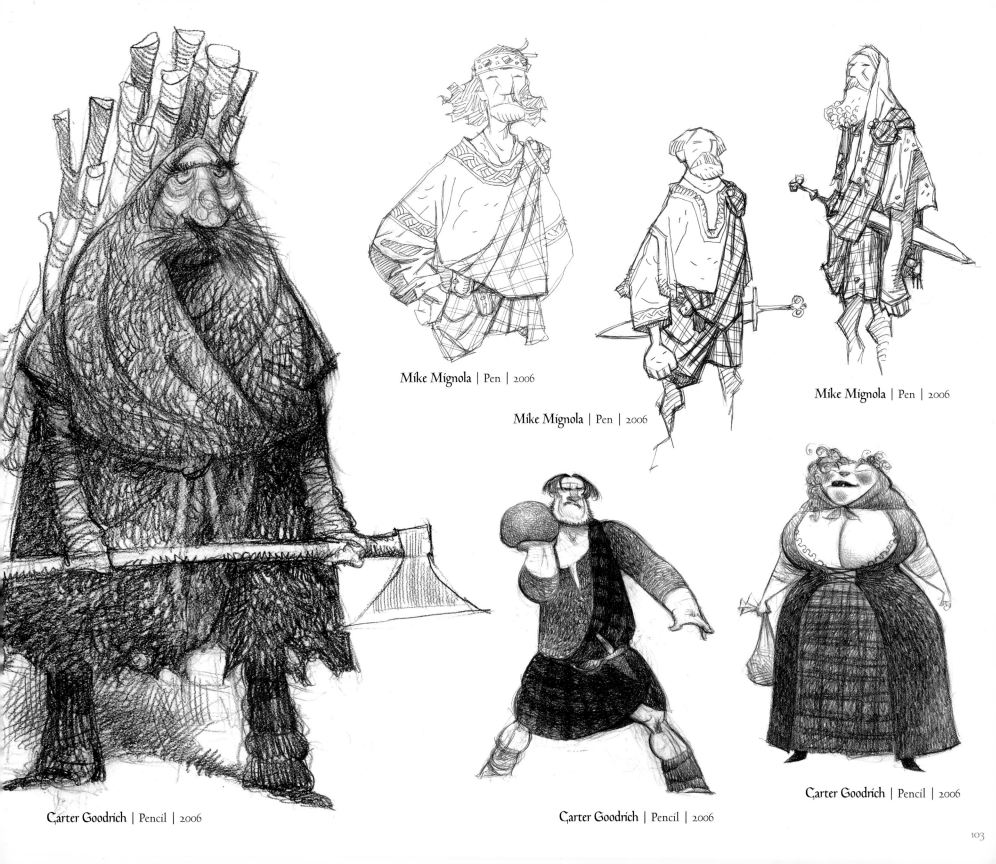

Mike Mignola | Pen | 2006

Mike Mignola | Pen | 2006

Mike Mignola | Pen | 2006

Carter Goodrich | Pencil | 2006

Carter Goodrich | Pencil | 2006

Carter Goodrich | Pencil | 2006

103

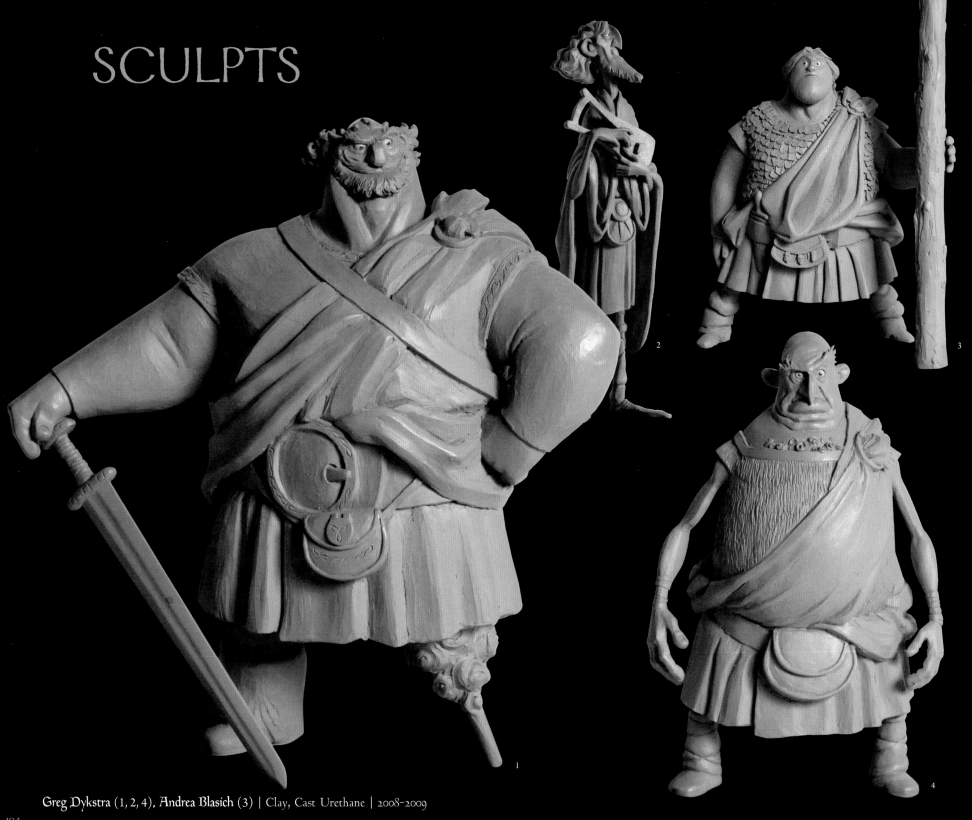

SCULPTS

Greg Dykstra (1, 2, 4), Andrea Blasich (3) | Clay, Cast Urethane | 2008-2009

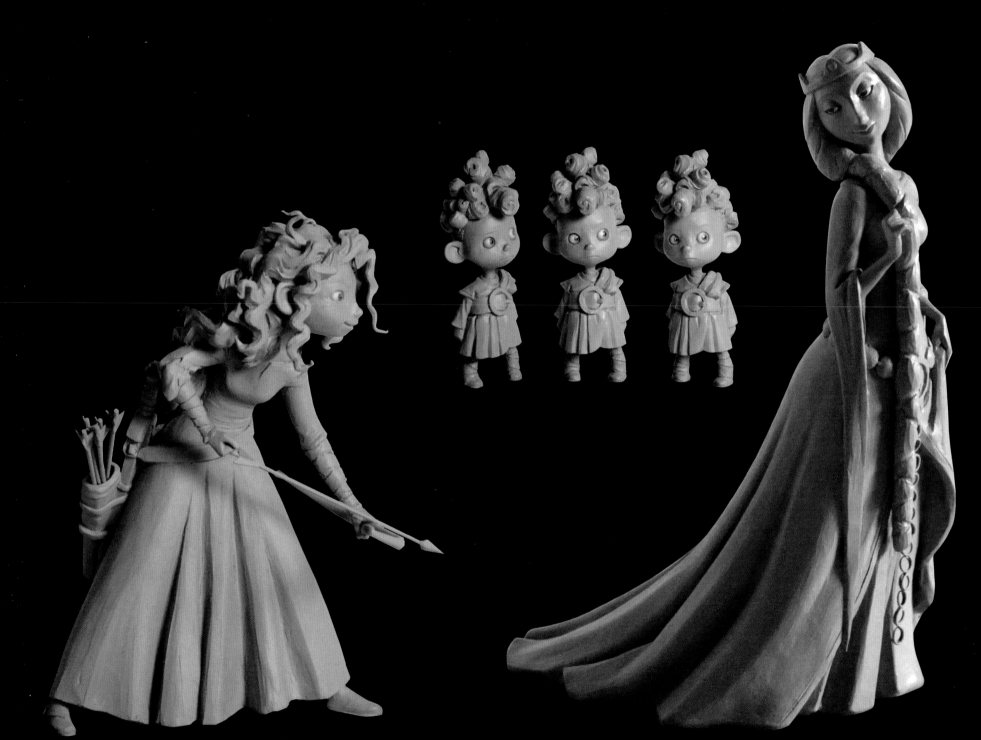

Greg Dykstra | Clay, Cast Urethane | 2008

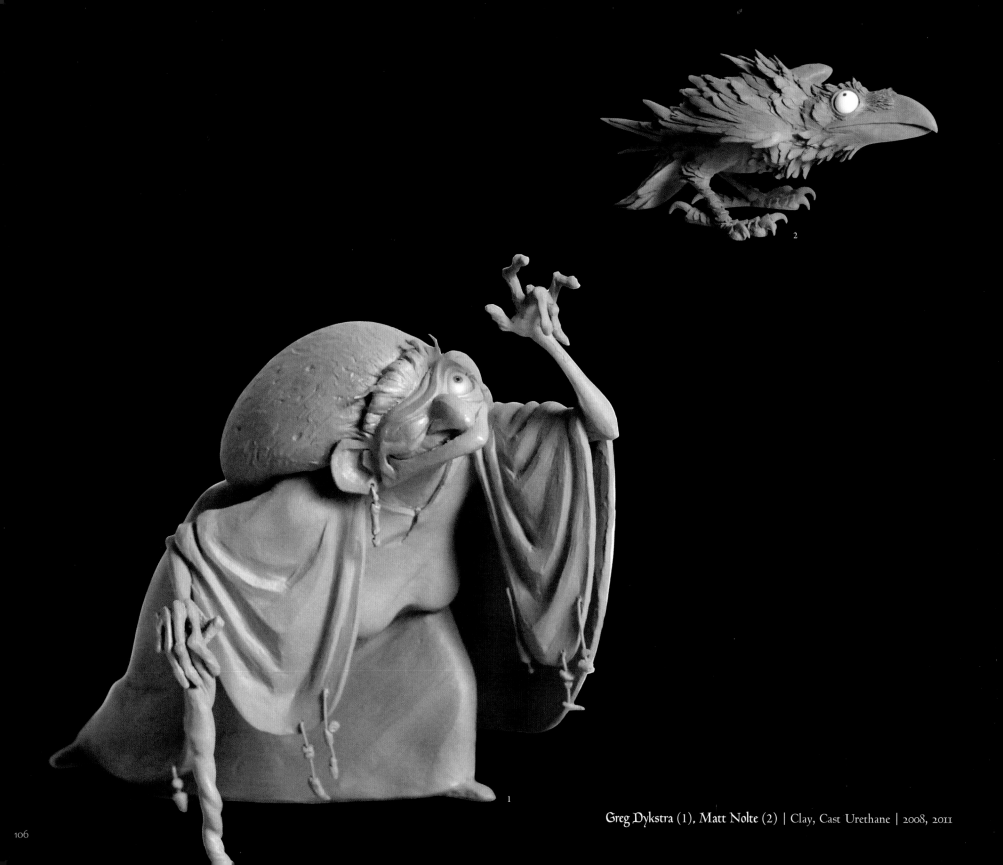

Greg Dykstra (1), Matt Nolte (2) | Clay, Cast Urethane | 2008, 2011

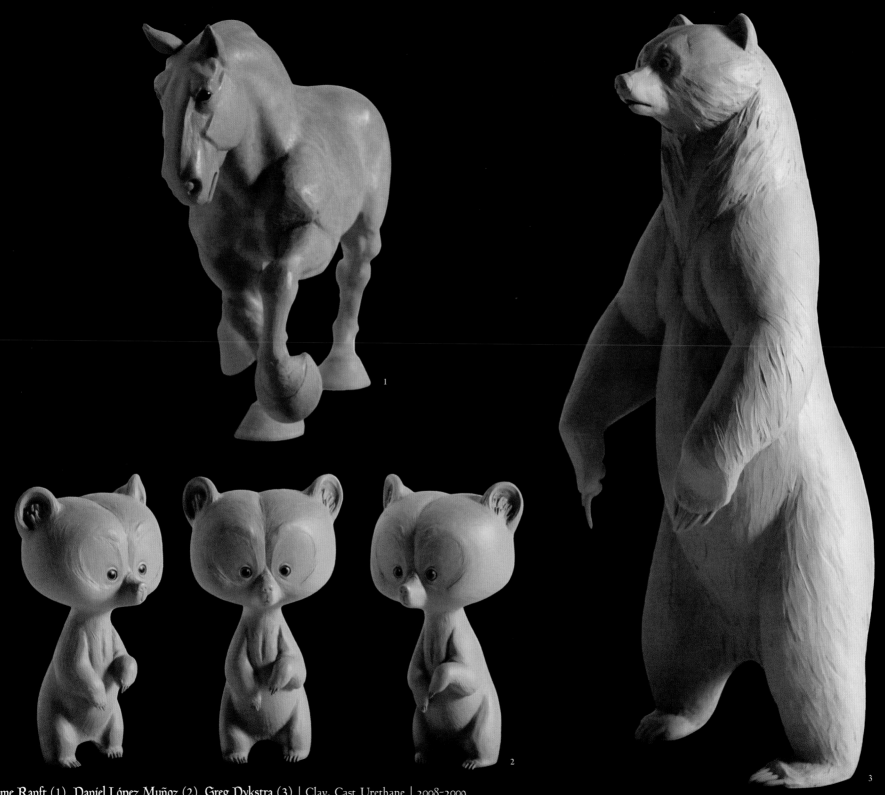

Jerome Ranft (1), Daniel López Muñoz (2), Greg Dykstra (3) | Clay, Cast Urethane | 2008-2009

SECTION TWO
STALKING THE BEAR

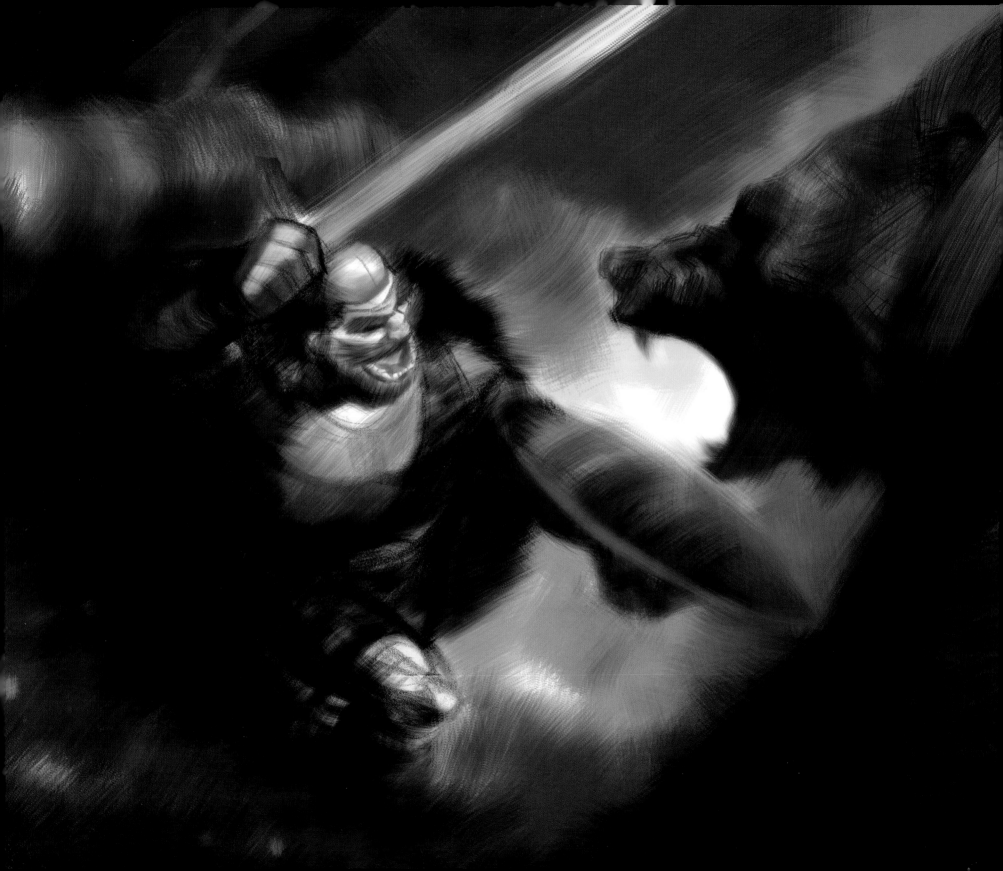

CHAPTER FOUR
FIGHTING WITH BROADSWORDS

*B*rave explores different kinds of transformations: physical, emotional, and magical. As the directors search for the best way to present the story—adding, subtracting, and tweaking—every other department has to adapt to the newest version. From production design and storyboarding through modeling, rigging, animation, effects, texturing, and lighting, everyone in what's called the animation "pipeline" is along for the ride while the editor assembles all the pieces at every stage into an evolving cut of the film. It's a journey that's sometimes more of a midair somersault with a couple of backflips thrown in.

The story is the backbone of an animated movie. Beginning with the film's green light, the work of the story artists continues all the way through the production. While the popular current perception is that "it's all done by computers," all story artists actually do draw. They may draw digitally onto a screen that stands in for paper using a special pressure-sensitive pen, but the result has the same line qualities and sweeps of tone that they could elicit from a stub of crayon. The technology's different, but it's still drawn one panel at a time, hundreds of panels prepared for each sequence, which lasts only a few minutes on-screen.

Via the story process, *Brave* is put together and taken apart again and again, over and over, through year after year of its production in the quest to make it the best film possible. It's a constantly shifting dynamic. Shifting and dynamic also mean changing; every story artist, including *Brave*'s, works with the knowledge that each panel of every scene generated has to be the very best while at the same time completely disposable. Like cameramen, they stage the scene; like screenwriters, they often write the dialogue and create the action; and like actors, they elicit performances from their characters. But in the story artist's world, each mini-movie he or she finishes is inevitably pulled apart each time his or her work is shown. Under a good deal of pressure (and keeping in mind that not all pressure is a bad thing) they juggle drawings delineating action, mood, pacing, the needs of the bigger story, the need to make it all fresh and entertaining,

Steve Pilcher | Digital | 2006
Pages 108-109: **Noah Klocek** | Digital | 2009

and the need to make it read—to make their drawings immediately recognizable as the film's characters in a specific situation. It's a tough job.

Brian Larsen went on one of the Scotland trips as a story artist; at that time, Steve Purcell was *Brave*'s head of story, the supervising story artist who oversees the story crew in much the same way a production designer manages the art directors. When Purcell was later promoted to co-director, Larsen was asked to step into his role as the story supervisor. A veteran from years in the trenches with his hard-driving friend Mark Andrews, Larsen knew the drill. Citing Michael Arndt, the Academy Award-winning screenwriter of *Toy Story 3*, Larsen recalls, "Michael says, 'Story is like building a house. Except that every two weeks, somebody comes in and throws a grenade at it, and it blows up. And whatever's left standing is what you keep working with.' It's hilarious to think of it that way, because it's this precious thing that you're building, but at the same time somebody comes in and tears it down. But then you look at it and say, 'Okay, that works. That wall stayed. Good. I can build off of that wall and the rest of the stuff doesn't need to be there.'"

As is often the case with Pixar's directors, Brenda Chapman and Mark Andrews started their careers as story artists, and though their styles of communicating are very different, they both had a firm understanding of how to elicit what they wanted from a story crew. Andrews may, on occasion, have gone about it at the top of his lungs—this is a man with a rack of swords in his office, after all. Chapman might have suggested something a little more quietly, but their goal was the same: to make *Brave* a deeply appealing adventure—traditional, yet fresh in its style and approach.

"One of the hardest things to do in film is to integrate drama and comedy so they don't feel mutually exclusive," observes Story Artist Ted Mathot. "This is especially true in a film like *Brave* that at times is very dramatic but also has humorous moments. Mark was great at infusing the film with comedy, keeping it dramatic when it needed to be, and striking a balance between the two. That is really hard to do."

Larsen adds, "In story, so much is constantly thrown out, brought back, and changed. Mark says it's like alchemy. It's a dash of this, a dash of that. I don't know why, but somehow it seems to work. In a story sequence you have to find the notes of music that are going to build up to a crescendo. Scenes and sequences need to have some type of rhythm and pattern, and ultimately you only know if it's working when you see them together."

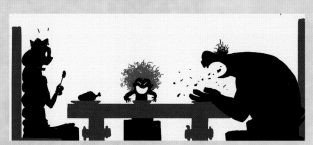

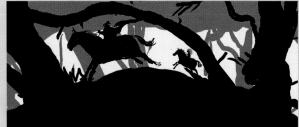
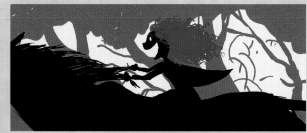

Prologue Storyboards | Louis Gonzales, Brian Larsen | Digital | 2009-2010

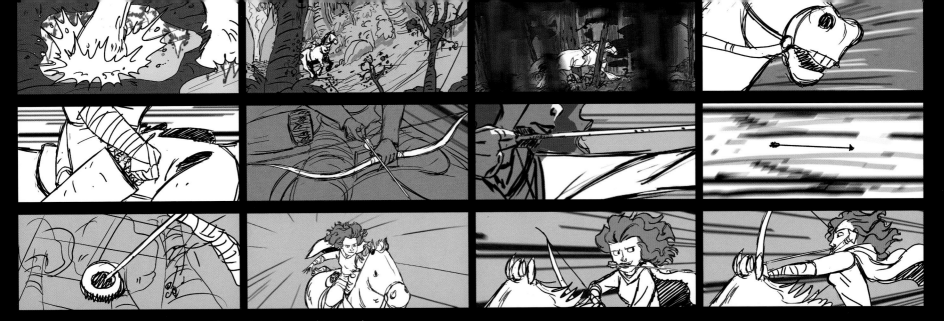

Merida's Opening Storyboards | Emma Coats, Brian Larsen | Digital | 2007-2009

Steve Pilcher | Digital | 2011

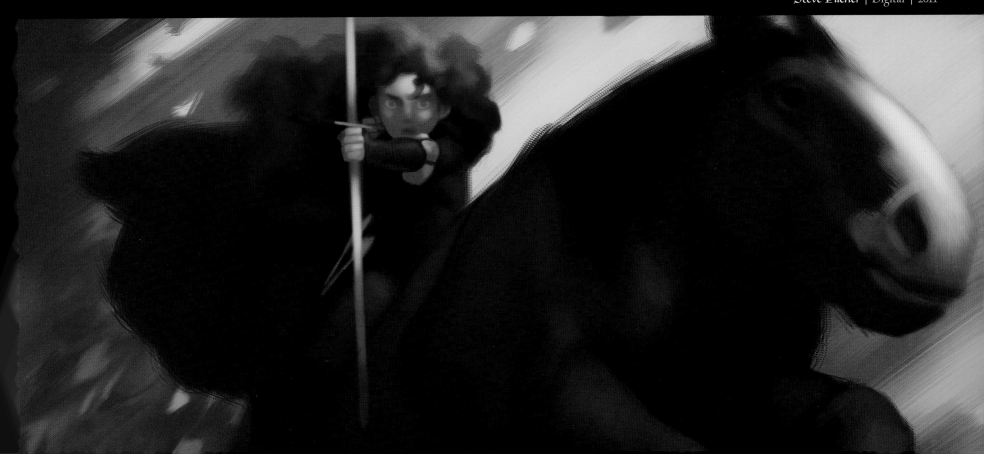

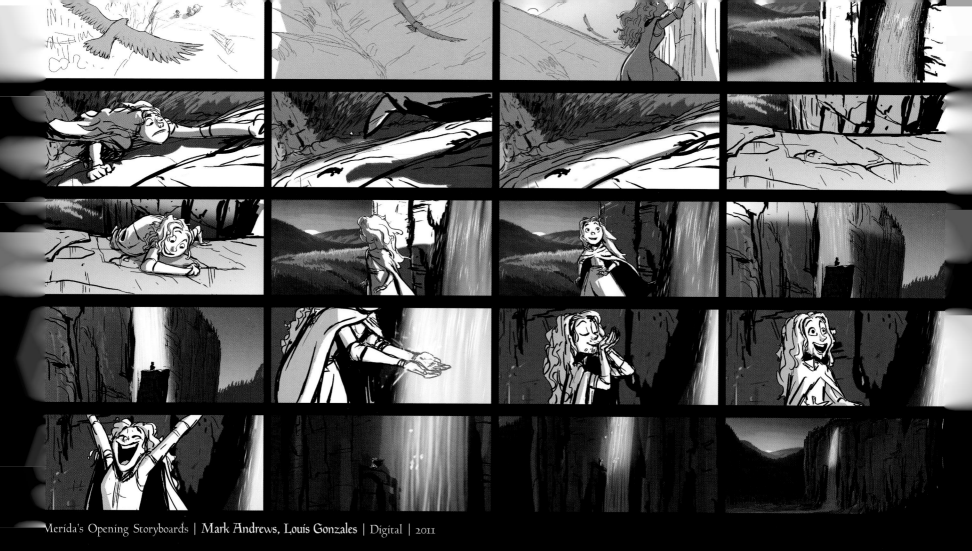

Merida's Opening Storyboards | **Mark Andrews, Louis Gonzales** | Digital | 2011

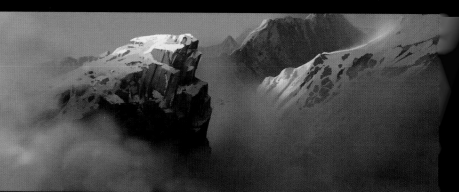

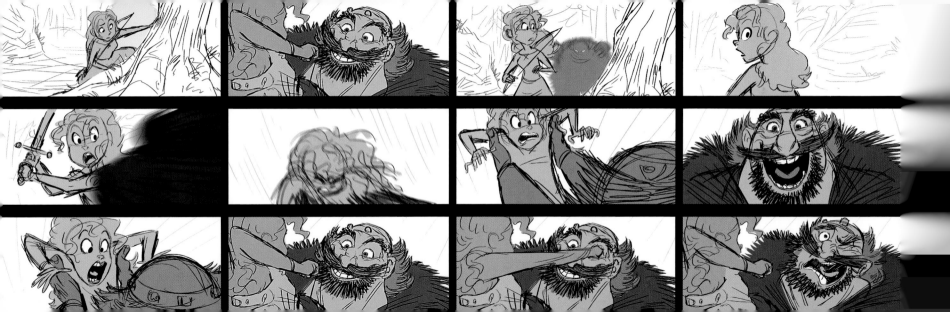

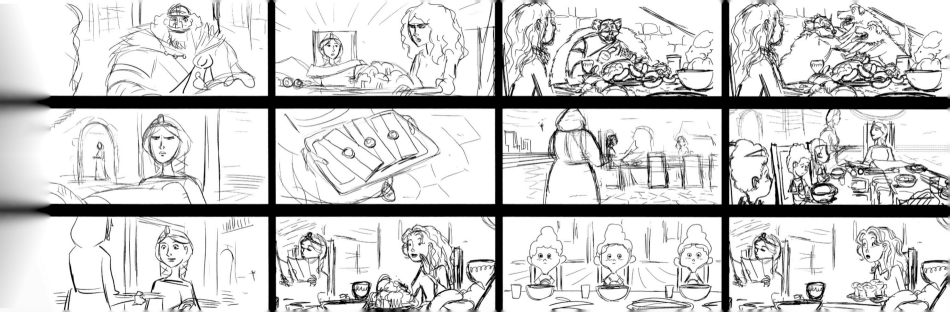

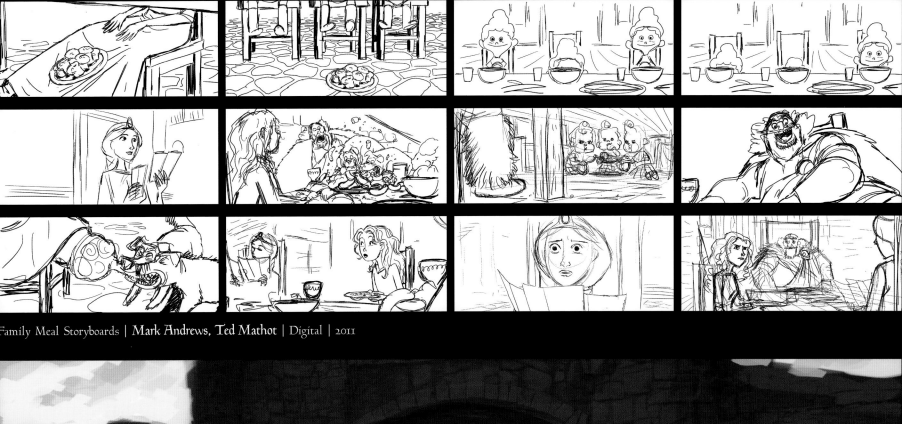

Family Meal Storyboards | **Mark Andrews, Ted Mathot** | Digital | 2011

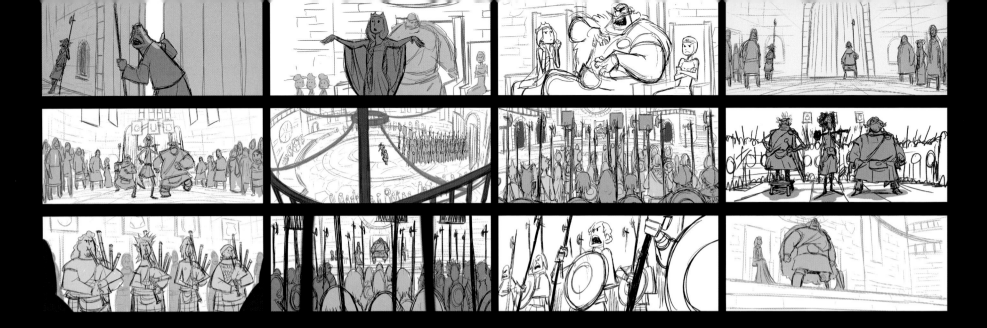

huy Nguyen | Digital | 2011

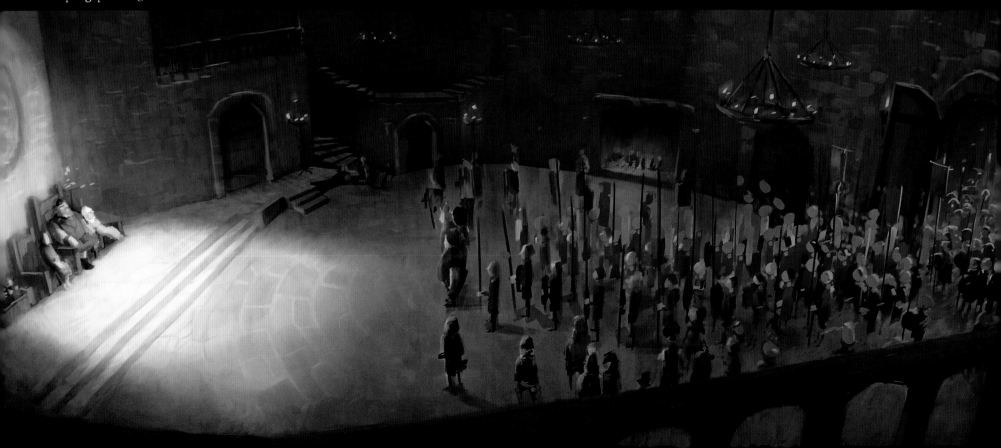

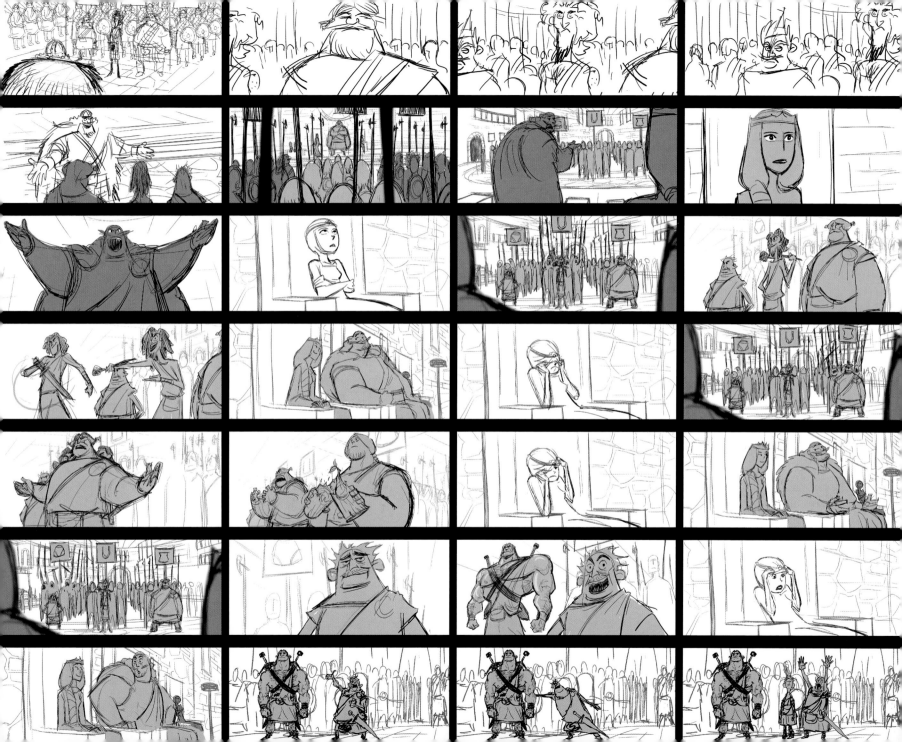

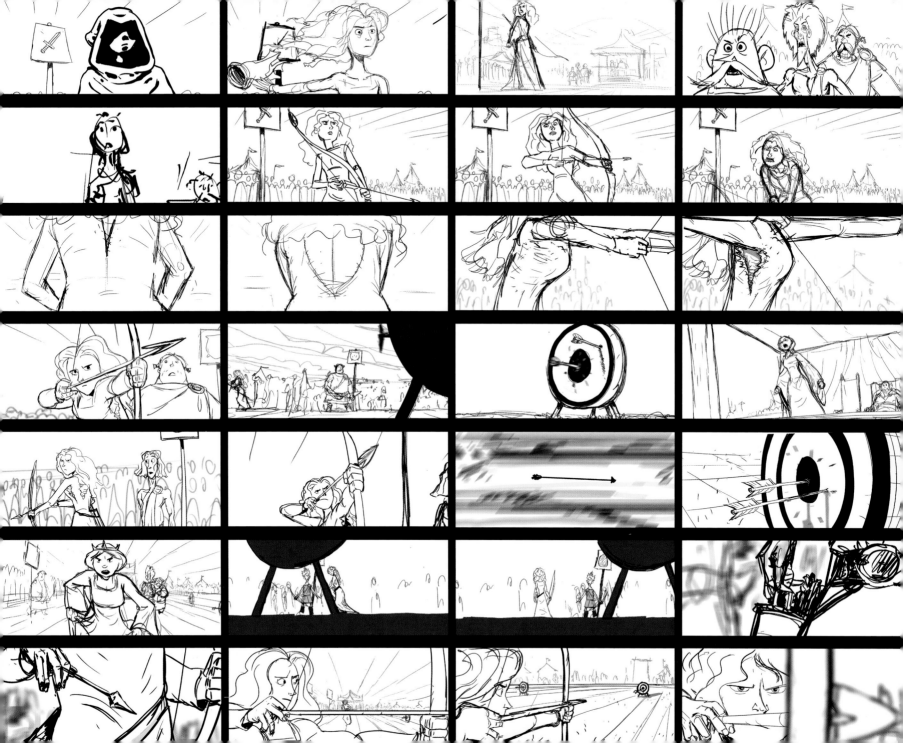

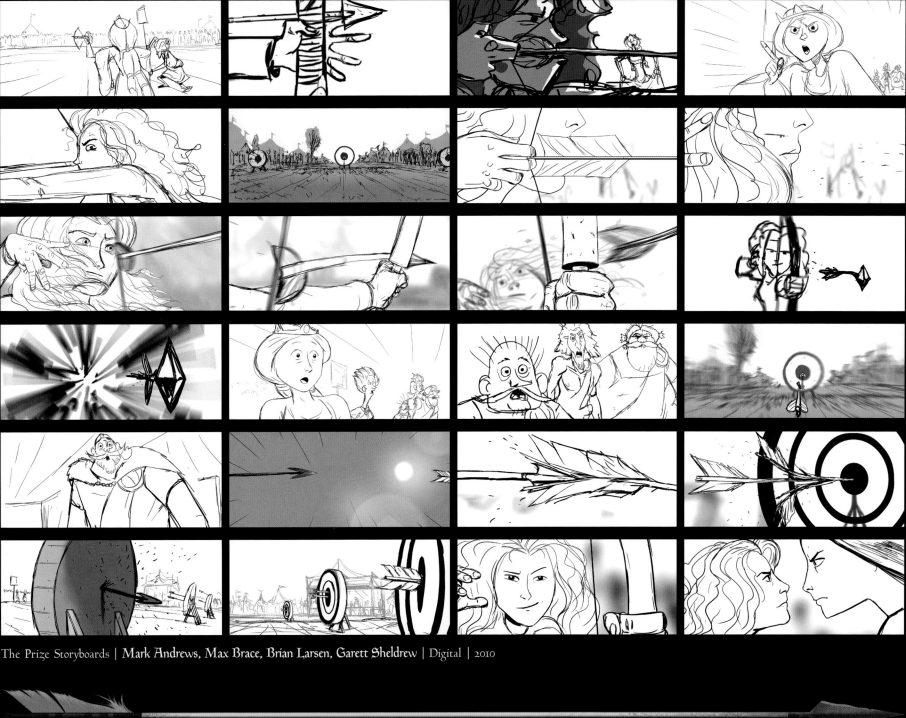

The Prize Storyboards | Mark Andrews, Max Brace, Brian Larsen, Garett Sheldrew | Digital | 2010

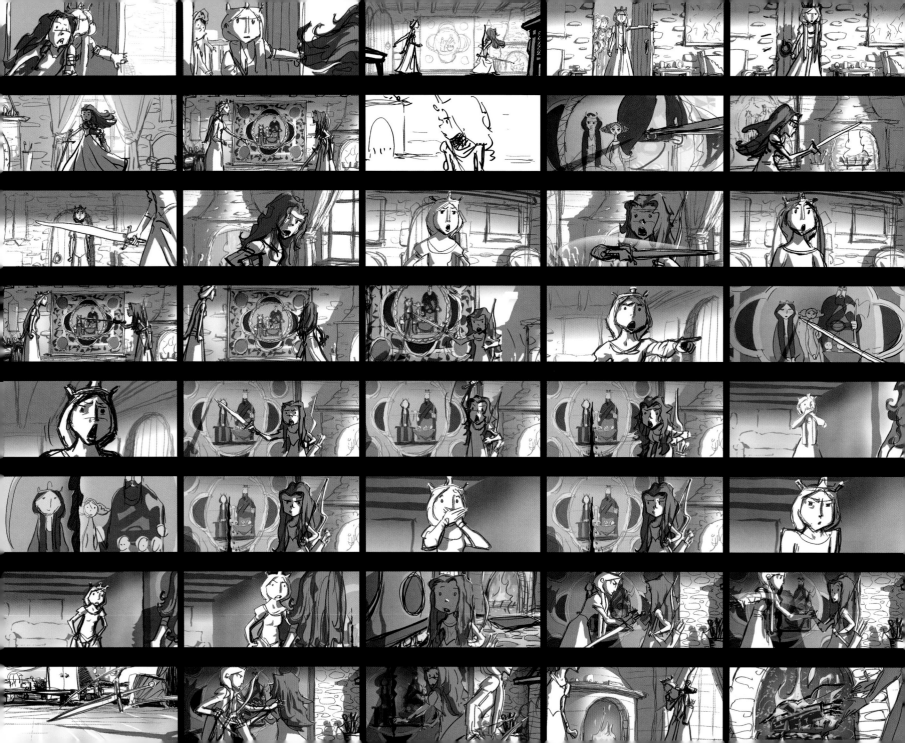

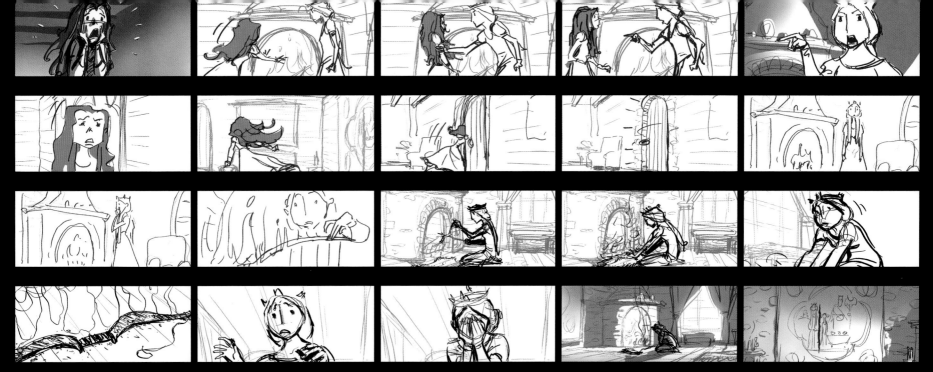

The Argument Storyboards | **Garett Sheldrew** | Digital | 2007-2010

"We have to care enough about Elinor at the beginning of the movie to get us on board with her when she becomes the bear, so we have empathy for her. Even though it's Merida's story and she is in conflict with her mother, we can't hate Elinor at the beginning. We have to open the door a little bit for the audience to understand her."
—Ted Mathot, story artist

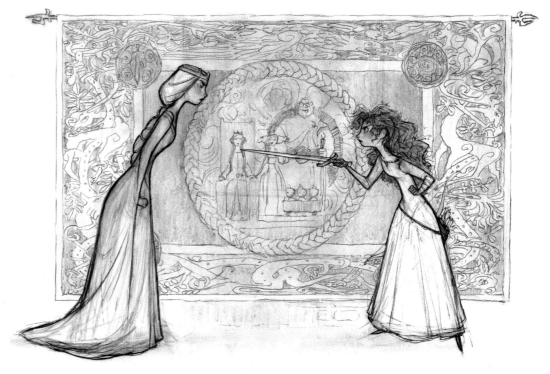

Matt Nolte | Pencil | 2007

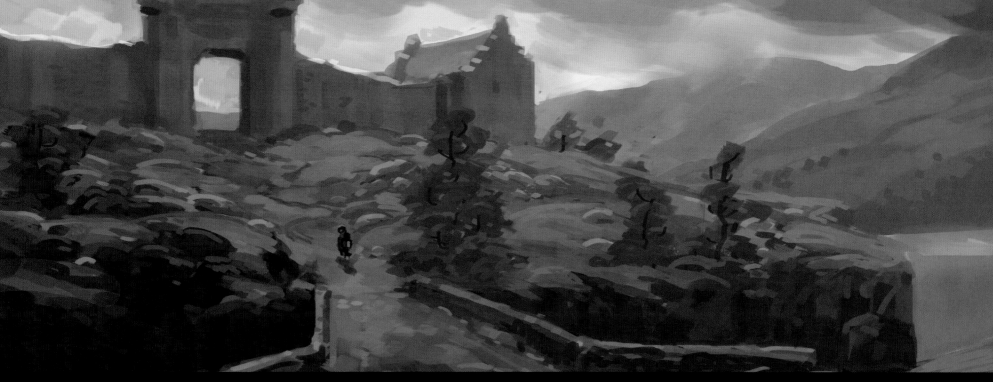

Noah Klocek | Digital | 2011

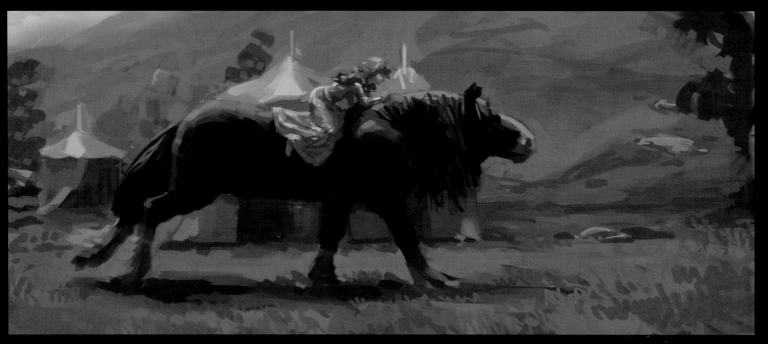

Noah Klocek | Digital | 2011

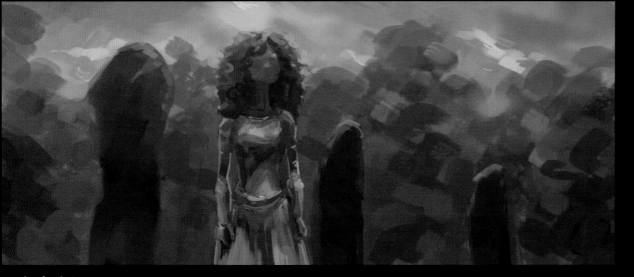

"Merida is crossing from childhood to adulthood. She feels her life is being planned to the nth degree and she doesn't get to be herself. But by the end of the movie, she realizes all those things that her mother makes her do aren't so bad. And when her mom's in her bear mode as Mum-Bear, they have a chance to be together that they usually don't get, time that doesn't have some job or lesson attached to it. They just get to be themselves."
—Mark Andrews, director

Noah Klocek | Digital | 2011

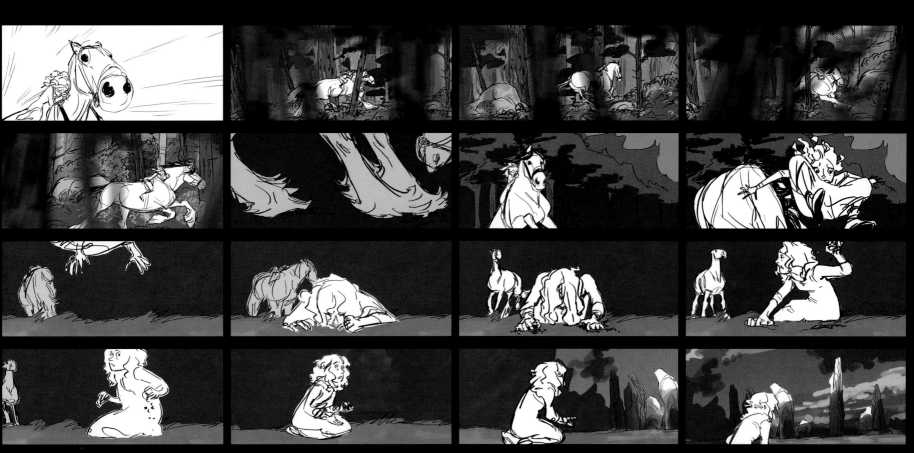

Merida Takes Off Storyboards | Emma Coats | Digital | 2007-2008

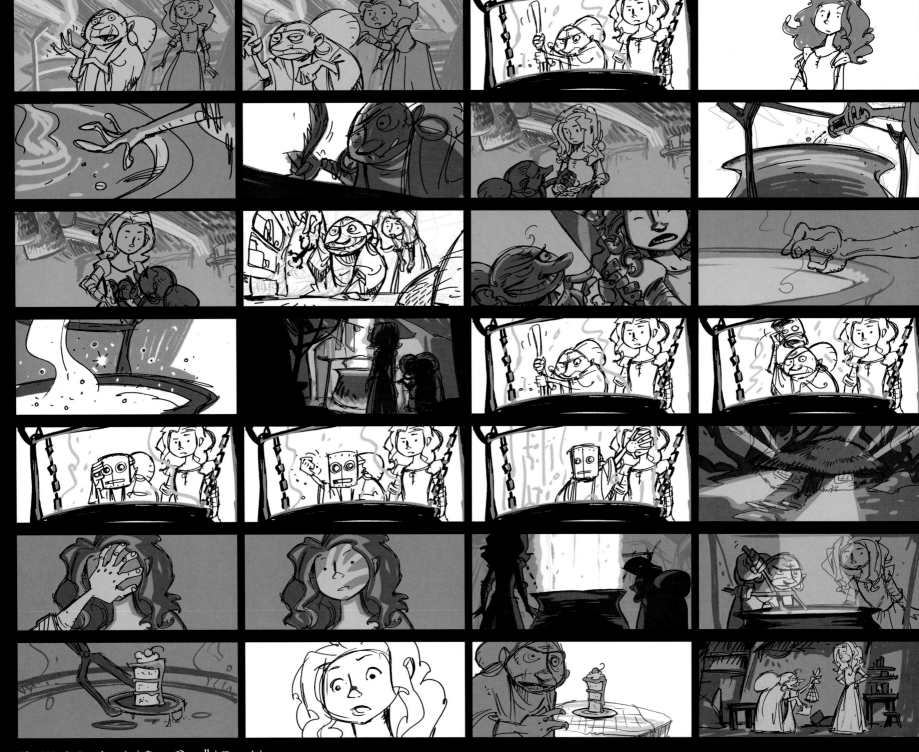

The Witch Storyboards | Steve Purcell | Digital | 2007-2009

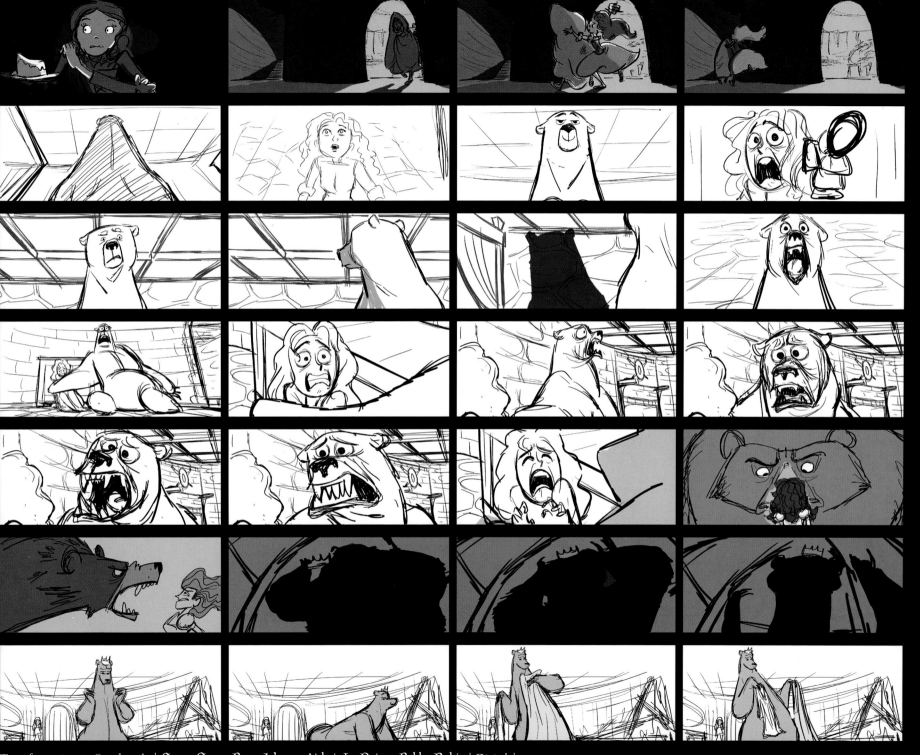

Transformation #1 Storyboards | Emma Coats, Barry Johnson, Valerie La Pointe, Bobby Rubio | Digital | 2007, 2011

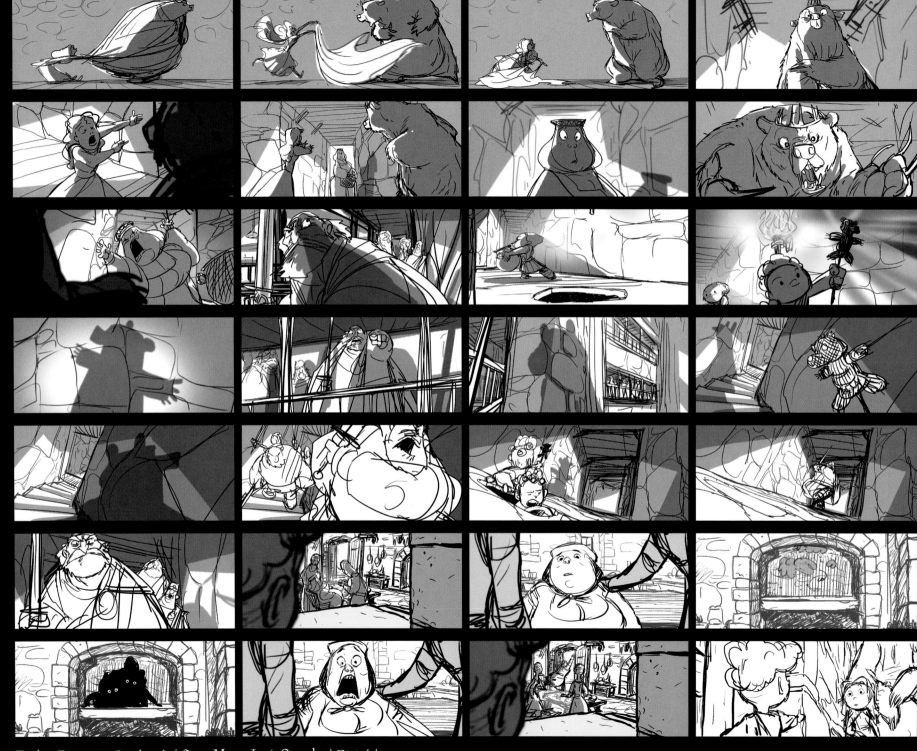

Triplets Distraction Storyboards | Scott Morse, Louis Gonzales | Digital | 2011

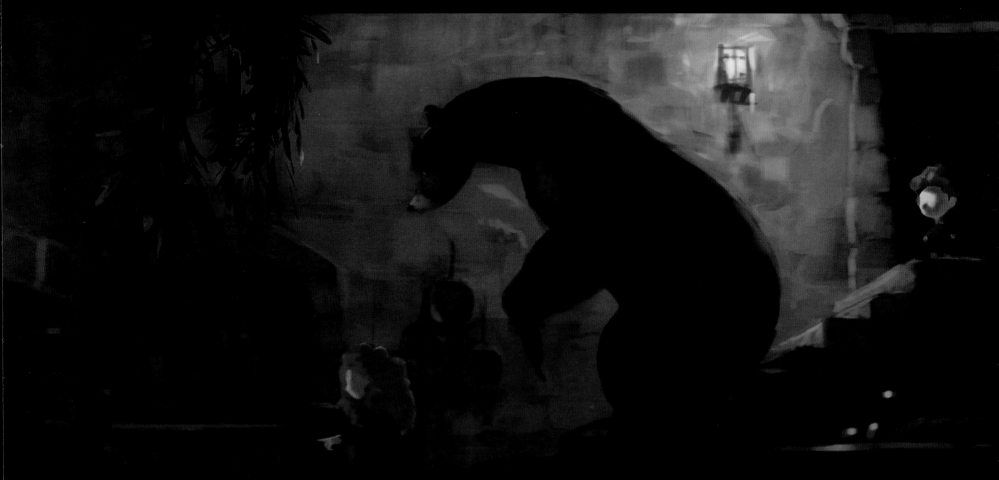

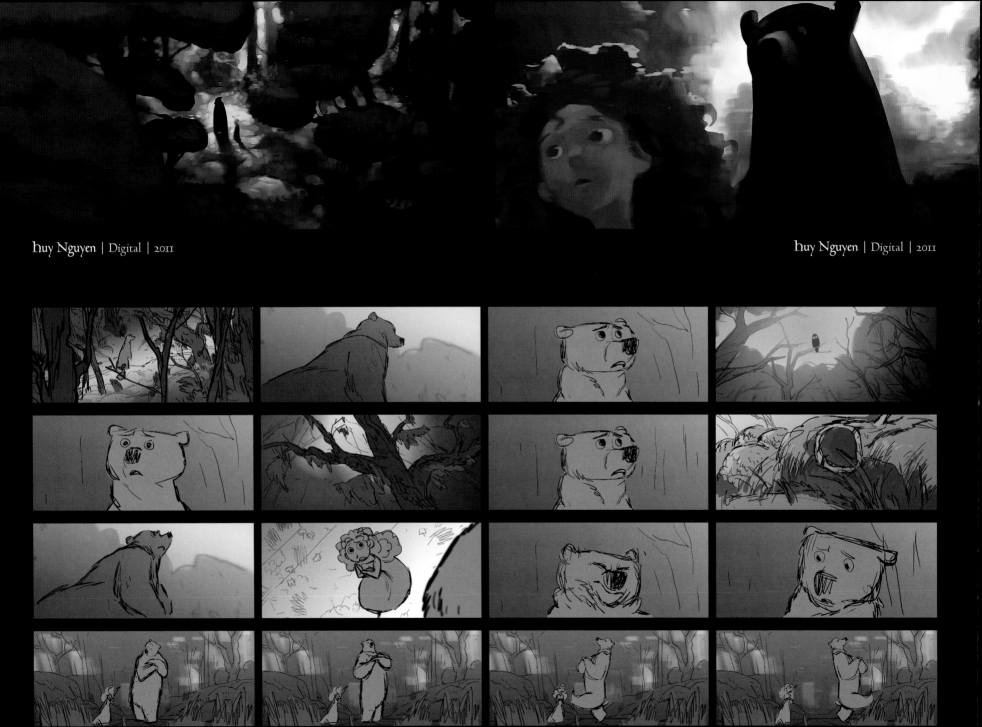

huy Nguyen | Digital | 2011

huy Nguyen | Digital | 2011

Walking Troubles Storyboards | Nick Sung | Digital | 2011

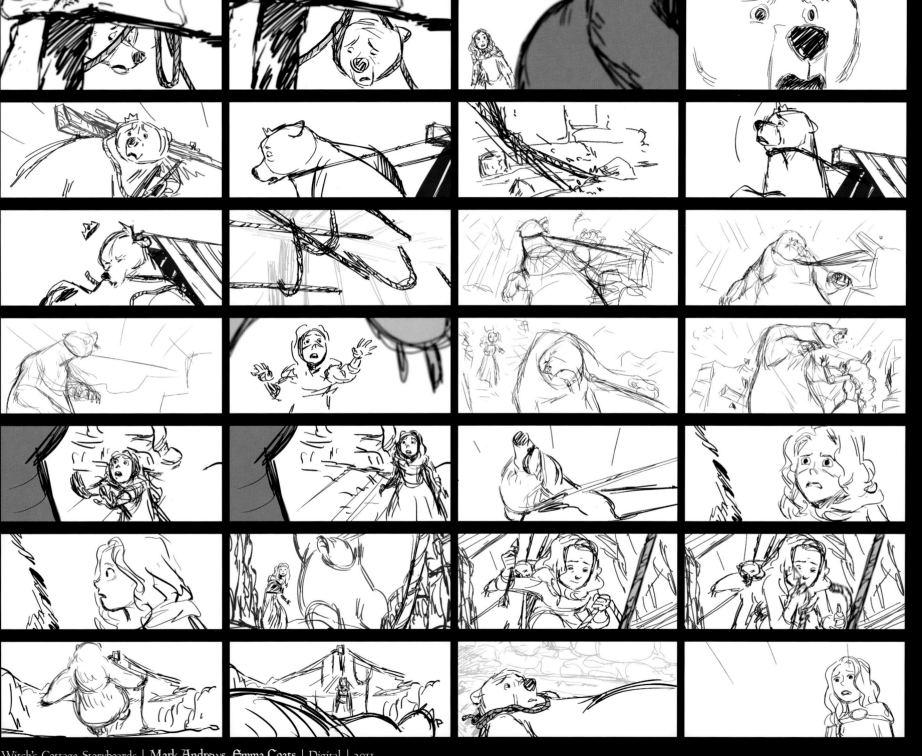

Witch's Cottage Storyboards | **Mark Andrews, Emma Coats** | Digital | 2011

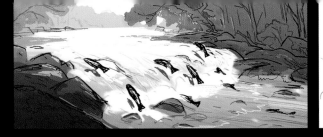

"Fishing with Mum is the midpoint. That's the happiest moment. They're not chased or hunted; they're just experiencing each other. The audience feels that they're getting along, and everything's good, no problems in the world. Just the fact that her mom's a bear."
—Mark Andrews, director

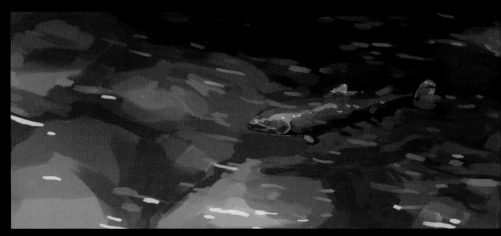

Noah Klocek | Digital | 2011

Noah Klocek | Digital | 2011

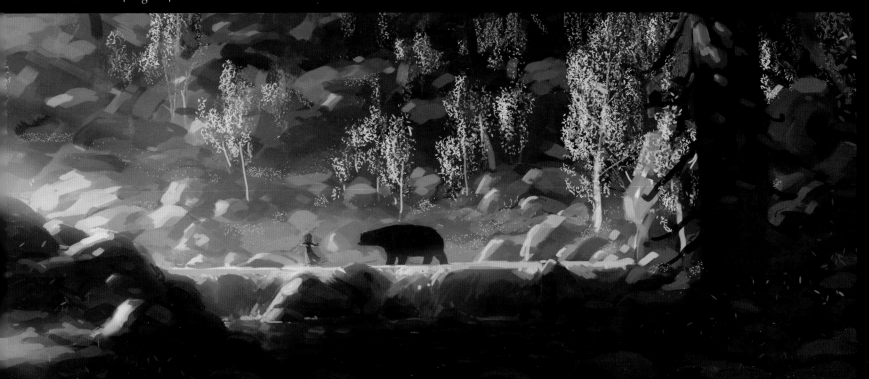

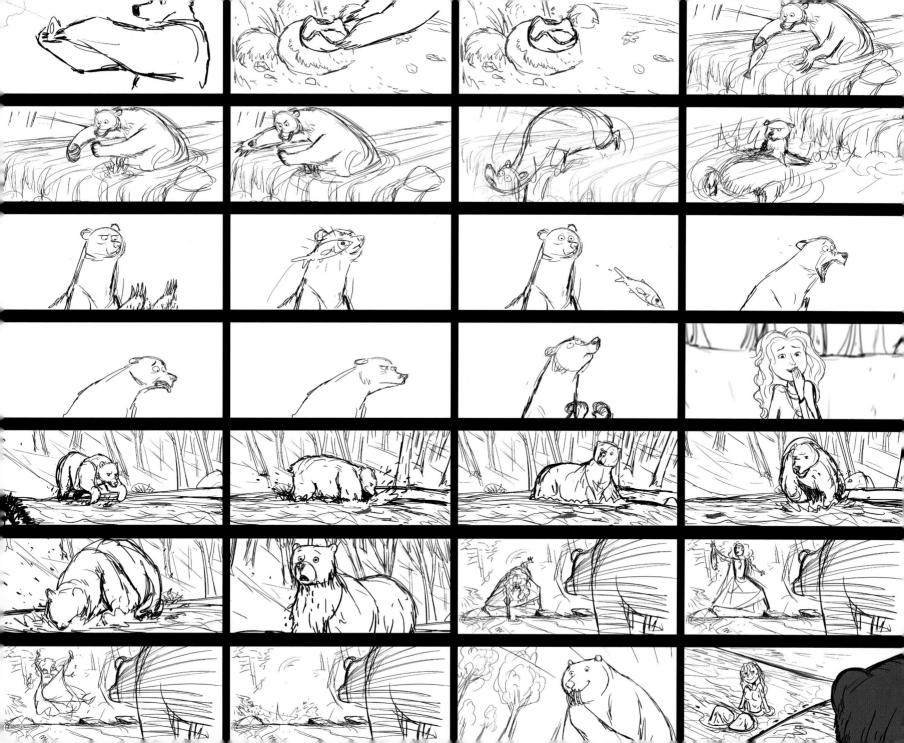

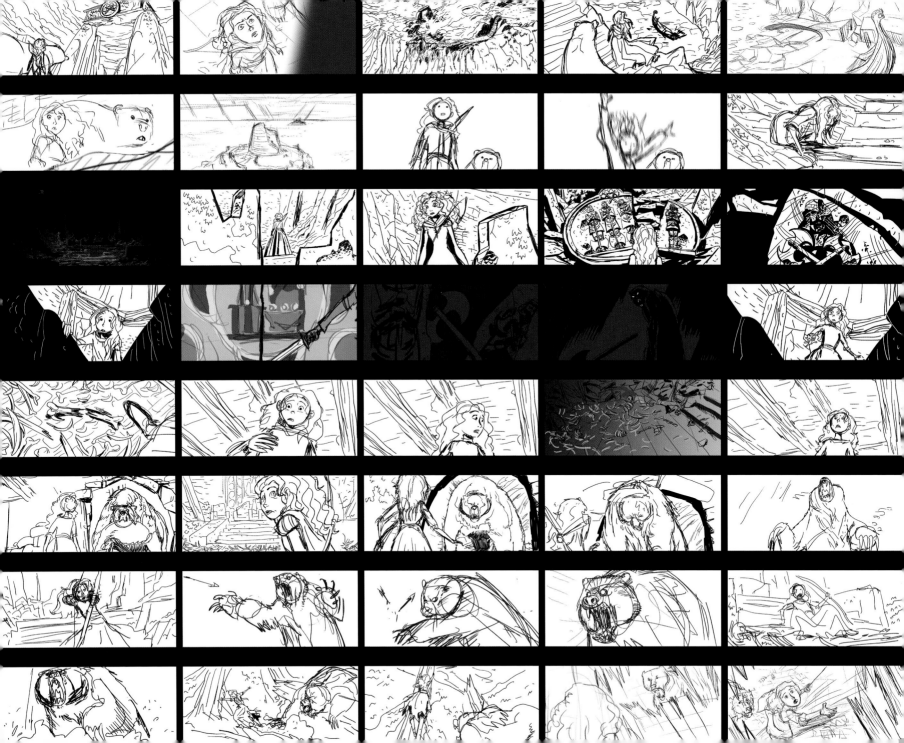

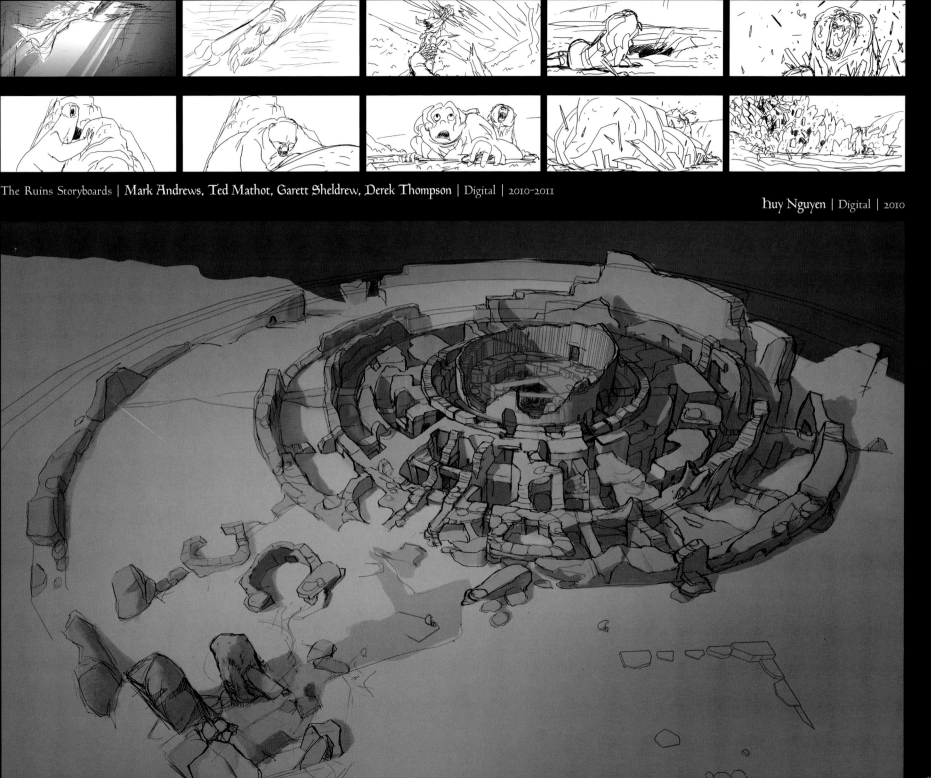

The Ruins Storyboards | Mark Andrews, Ted Mathot, Garett Sheldrew, Derek Thompson | Digital | 2010-2011

huy Nguyen | Digital | 2010

137

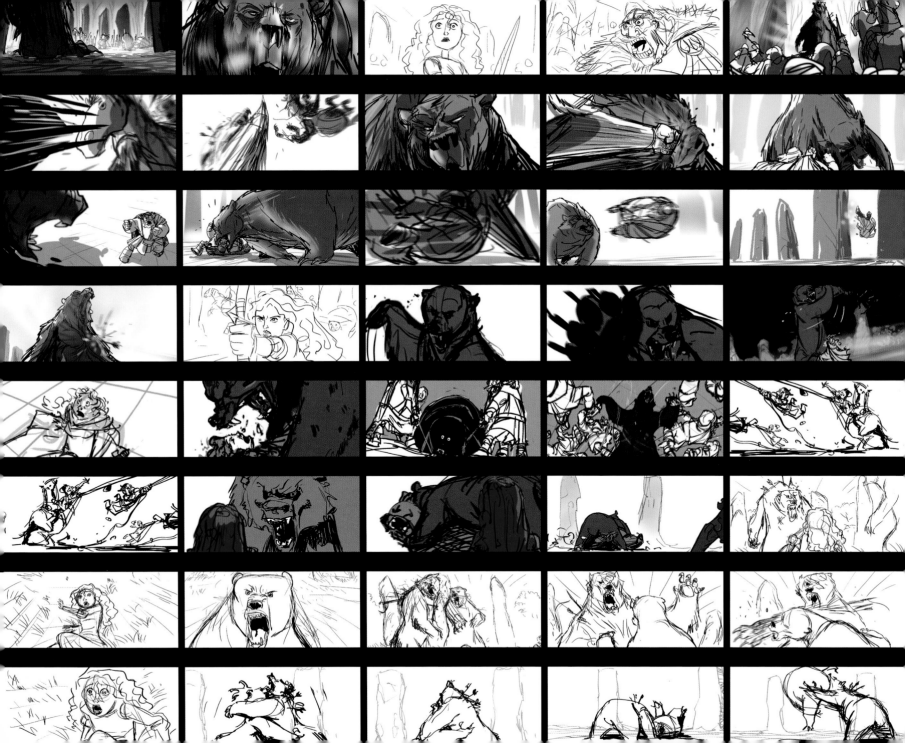

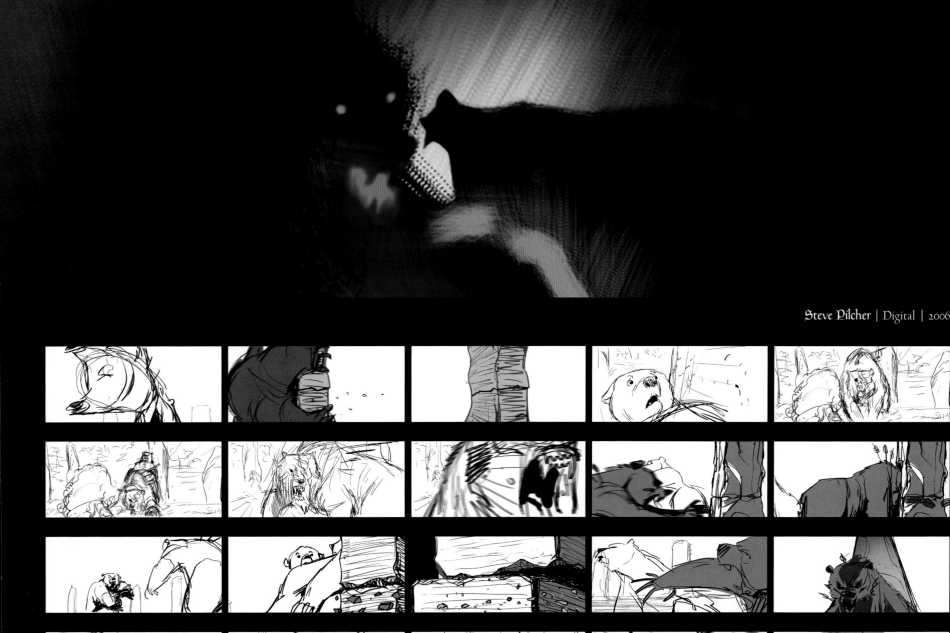

Steve Pilcher | Digital | 2006

Bear Fight Storyboards | Mark Andrews, Craig Grasso, Scott Morse, Garett Sheldrew | Digital | 2007, 2011

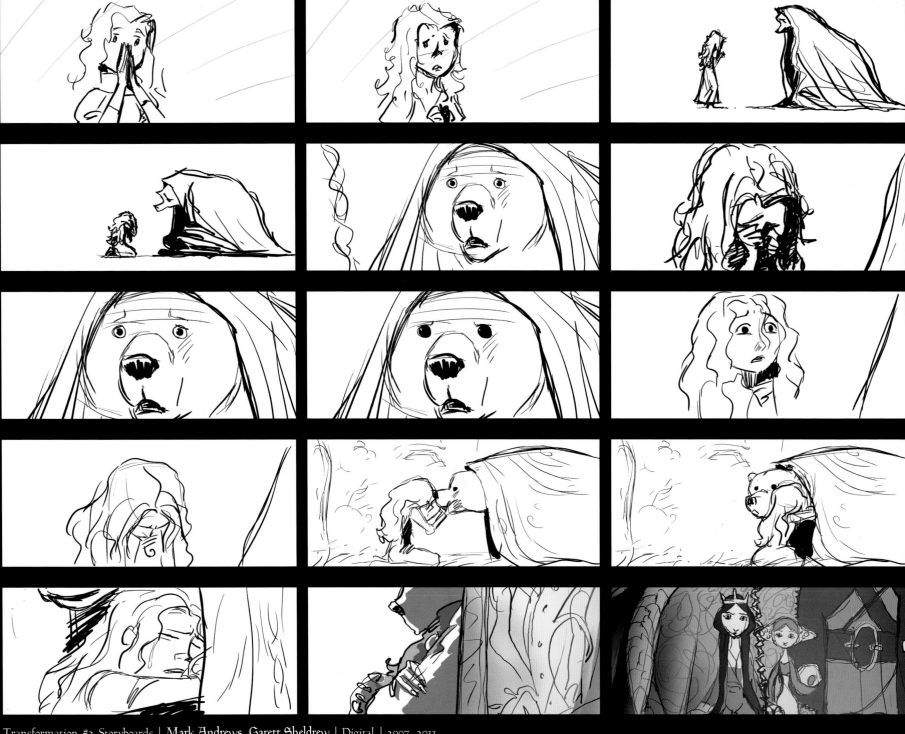

Transformation #2 Storyboards | Mark Andrews, Garett Sheldrew | Digital | 2007, 2011

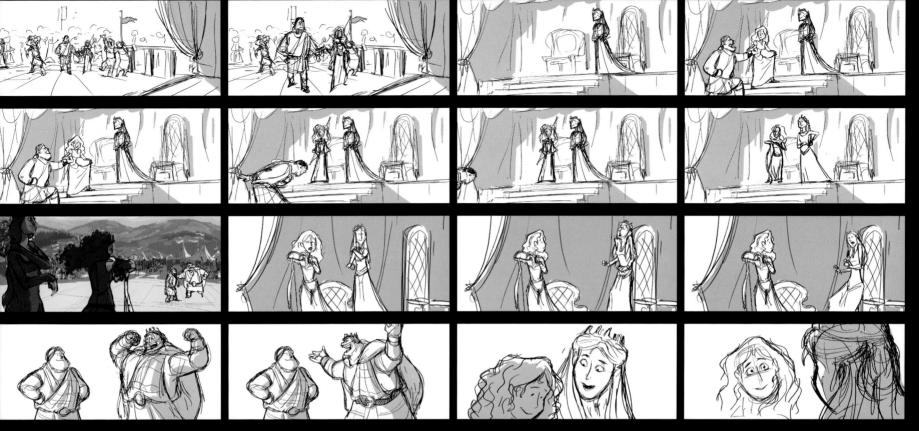

Epilogue Storyboards | Nathan Stanton, Craig Grasso | Digital | 2007-2008

huy Nguyen | Digital | 2010

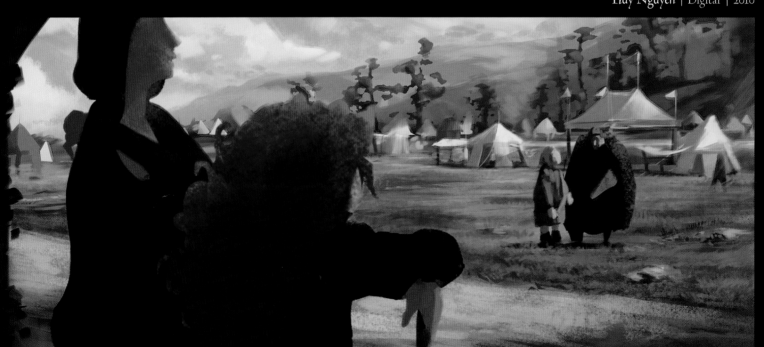

COLOR SCRIPT

Steve Pilcher, Noah Klocek, Huy Nguyen, Armand Baltazar | Digital | 2009-2011

DunBroch Clan Emblem | **Steve Pilcher** | Digital | 2009

"Color scripts visually orchestrate the overall lighting, color, weather, and time of day in an animated film. They are always evolving and our film is no exception. We had to discard around 90 percent of the work on our color script when the snow was cut from the movie. Like any creative endeavor, it can change dramatically right up to the last minute, so we rework it to retain all the beauty we had originally created. It's all part of the filmmaking process."
—Steve Pilcher, production designer

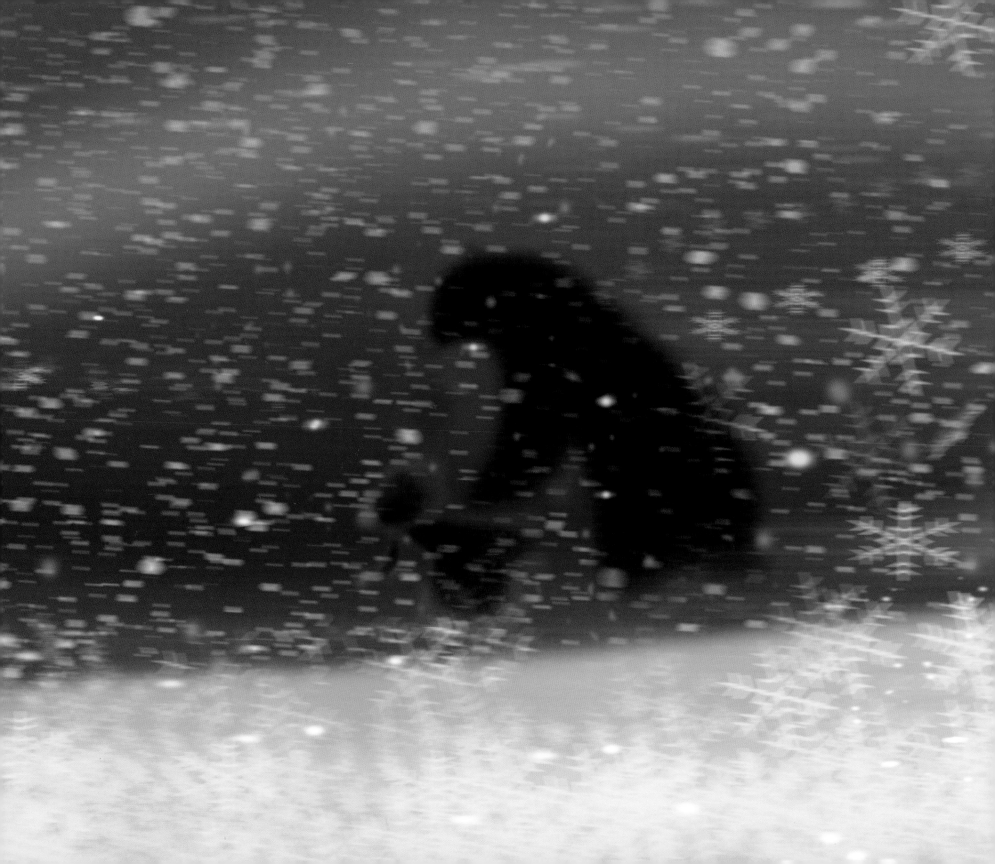

CHAPTER FIVE
TAMING THE ELEMENTS

Alan Barillaro and Steven Clay Hunter are *Brave*'s supervising animators. Two Canadians with a healthy sense of humor, they make a voluble team. Both came to *Brave* after finishing work on what was arguably the Pixar film at the furthest end of the spectrum stylistically: *WALL•E*. To segue from a futuristic world of robots in space and on a desolate, trash-piled Earth to the springy, moss-covered Eden of Scotland with rangy warriors and enchanted bears could have been a bit of shock, but these two and their crew jumped on board with gusto.

Animation is the crown jewel of the process, the place where the performance actually happens, where it all comes to fruition for the film. But Barillaro warmly acknowledges the influence of the production's design on the animation: "The best part of preproduction is when you can look at the art and be inspired. Pilcher's team set a high bar for every department that followed. Looking at their work brings a healthy combination of being inspired and being intimidated all in one, where you think, 'That is the best thing I've ever seen! I hope we don't screw it up.' Usually on a film, you've got one or two characters that are a particular challenge for you as an animator, but *Brave*'s been enormous in that respect. This is where you want to be as an artist.

"You want those challenges," he continues. "You want to be scared when you join a project. Somehow it feels wrong to us if we already know how to solve all the challenges in a film. This movie has definitely pushed us. We didn't know how to make a bear, or how to deal with the nine layers of clothes on a character, not to mention complex action scenes on horseback. But you want to be in that uncomfortable place where you're pushing past what you've done before. The challenges are endless on *Brave*, but what's great about it is that people rise up to the responsibility in surprising ways, hopefully creating a film that audiences have never seen before."

Once the characters' animation is in progress, all the characters then have to be dressed just as a live-action performer would be, with clothes, hair, and anything else

Steve Pilcher | Digital | 2006

Steve Pilcher | Photographs | 2007

that's a part of their costume and makeup. This is the job of the Simulation department, called Sim for short. Claudia Chung is *Brave*'s Sim supervisor. On *Brave* the Simulation department includes three sub-departments. "There's grooming, which is the creation of the hair and fur and the motion that goes with it," she explains. "And then there's tailoring, which is creating all things made of cloth, like the tapestry and all the costumes. Then once they're done with those things, the third component of this department is sending the cloth and hair we create into what's called shot work: the shot technical directors make the hair and clothing move with the characters, move in the wind, and anything else the shot calls for. At first look, you may not usually notice it consciously, that's true," Chung continues. "But you don't want a naked, bald character! These things are a big part of the character's design, especially on *Brave*. If there's any film where you would notice the cloth and hair, it would be this one. They affect how the characters act, just like they would in live action. Put on a kilt or a long dress and you'll find you move differently. Same with having long, curly red hair. The challenge but also the fun is for the animators to work with us—to have our two departments linked up."

Chung bubbles over with enthusiasm; for her, working on *Brave* was a dream assignment—and as with others in key supervisory positions, it was her first opportunity as a supervisor of so many people. What she brightly describes as "fun" boggles the mind of Director Mark Andrews: "The Sim work for clothes is just unbelievable. And the hair! The technology keeps getting pushed and pushed and pushed, so every film's a step up from the last one. What we've done on *Brave* goes even further than what we did with the humans on *Ratatouille* and *The Incredibles*. It's amazing."

The Witch's bubbling cauldron, the roiling waters of Scottish rivers leaping with fish, and the weird, ethereal wisps are all the work of David MacCarthy's Effects department. His drily bemused delivery gives way to bright intensity as he describes the challenge of creating more water for a Pixar film than has been done before, *Finding Nemo* notwithstanding. Those scenes were mostly set under the ocean, while *Brave*'s takes place aboveground and in the middle of quite a bit of movement. "The rivers in Scotland are not placid," he explains. "They roil, and foam and run over rocks. If you look at the body of work that we've done before, the

rivers were either falling—as in the case of *Up*'s waterfall—or fairly still. In *Brave* we really wanted to push the fact that this water was different, that it flows from an ice runoff."

Interestingly enough, water is one of the most difficult effects that is tackled by an animated production. It's tremendously complicated, it's expensive, and it's notoriously time-consuming to create. So it must be not only absolutely necessary for the film, but carefully planned out once it's on the agenda. Animating water in a movie is something that the audience takes entirely for granted as being the most natural thing in the world; irony abounds in the fact that it's one of the most difficult to achieve. And it involves a skill at animating that can't be achieved via shortcuts, as everyone knows what water moves like and the human eye can spot irregularities immediately if it's not done just right.

"In effects you have to have a perfect sense of timing," notes MacCarthy. "You don't need to have the knowledge of an animator with regards to the emotional aspect of the acting, but you have to have the timing of an animator. And you have to have the creative eye of a lighting artist." A healthy sense of humor coupled with the patience of a saint doesn't hurt either.

All the action in *Brave* takes place in a three-dimensional world. As a result, every "set" must be built and lit in the computer, using much the same approach as in live-action filmmaking—particularly where the lighting is concerned. Derek Williams is *Brave*'s sets supervisor. "Basically it's my job to oversee the big picture of the Sets department—how we're going to liaison with the other departments, and figure out the things that we need," he explains. "For me, set dressing is really my forte. That's what I was first trained in." Williams is a native of Britain with a sister residing in Scotland, and before he began work on the film he took advantage of a holiday visit with her to take photographs of the Highlands and forest. He used these as reference, but stresses the importance of deviating from the reality—no matter how beautiful—to achieve the absolute best "stage" for the film's action.

"There are two stages to our work," he continues. "The first stage is creating environments for layout to go into and actually shoot. The second

Steve Pilcher | Ink, Digital | 2007

part of our job is that once the sequence has gone through layout we reassess every single shot, and figure out how we can plus it by modeling, shading, and camera dressing. How do you make a forest interesting? Can you make it look different from shot to shot? It's interesting how much negative space we create in our sets, by what we choose not to include. Instead of having just a wall of trees we take some of them out of the frame. Those open spaces create more visual interest."

The movement of the camera and the mood of the lighting are achieved through careful choices by the Directors of Photography for both Lighting and Layout. On *Brave* these were Danielle Feinberg and Rob Anderson, respectively. In layout, choices have to be made from an almost infinite number of placement options for the camera. Fortunately for Anderson, Mark Andrews has a well-earned reputation as an artist with a cinematic eye.

"Mark's very comfortable with the camera," Anderson says. "He's interested in seeing different shooting options, but he also has a very good idea of what he wants to see from the start. It's great for us, because it allows us the latitude to say, 'Hey, you may not know, but if we moved the camera left, we'll see something really wicked over here, and if the camera moves like this, maybe we could reinforce that story point.' Yet, when we're done, he really knows what he wants—he's really thought through the sequence before handing it off."

Of the lighting, Feinberg says, "Our tools are set up so that we can work in a much more painterly way, with complete control over where the light falls, the quality of light, and every tiny bit of color. That way we can satisfy any direction desired, any story point needed. The tools are incredibly flexible—you can do almost anything that you want with them." Anderson adds, "You see a lot of films out there with these spectacular shots that do nothing to tell the story; we're very aware of building our cameras to reinforce every storytelling moment of every shot. If you look at the artwork, you will see we have bears and horses that look pretty close to realistic, and other characters that are very caricatured. We have to negotiate that balance on every film and make it all believable. Because it is easy for the computer to be perfect, part of our craft is working the imperfections into everything we make."

"Some of our technical artists are magicians in terms of what they can innovate. The cloth in this film—the level of detail in the weave and the fraying—it's incredible. And large sections of the film take place outdoors in the wind and weather, in a very naturalistic Scotland. Wind, weather, and snow—it's hard to produce that organic, complex world in a believable way. Not photo-real, but always stylized and compelling and convincing and detailed enough to really feel like the weather. Those were the challenges."
—Bill Wise, supervising technical director

Paul Abadilla | Digital | 2010

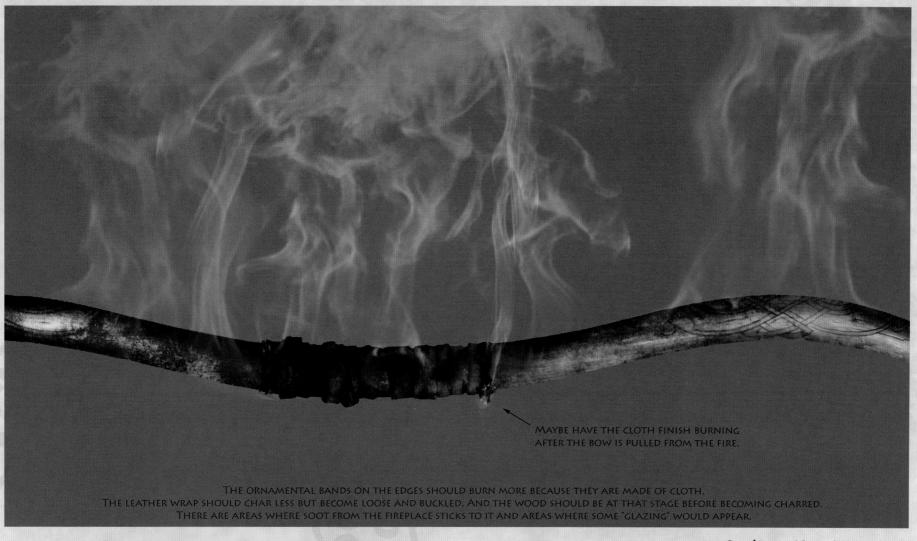

MAYBE HAVE THE CLOTH FINISH BURNING
AFTER THE BOW IS PULLED FROM THE FIRE.

THE ORNAMENTAL BANDS ON THE EDGES SHOULD BURN MORE BECAUSE THEY ARE MADE OF CLOTH.
THE LEATHER WRAP SHOULD CHAR LESS BUT BECOME LOOSE AND BUCKLED. AND THE WOOD SHOULD BE AT THAT STAGE BEFORE BECOMING CHARRED.
THERE ARE AREAS WHERE SOOT FROM THE FIREPLACE STICKS TO IT AND AREAS WHERE SOME "GLAZING" WOULD APPEAR.

Daniel López Muñoz | Digital | 2009

Putting it all together from the beginning to end is Editor Nick Smith—along for the journey at its start in Scotland, and in the screening room when the last shot was finalized. He uses his skill to create a seamless whole from the million various parts of the production: story panels, rough animation, finished animation, temporary tracks of music scoring, the voice performances of the actors, and all the sound effects. Smith gracefully describes the special generosity required of the editor in animation: "As an editor, you try and live through the eyes of the

directors, because you're not making the movie for yourself, you're making it for them. You're trying to realize their vision."

In his way, though, Nick Smith does have a kind of last word on the film, both figuratively and literally, coming as he does from the perspective of seeing the whole picture in all its forms through the years of production, start to finish. "The blessing of animation is that you can do anything," he notes, before adding with a slight smile "and it's also the curse, because . . . you can do anything."

Steve Pilcher | Digital | 2009

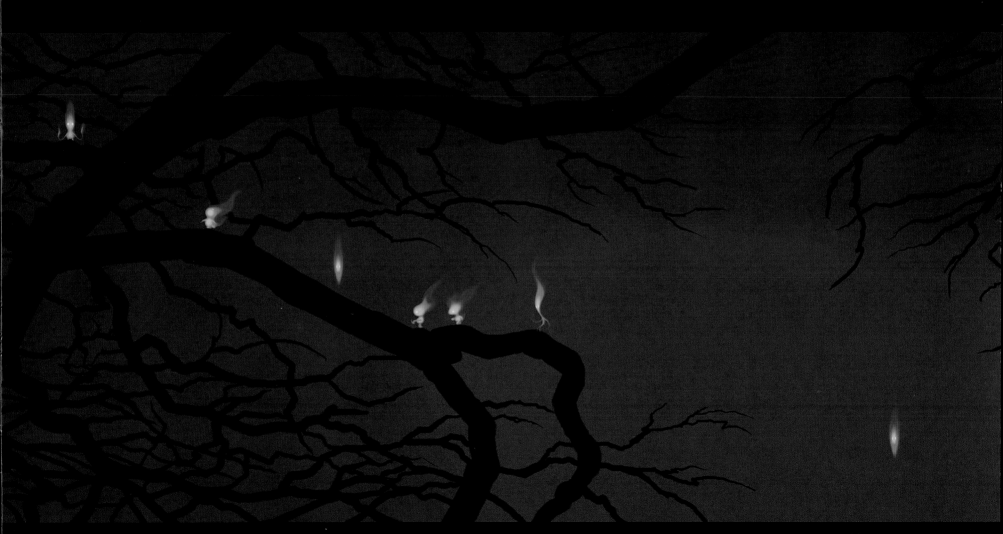

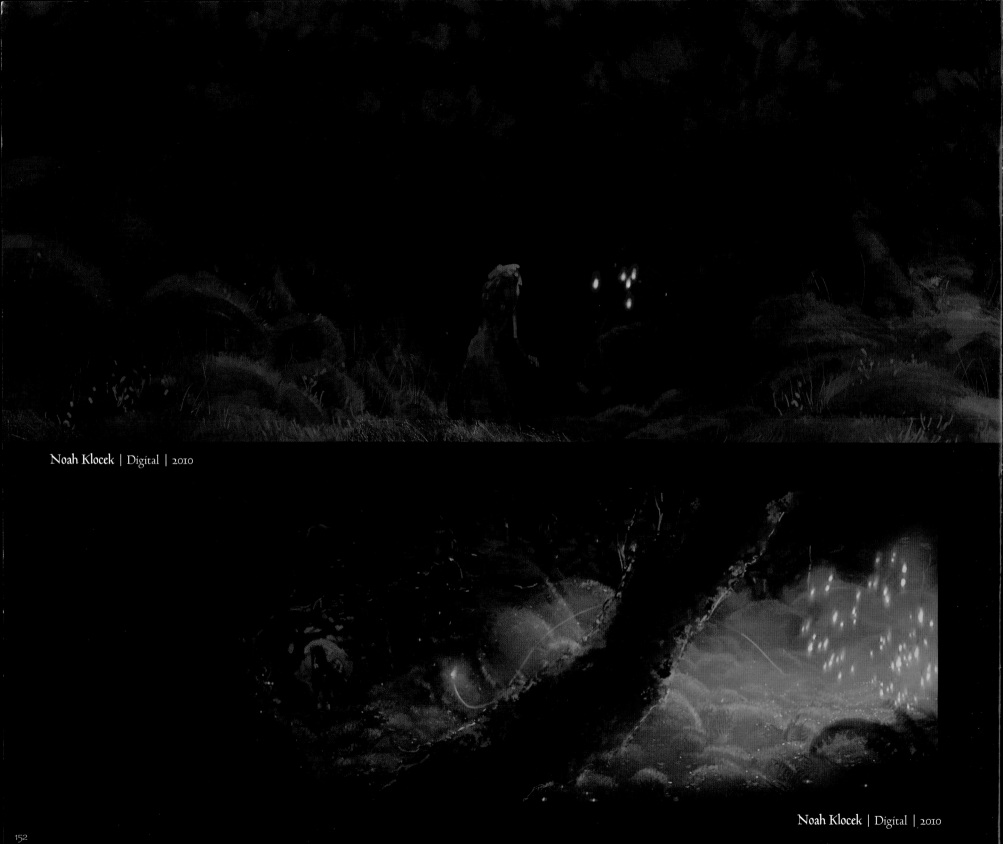

Noah Klocek | Digital | 2010

Noah Klocek | Digital | 2010

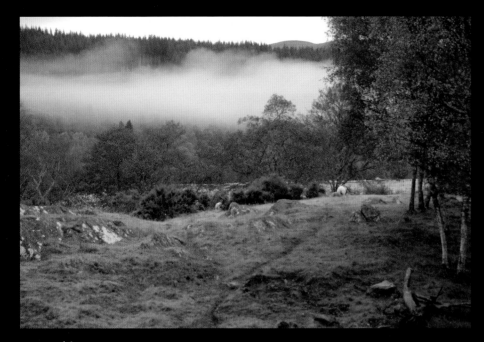

"The forest in *Brave* is one of the most complex things we've ever done. Then we have these extremely complex characters with tons of hair and layers of clothing, on horses that have more hair, riding through the middle of that insane forest. The complexity, when you're trying to bring those shots to the big screen, is mind-boggling."
—Danielle Feinberg, director of photography for lighting

Steve Pilcher | Photograph | 2007

Ernesto Nemesio | Digital | 2006

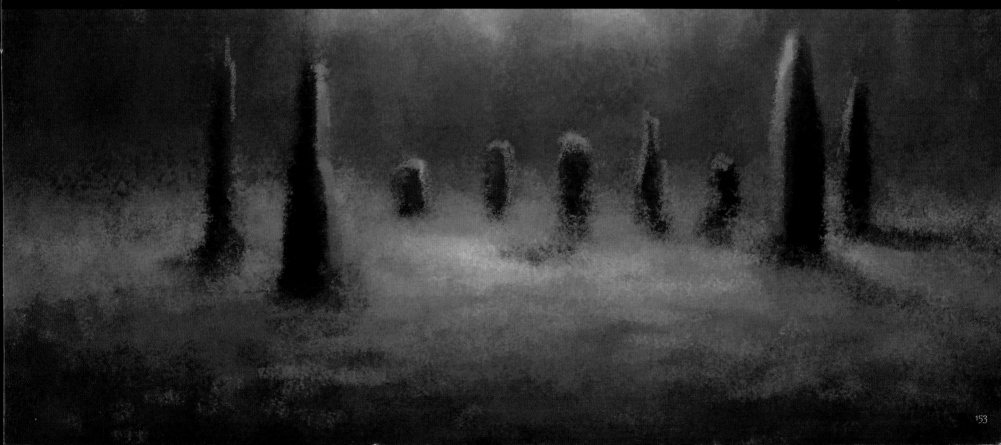

huy Nguyen | Digital | 2011

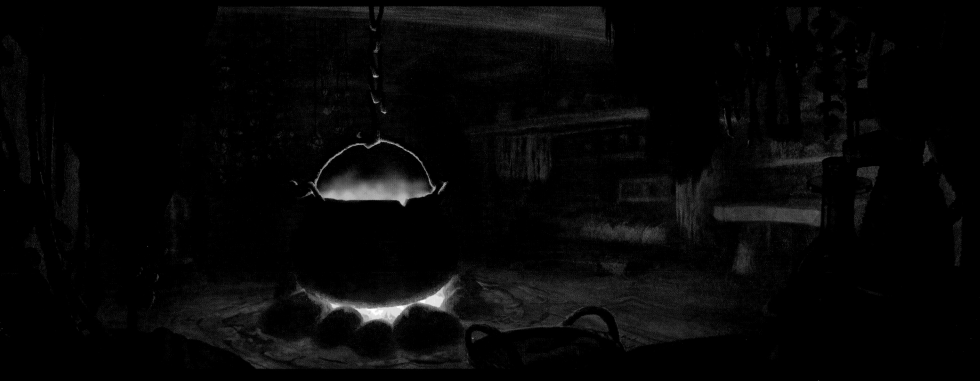

Tia Kratter | Digital | 2008

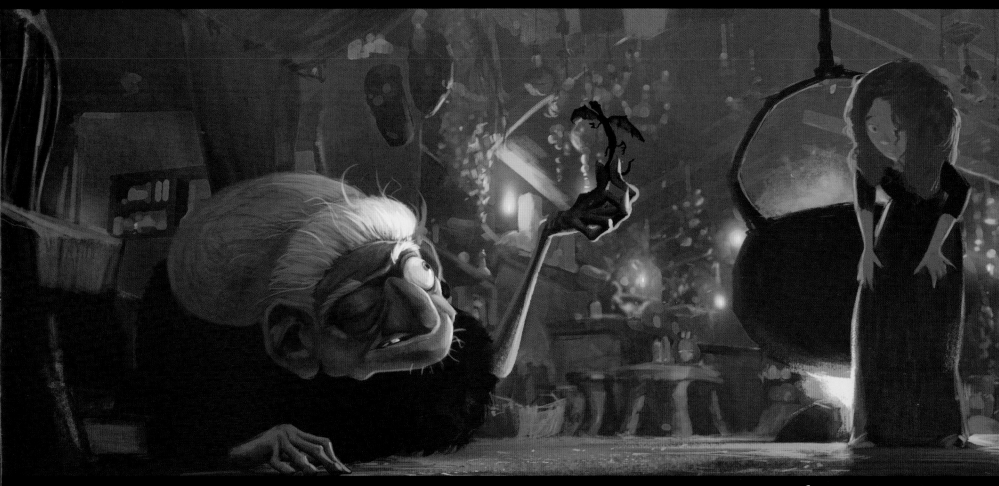

huy Nguyen | Digital | 2010

"On *Brave*, we're creating designs that are more informed anatomically than we've seen in other films—though we're not going for full anatomy or replicating exactly what we see in reality, nor are we going for a more cartooned CG design. We're aiming for somewhere in between. It's difficult, because on any particular character there might be a combination—a nonrealistic feature next to another area that is anatomically correct."

WEAVING THE TAPESTRY

"Mend the bond torn by pride,
lest the outside become the inside."

Stitching Detail | **Tia Kratter** | Pencil | 2007

Pixar is its own culture: a community of artists committed to realizing a common vision of filmmaking. Within that larger culture, the crew of *Brave* had its own life, also one of common aims and shared vision. Though its artists are individuals unique in style, sometimes in taste, and definitely in personality, they operated as a tight, breathing, cross-pollinating unit, wherein one's personal work is always serving a larger vision.

Sets Art Director Noah Klocek notes that there's a "difference between being a professional and being your own artist. There's a misperception sometimes about what we actually do here at Pixar. A lot of emphasis is put on your hand, your actual skill with a pencil—which is valid, as we do need to get everyone up to a certain level—but people who rise to the top are also good at communication and have ideas that are beyond 'I like to draw pictures.' We need to bring ideas to the table that no one else is thinking of. I think that if you only know the mechanics of art and animation, it's a disservice."

"You want to remain passionate about the film, to invest in it and to love it and feel great about it," says Art Director Tia Kratter, the Pixar veteran whose warm, life-affirming influence pervaded *Brave* from its earliest days. "But at the same time you also have to have enough distance to the point where you're willing not to take criticism personally, and able to chuck an idea and think about it in a whole different way. Once you find that balance, then you can function without a lot of the emotional ups and downs that might otherwise happen."

In the final scenes of the story, Merida must mend her mother's tapestry and use it to make her family whole; her love works magic from an ordinary piece of cloth. Under another mantle of a different kind—rendered and stitched together from the efforts of everyone working to his or her fullest potential—a lovely, filmic legend was spun from the art of *Brave*.

Steve Pilcher | Digital | 2005-2010

"The tapestry design was set from the beginning,
when Steve Pilcher did a beautiful study of it. It's
a great representation of all that's in the film—it's
organic, handcrafted, mysterious, it has magical
properties . . . and most of all, it is about a family."
—Katherine Sarafian, producer

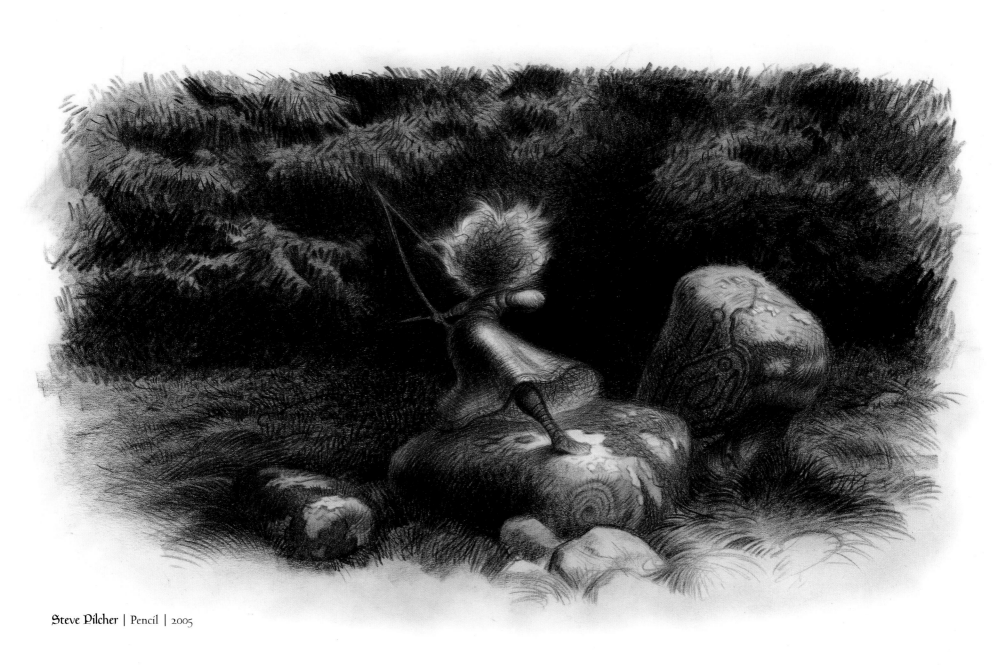

Steve Pilcher | Pencil | 2005

ACKNOWLEDGMENTS

When first approached about undertaking *The Art of Brave* in March 2010, I asked Brenda Chapman what sort of book she would like it to be. As *Brave* was such a deeply personal project for her, I'd anticipated she would talk of focusing on the long journey of production, of her struggles and personal triumphs. Instead, without hesitation she said what mattered most to her was that this book would shine a light on the artists, the crew who had worked so hard for so long and achieved such beautiful results.

That generosity of spirit was in evidence everywhere I went at Pixar, reflected in the openness and good humor of everyone I spoke with. To all of them go my heartfelt thanks and admiration, and first among these are directors Brenda Chapman and Mark Andrews. *Brave* is an amazing achievement, and I thank you both for letting me glimpse its production. I gained a new perspective and an increased love for the medium through your eyes.

I'm also indebted to Katherine Sarafian, whose stewardship allowed both magic to happen and the pipeline to be appeased; the inimitable Steve Pilcher, whose passion for both a life of art and the art of life is infectious; Steve Purcell, who achieves the remarkable feat of being as intriguing as the wonders displayed in his office; Tia Kratter, with her kindness, her wicked sense of humor, and her sixth sense about exactly when a cup of tea is necessary; Brian Larsen, Noah Klocek, Matt Nolte, Bill Wise, David MacCarthy, Claudia Chung, Steve Hunter, Alan Barillaro, Garett Sheldrew, Emma Coats, Barry Johnson, Bobby Rubio, Ted Mathot, Louis Gonzales, Max Brace, Scott Morse, Kris Klein, Derek Williams, Megan Bartel, Ryan Lynch, Matt DeMartini, Crosby Clyse, Susan Loshin, Lorien McKenna, Corinne Cavallaro, Dana Murray, and everyone else I was fortunate enough to speak with—in particular the effects, sets, sim, and lighting departments. I'll never think of the pipeline in the same way again.

On the publishing side, Emily Haynes of Chronicle Books is a patient soul of brevity and wit. Michael Morris, Jake Gardner, Becca Cohen, Claire Fletcher, Emilie Sandoz, and Beth Steiner all contribute to make Chronicle a great publisher to work with. Glen Nakasako of Smog designed the book's layout and the results speak for themselves, beautifully. Kiki Thorpe, LeighAnna MacFadden, and Kelly Bonbright of Pixar and Disney Publishing deserve kudos for their considerate and considerable help. Sarah Boggs of Pixar bore the brunt of juggling interviews and escorting the author with alacrity and charm. I'm also grateful to Amid Amidi for, among other things, his introduction to Taylor Jessen and Michael Ruocco, who did a brilliant job of transcribing the interviews excerpted in this book. Above and beyond.

My life and work during this project were enhanced by the support and encouragement of my friends, most particularly Rob Berman, Michael Lerew, David Pimentel, David Derrick Jr., Pete Docter, Toby Shelton, and Traci Mars. Lastly, to Paul Fisher, inadequately but earnestly, *mòran taing*.
—Jenny Lerew

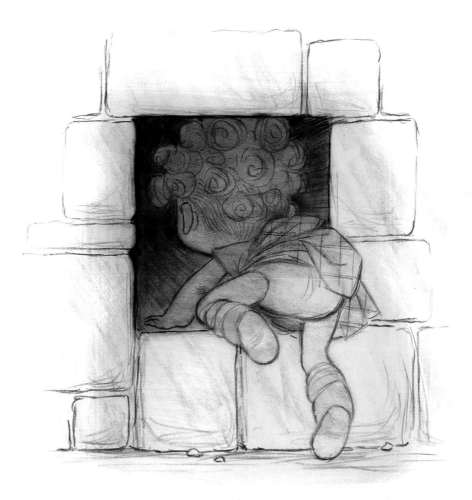

Matt Nolte | Pencil | 2011